Gozzoli

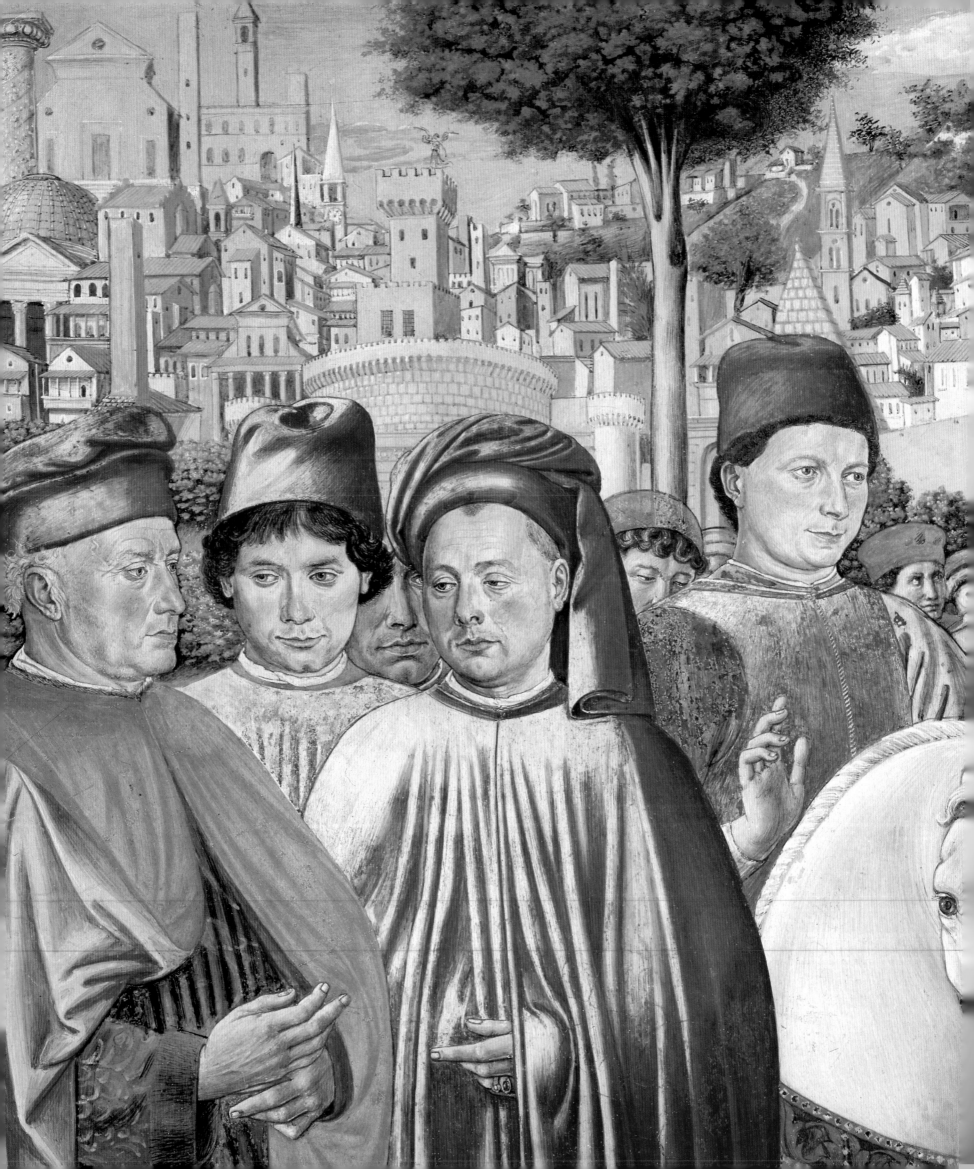

Marion Opitz

Benozzo
Gozzoli
1420–1497

KÖNEMANN

1 (frontispiece)
St. Augustine departing for Milan (cf. ill. 62, detail ill. 70), 1464/65
Fresco, 220 x 230 cm
Apsidal chapel of Sant'Agostino, San Gimignano

© 1998 Könemann Verlagsgesellschaft mbH
Bonner Str. 126, D-50968 Köln

Art Director: Peter Feierabend
Project Manager and Editor: Sally Bald
Assistant: Susanne Hergarden
German Editor: Ute E. Hammer
Assistant: Jeannette Fentroß
Translation from the German: Fiona Hulse
Contributing Editor: Susan James
Production Director: Detlev Schaper
Assistant: Nicola Leurs
Layout: Wilhelm Schäfer
Typesetting: Greiner & Reichel, Cologne
Reproductions: CLG Fotolito, Verona
Printing and Binding: Neue Stalling, Oldenburg
Printed in Germany

ISBN 3-8290-0250-5
10 9 8 7 6 5 4 3 2 1

Contents

Benozzo, "an Inventive Master"
6

Inset: Wall Painting
14

The Cycle of Frescoes in Montefalco
16

Biblical History as a Means of Civic Self-Portrayal
44

Inset: The Three Kings
60

The Outstanding Revival of Painted Narratives: the Cycle of St. Augustine
62

Benozzo's Late Work
111

Inset: Savonarola and the Bonfire of the Vanities
114

Chronology
116

Glossary
117

Selected Bibliography
120

Photographic Credits
120

BENOZZO, "AN INVENTIVE MASTER"

2 Fra Angelico and Benozzo Gozzoli
Adoration of the Magi, 1438–1444/45
Fresco
San Marco, Cell 39, Florence

During his "apprenticeship" years in the workshop of Fra Angelico, Gozzoli had taken part in the decoration of the cells in the Dominican monastery of San Marco. The paintings in cell 39 are thought to be almost exclusively by him, and these include a depiction of the Three Kings in the type of Adoration that was customary in the 12th and 13th centuries: the oldest king Caspar has sunk right to the ground before the Christ Child in order to kiss his feet. The middle-aged king is kneeling reverently next to him, while the youngest king is standing behind him.

Benozzo Gozzoli was born in 1420 in Florence, the son of the tailor Lese di Sandro. In a source dating from 1480 the artist stated that he was 60 years old, confirming 1420 as his date of birth.

By his contemporaries he was "valued as a proficient and inventive master who was particularly lavish in his depiction of animals, perspective, landscapes and ornamentation" – as Giorgio Vasari (1511–1574) wrote in his "Lives of the Most Eminent Italian Painters, Sculptors and Architects".

In the first edition of his "Lives of the Artists", which appeared in 1550, Vasari simply referred to him by his

Christian name, Benozzo, though he was actually called Benozzo di Lese di Sandro. In the second edition of 1568, he for the first time called him by the complete name which has continued to be used to the present day, Benozzo Gozzoli. In documents, and his signature, he is referred to as "Benozzo de Florentia" or "Benozzo di Lese".

Apart from his main works, three extensive cycles of frescoes in Montefalco, Florence and San Gimignano, there are also records relating to panel paintings, bronze works, illuminated manuscripts and designs for embroideries, as was typical for the artists of the time.

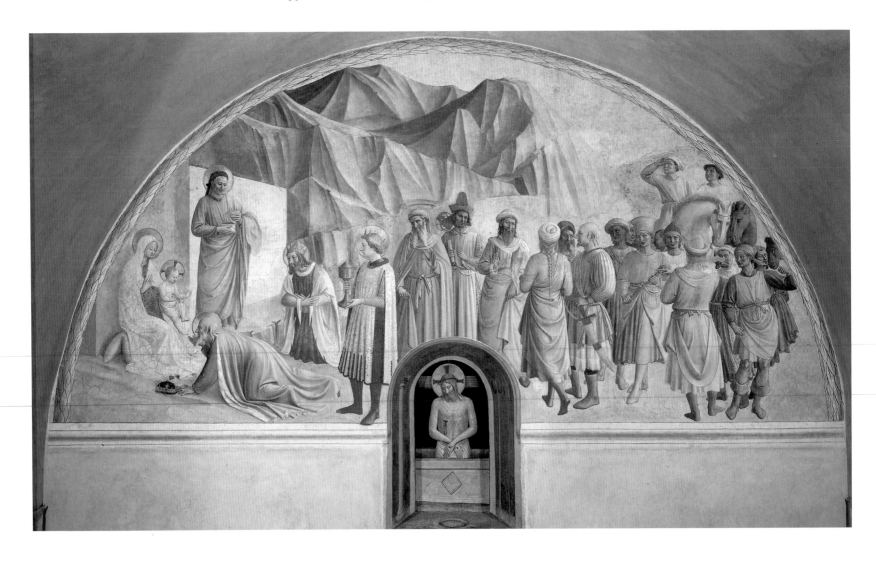

Benozzo Gozzoli was a student of Fra Angelico (ca. 1395–1455), who had a formative influence on him. In an entry in the Florentine land register of 1442, it says that Benozzo Gozzoli is "learning to paint". This note refers to the decoration of the dormitory cells in the Florentine Dominican monastery of San Marco, which took place from 1438 to 1444/45. There Fra Angelico and his assistants were painting a small devotional fresco in each cell, while Cosimo de' Medici's double cell (cell no. 38/39) was furnished with a larger wall painting, the *Adoration of the Magi* (ill. 2). Benozzo played a decisive part in the production of this picture. This can be recognized stylistically by the fact that, compared to the works of his teacher, the colors are softer, the plasticity of forms is reduced in favor of sharper contours, and the landscape in the background acts as a backdrop. Here, the religious theme of the Epiphany is set in a bleak rocky landscape which rises up behind the Three Kings' retinue. This corresponds to the religious mood of Fra Angelico's pictures and does justice to the fresco's function as a devotional picture.

After completing the works in San Marco, Benozzo entered into a contract with Lorenzo Ghiberti (1378–1455), dating from 24 January 1445 (1444 according to the Florentine calendar, as their year began on 1 March), to work with him for three years on the second Baptistery door in Florence, the Gate of Paradise. He is quite explicitly mentioned in the contract as a "painter's assistant". Benozzo appears to have acquired precise knowledge on perspectival depiction from Ghiberti, for in contrast to earlier works there is a more sophisticated conception of pictorial space here, that is of nearness and distance, foreground and background. Due to stylistic correspondences with Gozzoli's paintings, sections of the Baptistery door are attributed to him, such as the subordinated group of people in the *Meeting of Solomon and the Queen of Sheba* (ill. 4). We do not know whether he did indeed continue to work in Ghiberti's workshop for the three years stipulated in the contract.

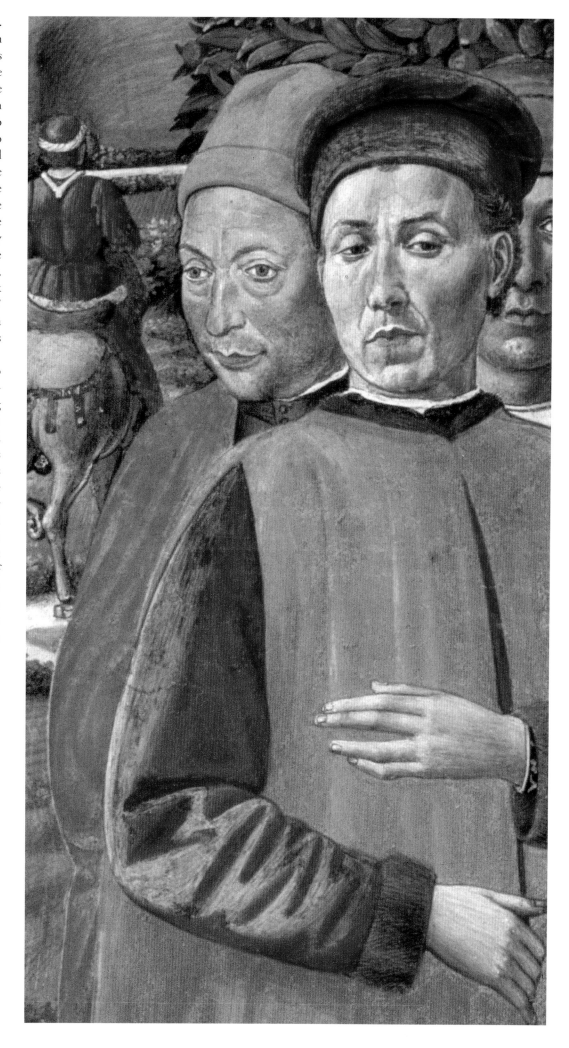

3 *St. Augustine departing for Milan* (detail ill. 70), 1464/65

A self-portrait of Benozzo Gozzoli appears at the right of the picture.

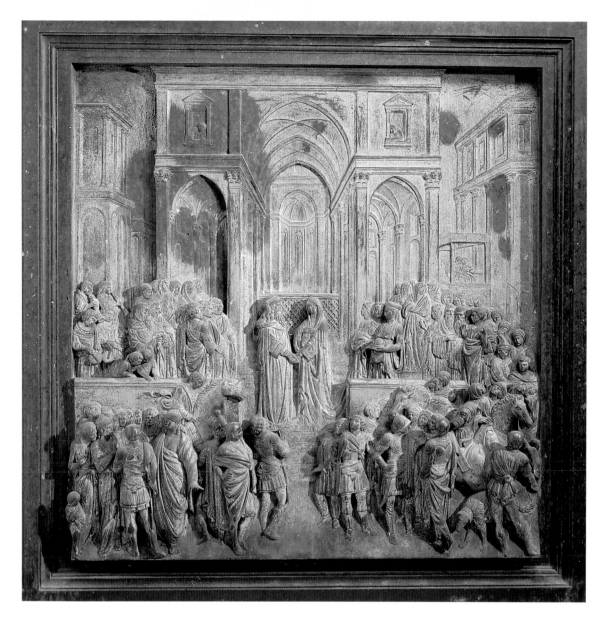

4 Lorenzo Ghiberti
The Meeting of Solomon and the Queen of Sheba,
1425–1452
Bronze relief, gilded, 80 x 80 cm
Battistero San Giovanni, East portal, Florence

The meeting of the Queen of Sheba and Solomon takes place in front of a clearly structured background architecture. The well planned arrangement of a multitude of other figures on two spatial levels is a compositional device to direct the viewer's gaze towards the encounter. Researchers have assumed that the secondary figures on the level occupied by Solomon and the Queen of Sheba were produced by Gozzoli. At the time the work was created, the theme was interpreted as a sign of hope of unity between the Orthodox (Queen of Sheba) and Western (Solomon) Churches.

After finishing his work for Lorenzo Ghiberti, Benozzo went to Rome. There he again worked for Fra Angelico, helping him paint the apsidal chapel in St. Peter's in Rome, which was destroyed when the basilica was rebuilt by Pope Julius II (1503–1515). A document dating from 13 March 1447 mentions that Benozzo was paid the sum of seven florins for his work.

Benozzo moved from Rome to Orvieto in 1447, where together with Fra Angelico he painted two of the four vault sections of the Chapel of San Brizio in the cathedral; *Christ the Judge, Angels and the Chosen* and the *Choir of Prophets.* The two vault sections that remained empty were completed, 52 years later, by Luca Signorelli (ca. 1445–1523) using cartoons produced by Fra Angelico. We also have information relating to this task. While Benozzo is still referred to as an "assistant" of Fra Angelico's, he is paid far more than the other assistants. It is probable that his artistic standing had already risen by this time.

From Orvieto, Fra Angelico and Benozzo returned to Rome in order to paint the Chapel of Pope Nicholas in the Vatican – now part of the Vatican Museum. Its name is derived from the donor and commissioner of the frescoes, Pope Nicholas V (1447–1455). The Chapel of Pope Nicholas, which is dedicated to the archdeacons Stephen and Lawrence, contains two rows arranged above each other, each with six scenes from the lives of the two saints. It is now thought that the works produced by Benozzo were the *Preaching of St. Stephen, St. Lawrence before Decius* and the *Martyrdom of St. Lawrence.*

Vasari mentions other works by Benozzo Gozzoli, though it is not known during which of his periods in Rome these works were produced, for he returned there again in 1458. Above the entrance gate to the Torre dei Conti there was originally a fresco, which has unfortunately been lost, containing a depiction of the Madonna and saints. According to Vasari, Benozzo is supposed to have created "numerous figures in a chapel" in Santa Maria Maggiore. These pictures have also been destroyed.

However, a picture of the *Madonna and Child giving Blessings* (ill. 5), painted on silk and mounted on a wooden panel, still exists in Santa Maria sopra Minerva in Rome. This picture dating from 1449 was painted in the manner of early Christian Madonna pictures. The Mother of God and the Christ Child are standing in a ciborium. The inscription MARIA VIRGO in the golden nimbus refers to Mary's virginity. Christ appears as the ruler of the world, carrying a globe in his hand, on which the names of the continents known at that time, ASIA, EVROPIA AND AFRICA are written.

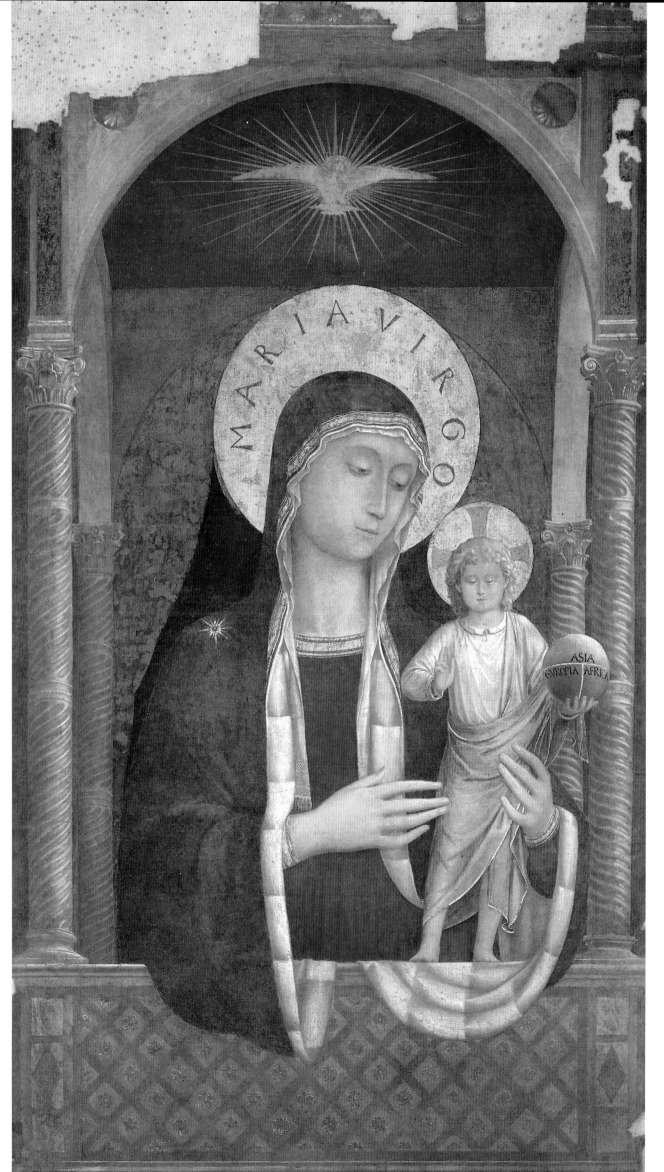

5 *Madonna and Child giving Blessings*, 1449
Tempera on silk on a wooden mount, 254 x 130 cm
Santa Maria sopra Minerva, Rome

Gozzoli has placed the Madonna standing in frontal view, common in the early Middle Ages, within an architectural framework. The dark blue cloak of the Mother of God is draped across the balustrade, thus creating the impression that she is about to step out of the ciborium. With her left hand she is embracing the Christ Child who, as a sign of his dominion over the world, is holding a globe in his hand.

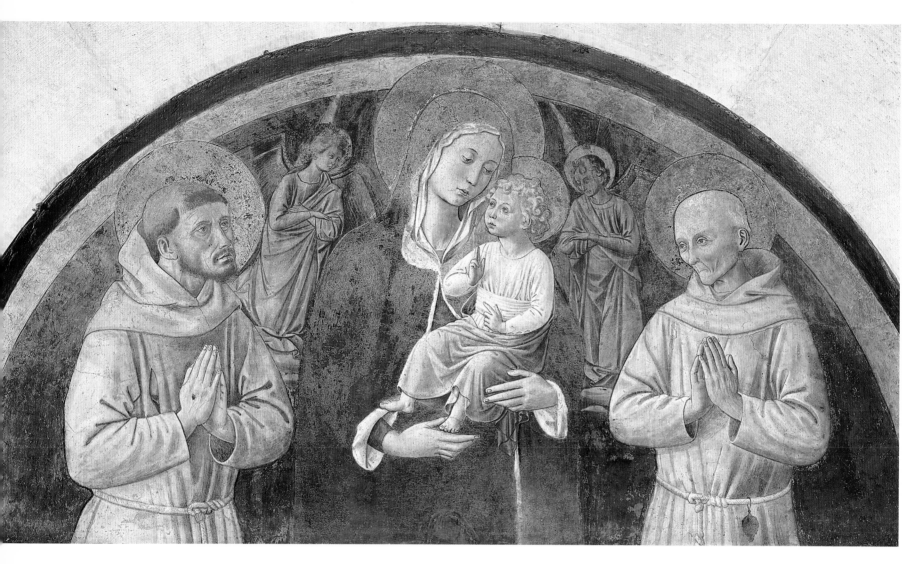

6 *Madonna and Child between*
St. Francis and St. Bernardine of Siena, 1450
Fresco
Door lunette, San Fortunato, Montefalco

Gozzoli created his first independent works in
Montefalco: however, only fragments remain of the
frescoes produced for the monastery church of San
Fortunato.
In this *Sacra Conversazione*, the Mother of God is flanked
by St. Francis on her left and St. Bernardine of Siena on
her right. The Christ Child appears to float in her hands.
The founder of the Franciscan order, and the Franciscan
monk who was canonized in 1450, are both clad in a
simple habit with a rope belt.

Benozzo began his stay in Montefalco (Umbria) in the
second half of 1449. There he at first worked in the
monastery church of San Fortunato, renovated in 1446,
which is situated 1.2 kilometers outside the town on the
road to Spoleto. Only fractions now remain of the
cycle of frescoes dating from 1450. A lunette fresco of the
*Madonna and Child between St. Francis and St. Bernardine
of Siena* (ill. 6) above the entrance portal has survived. At
the height of the Madonna's shoulders, two worshipping
angels are floating in the background. On her right side
is St. Bernardine of Siena, and on her left St. Francis. The
depiction of Bernardine of Siena as a saint means it is
unlikely that the work dates from before the summer of
1450. The Franciscan monk, who died in 1444, was
canonized by Pope Nicholas V at Whitsun 1450.

On the right altar there was originally a painting
of the church's patron saint, *St. Fortunatus Enthroned*
(ill. 7), but it was severely damaged in the 17th century
when the altar was renovated. What has survived is the
enthroned saint who, as usual, appears as a priest with
a tonsure wearing a chasuble and holding a flowering
staff in his right hand. The staff is a reference to his
legend, according to which Fortunatus used it to drive
oxen. When it was placed on his grave, the staff began
to flower. Fortunatus, who was born in Spoleto in about
400, converted the area around Montefalco. He is the
patron saint of this town, and depictions of him are only
found in the local area.

A fragment of the *Madonna and Child* (ill. 8) can be
seen on the right church wall. The Mother of God is
sitting on a cushion in a stone throne niche. She is
reverently gazing at the child on her lap, while folding
her hands in prayer. In this composition, Gozzoli
combined two depictions of the Madonna: the
Adoration of the Child and the Enthroned Madonna.
The artist's signature appears on the throne's pilaster
(ill. 8): BENOZII FLORETIA, Benozzo of Florence.

Benozzo painted one of his highest quality paintings
for the high altar of the church of San Fortunato; it is
the panel painting of the *Madonna della Cintola* (ill. 9),
which is now in the Pinacoteca Vaticana in Rome. The
town of Montefalco presented the painting to Pope Pius
IX (1846–1878), who bequeathed it to the Vatican
Museum.

Angels are surrounding Mary in a semi-circle and, as
it were, form an aureole in which the arrangement of
the angels' wings matches the points of a crown. The
gold background, which in the Middle Ages was used
to elevate the depicted scene and give it an unreal,
supernatural element, had from the 15th century
onwards been replaced by depictions of landscapes and
architectural settings. By this time, the gold background
was already much rarer in Italian panel painting and
symbolizes the transcendental, divine space, increasing
the distance between the saints and secular world. The
subject of Mary lowering her girdle is not mentioned in

7 *St. Fortunatus Enthroned*, 1450
Fresco, 200 x 110 cm
San Fortunato, Montefalco

The church's patron saint is wearing a light red, bell-
shaped chasuble, decorated with a golden colored stole,
over a white undergarment. These liturgical vestments
identify Fortunatus as a priest. The book is a reference to
his missionary activities in the Montefalco region, and the
flowering staff is his characteristic attribute: according to
a legend, the staff had originally been used to drive cattle
and finally started flowering on the saint's grave.

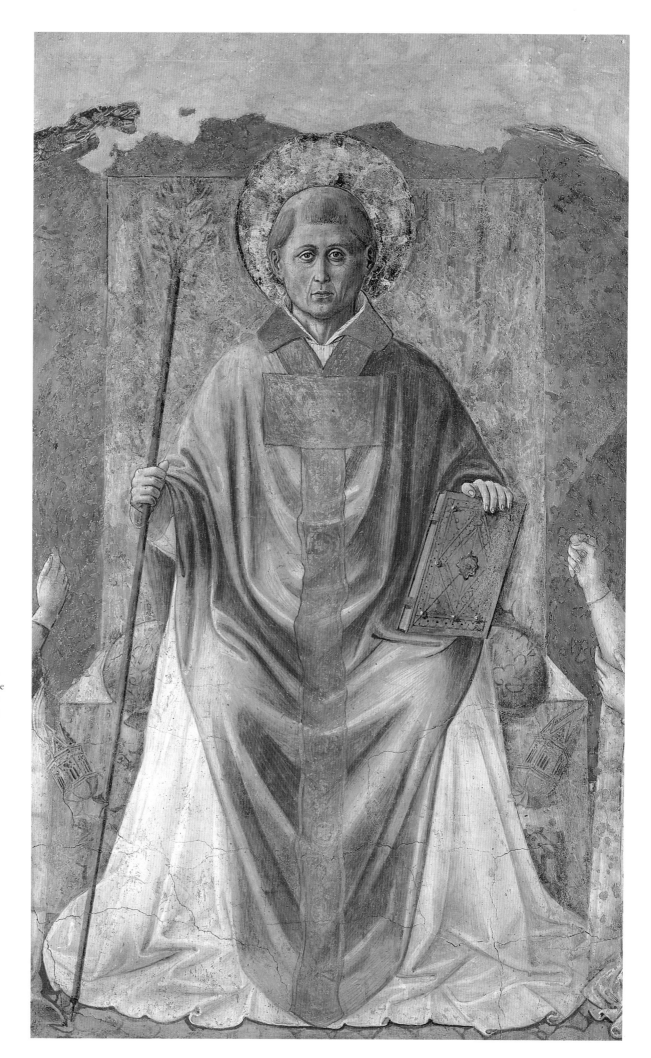

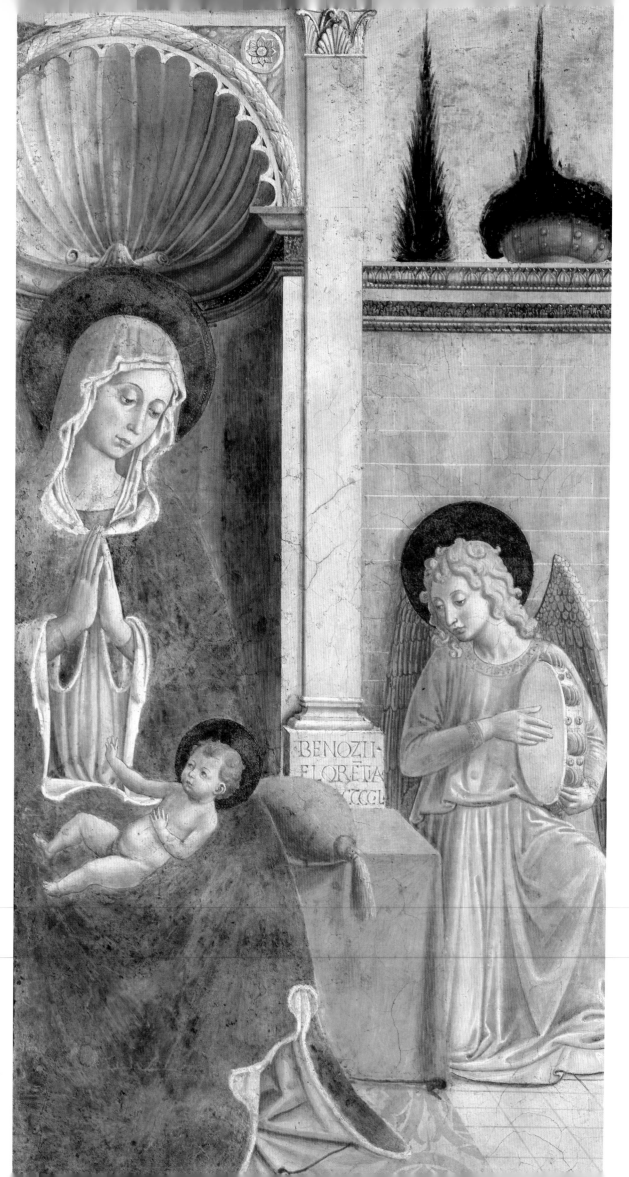

8 *Madonna and Child*, fragment, 1450
Fresco, 250 x 135 cm
San Fortunato, Montefalco

The surviving right half of the picture is completed by a
second angel making music to the left of the Mother of
God in front of background architecture. In this
composition, Gozzoli was combining two variations of
depictions of the Madonna, the Adoration and the
Enthroned Madonna.

the Gospels, but in the New Testament Apocrypha. Thomas, one of the 12 apostles, doubted Mary's Assumption. The Virgin appeared to him and, as proof, gave the doubting apostle her girdle. The theme was particularly popular in Italian, and specifically in Tuscan art during the 15th century, for since 1365 the Madonna's girdle had been venerated as a relic in the cathedral of Prato. The lowering of the girdle was frequently depicted – another peculiarity of Italian art from the 15th century – in combination with the Assumption of the Virgin. The pillars at the side of the altar panel contain depictions of saints, St. Francis, St.

Fortunatus and St. Anthony of Padua being on the left. St. Louis of Toulouse, St. Severus of Montefalco, whose remains are kept in San Fortunato, and St. Bernardine of Siena are standing on the right side. The predella contains six scenes relating episodes from the life of Mary. It begins on the left side with the *Birth of Mary*, continues with her *Marriage*, the *Annunciation*, the *Birth of Christ* and the *Presentation in the Temple*, and ends with the *Death of Mary*.

9 *Madonna della Cintola*, 1450
Tempera on panel, 133 x 165 cm
Pinacoteca Vaticana, Rome

Here Gozzoli combined the Assumption of the Virgin and Mary lowering her Girdle. The two scenes are directly connected: when the sceptical Thomas doubted the apostles' report of the Assumption of Mary, the Madonna appeared to him and gave him her girdle as proof. Inside the sarcophagus, which is a reference to the Assumption of the Virgin, various meadow flowers are blooming. On the left St. Thomas is kneeling and receiving the girdle from the Madonna. The pillars at the sides are decorated with the figures of saints. The predella depicts episodes from the life of Mary.

Together with *sgraffito* and *stucco lustro*, fresco painting is a technique of painting on lime mortar, one of the oldest processes in painting. Cave paintings produced during the Stone Age can also to some degree be considered frescoes, as they have a lime base and the paintings have been preserved due to a natural sinter process of rainwater seeping through that base. The fresco technique was also widespread in classical times, as shown by surviving fragments in Pompeii and Herculaneum.

In contrast to *secco* painting, the term *fresco* is applied

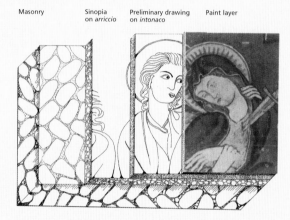

| Masonry | Sinopia on *arriccio* | Preliminary drawing on *intonaco* | Paint layer |

10 (right) Detail from the *Passion* cycle, ca. 1330–1340
Scheme for the construction of a fresco
Protestant church of Waltensburg

After the first two layers of mortar have been applied to the bare wall as a scratch coat, the third layer of mortar is applied as a brown coat (*arriccio*), which means that it will eventually be primed with grooves in order to provide the layer to be painted on (*intonaco*) with a better grip. Frequently a preliminary drawing in red chalk appears on the brown coat, and this is called a sinopia.

to all paintings created on wet plaster. The starting material is limestone, limestone spar or marble, which is fired in a limestone oven and changed into fired lime (calcium oxide). The next stage of work is to slake this using water, producing slaked lime. If this is mixed with sand, mortar is obtained. Chemically, the calcium oxide is changed into calcium hydroxide. The preparation of the surface to be painted starts with the application of, usually, three or four layers of mortar onto the thoroughly moistened stone or brick wall. Before work begins all the old plaster should be removed from the wall. The first two layers of mortar are applied as a scratch coat, which means that the mortar is composed of one part thick lime to three to five parts of rough sand which must be salt-free, as salt would destroy the fresco. The first scratch coat must be wetter than the second one. The third layer of mortar is called the *arriccio* or brown coat and comprises one part of lime, two parts of rough sand and half a part of fine sand. The brown coat is applied on the wet second coat once the latter is firm to the touch, and this brown coat is the undercoat (ill. 10). The top coat on which the actual painting will be done – also called the *intonaco* – is applied to the brown coat. The areas of fresh plaster applied and painted within the space of a day are called *giornate* (day's work). It is frequently difficult to differentiate between the *arriccio* and *intonaco* if there is no sinopia between them. Sinopias (ill. 11) are full-scale preliminary drawings on the *arriccio*, which the fresco painter can use to check the composition and ornamental scheme in the room and on the wall. The term is derived from the red chalk used for the preliminary drawing, a high quality red ochre which was quarried near Sinop on the

Black Sea. Sinopias (ills. 11, 12) are only used as preliminary drawings on frescoes with several layers of plaster and are painted onto the damp coat. In the 15th century the sinopia lost favor due to the increased use of tracings, especially cartoons. The latter is a preliminary drawing which is transferred to the wall in a scale of one to one. The section that can be transferred during the course of a working day is cut out. The cartoon is pressed against the freshly applied *intonaco* in order to mark the contour lines. The drawing is transferred by perforating the cartoon with a pointed iron tool, and the rear side of a detailed preliminary drawing is pounced with charcoal or red chalk. Other means of transferring the design are the drawing frame and tracing. In the latter process, the contour lines are perforated and the drawing frame is placed over the design. This was not, however, in regular use again until the 15th century, though it was a process of drawing known to stone masons and used in medieval workshops. This method of transferring designs became more widespread following the publication of Alberti's "Della Pittura" in 1436, in which he made a detailed description of the drawing frame. At this point mention should also be made of the stencil, which was used for repetitive forms such as the decorational system. The process was to cut out the desired forms from the original – usually parchment, paper or metal – and use them to produce contour drawings. Another method of producing a preliminary drawing was to use a taut cord and stylus. They were used to mark the borders of pictures, registers and friezes. The cord was dipped in red chalk, and then tightened over the desired line. When released, the cord marked the surface. It was also customary to press it into the damp plaster.

In fresco or *fresco buono* painting the majority of the painting is applied to fresh lime mortar that is already firm to the touch. It is extremely unusual to find a painting that was carried out solely with the use of the *fresco buono* technique, as not all pigments were suitable for use on frescoes, meaning that they could not all be applied wet and set using water alone. There were also technical reasons why it might be necessary to paint the work *secco*. Fresco colors that were naturally light, and would only permit limited depths of shade, were produced in later *secco* additions. The rapid drying of the fresco colors made it almost impossible to produce a detailed picture, and this had to be added later as *fresco secco*.

For fresco painting it is important to have limeproof pigments which can be ground in distilled water to a state of suspension. These mineral colors, the natural inorganic pigments, include all the earth colors such as ochre, *terre verte* (green earth) and *terra di Siena* as well as all the colorful minerals such as lapis lazuli, cinnabar, malachite and azurite. Medieval fresco painters had a palette of several dozen pigments at their disposal. Since the colors change as the fresco dries – blue and green, for example, become lighter – these were underpainted and then applied

11 *Annunciation* (detail: the archangel Gabriel), 1491
Sinopia
Museo della Sinopie, Camposanto, Pisa

The sinopia is a preliminary drawing on the brown coat (*arriccio*). Above it the fine coat (*intonaco*) to be painted on is applied. Only just enough *intonaco* as the artist could paint in one day was applied to the brown coat, which is why these freshly plastered areas are called *giornate*, the amount of fresco work done in one day.

12 *Annunciation* (detail: Mary), 1491
Sinopia
Museo delle Sinopie, Camposanto, Pisa

Before the last World War very little was known about the
sinopias. Due to damage caused by the war, many frescoes
were separated from the walls and the preliminary
drawings beneath, the sinopias, became visible. The
detailed preliminary drawing is more than a simple layout
of the composition and the figural scene. It already shows
details such as the lavishly executed arrangement of the
folds of the garments or the gestures and facial expressions
of the depicted people.

very thinly in order to achieve a uniform tone. At the same
time, this manner of applying color resulted in a translucent
property in which light was reflected back through the layer
of color from the surface below. Colors applied to fresh
plaster only need water as a thinning agent. *Fresco buono*
requires no binding agent as the chemical reaction of the
lime sets the colors as the plaster dries. *Secco* painting, in
contrast, requires binding agents such as casein or animal
glues (such as curd cheese). All the pigments used for fresco

painting can be applied *secco*, but the same is not true in
reverse.

The painting tools used were, as Cennino Cennini tells us
in his "Libro dell' Arte" (Book on Art), dating from the end
of the 14th century, bristle brushes for applying the lime
and priming, and hair brushes for sketching and painting.
According to Cennini, the bristle brush had to be produced
from the white bristles of the domestic pig, and the hair
brush from the tail hairs of the squirrel.

The Cycle of Frescoes in Montefalco

14 View of the main apsidal chapel, 1450–1452
San Francesco, Montefalco

The pentagonal choir of the Franciscan monastery church in Montefalco was decorated by Gozzoli with a cycle of frescoes depicting the most important stages and deeds from the life of the founder of the order. In contrast to the customary direction of reading, the series starts at the bottom left with the birth of St. Francis and ends at the top right with his Ascension. In this way, Gozzoli was illustrating St. Francis' path to salvation from earthly life to heavenly glory, which is depicted in the vault.

13 Scheme of the main apsidal chapel
San Francesco, Montefalco

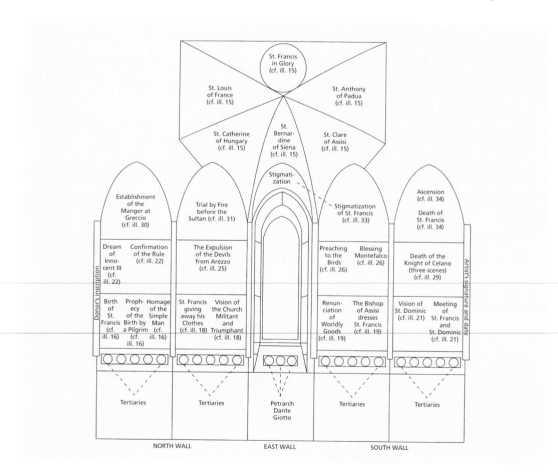

The work in San Fortunato was followed by the painting of the main choir and Chapel of St. Jerome in the church of San Francesco in Montefalco. The single-aisled church with an open roof truss, built between 1336 and 1340, has housed the town's art collection since 1895. The cycle of frescoes decorates the rib-vaulted, pentagonal main apsidal chapel (ill. 13) and depicts episodes and deeds from the life of St. Francis (ill. 14).

In order to understand the pictures it is useful to remind oneself about his life. Francis was born in Assisi in 1182, the son of the wealthy cloth merchant Piero Bernadone. Though he was baptized Giovanni, or John, he was called Francesco due to his particular love of the French language and courtly culture. During the battles to create a republic of Assisi, Francis was held captive in Perugia between 1202 and 1203. While imprisoned, he

suffered a severe illness and this brought about an inner change which led him to resolve deliberately to renounce his inheritance from his father and embrace a life of poverty. In 1206, in the small ruined church of San Damiano outside Assisi, St. Francis heard a call from God. The crucified Christ spoke to him in prayer and required him to rebuild his ruined house. Thereupon, Francis sold his father's bales of cloth and used the money to rebuild the chapels of San Damiano, San Pietro della Spina and Portiuncula. Between 1207 and 1209, he lived the life of a hermit in the Portiuncula, a small chapel outside the gates of medieval Assisi. The Carthusian community developed into the order of the Minorites, or First Order of Franciscans. Today the church of Santa Maria degli Angeli, built around the Portiuncula by Pope Pius V (1566–1572), is still a popular destination for numerous pilgrims. In 1209, Pope Innocent III was prompted by a dream to verbally confirm the rule of the Minorites: St. Francis had appeared to him, and had prevented the imminent collapse of the Lateran church. The written confirmation of the rule was made by his successor, Pope Honorius III, in 1223. Between 1213 and 1215, Francis lived as an itinerant preacher in southern France. As such he became so popular that he was nicknamed "God's troubadour and minnesinger". In 1219 St. Francis went to undertake missionary work in the Near East, where he survived the sultan of Egypt's trial by fire. In order to prove the true faith, he walked through fire before the eyes of the sultan and his Muslim priests. During the following year, St. Francis returned to his native land. There, due to the dissension amongst his friars as to the interpretation of the order's rule, he resigned as superior and in 1221 founded the so-called Third Order of Franciscans (Tertiaries) for lay brothers, as well as the Order of the Poor Ladies (Poor Clares), the Second Order, in 1222. The latter are named after St. Clare of Assisi (1193/94–1253), who left her parents' home and was made a nun by St. Francis. In 1222 St. Francis went to live in the seclusion of the Tuscan monastery of Alverna (La Verna), where in 1224 he received the stigmata, the wounds of Christ, which he concealed during the rest of his life and which were only revealed on his death bed. After receiving the stigmata,

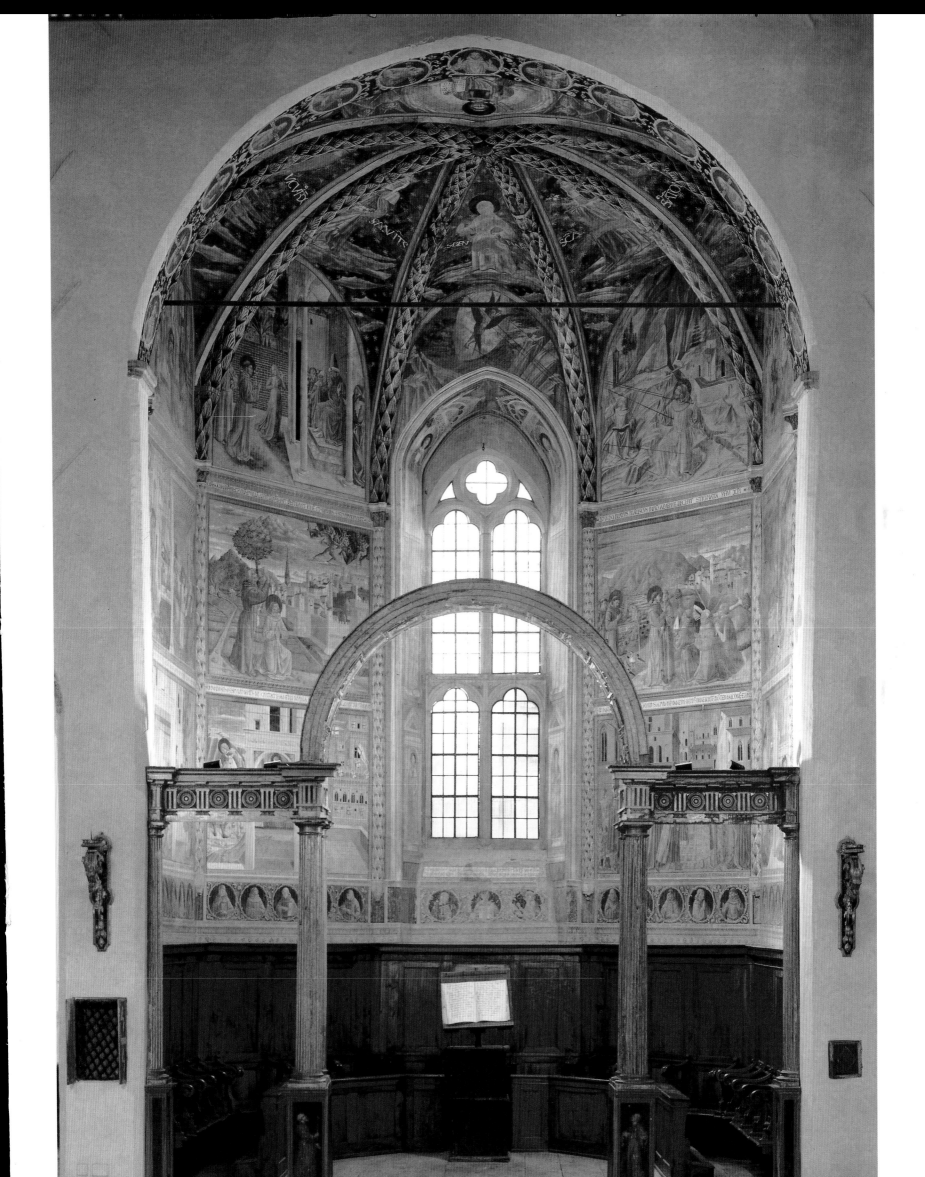

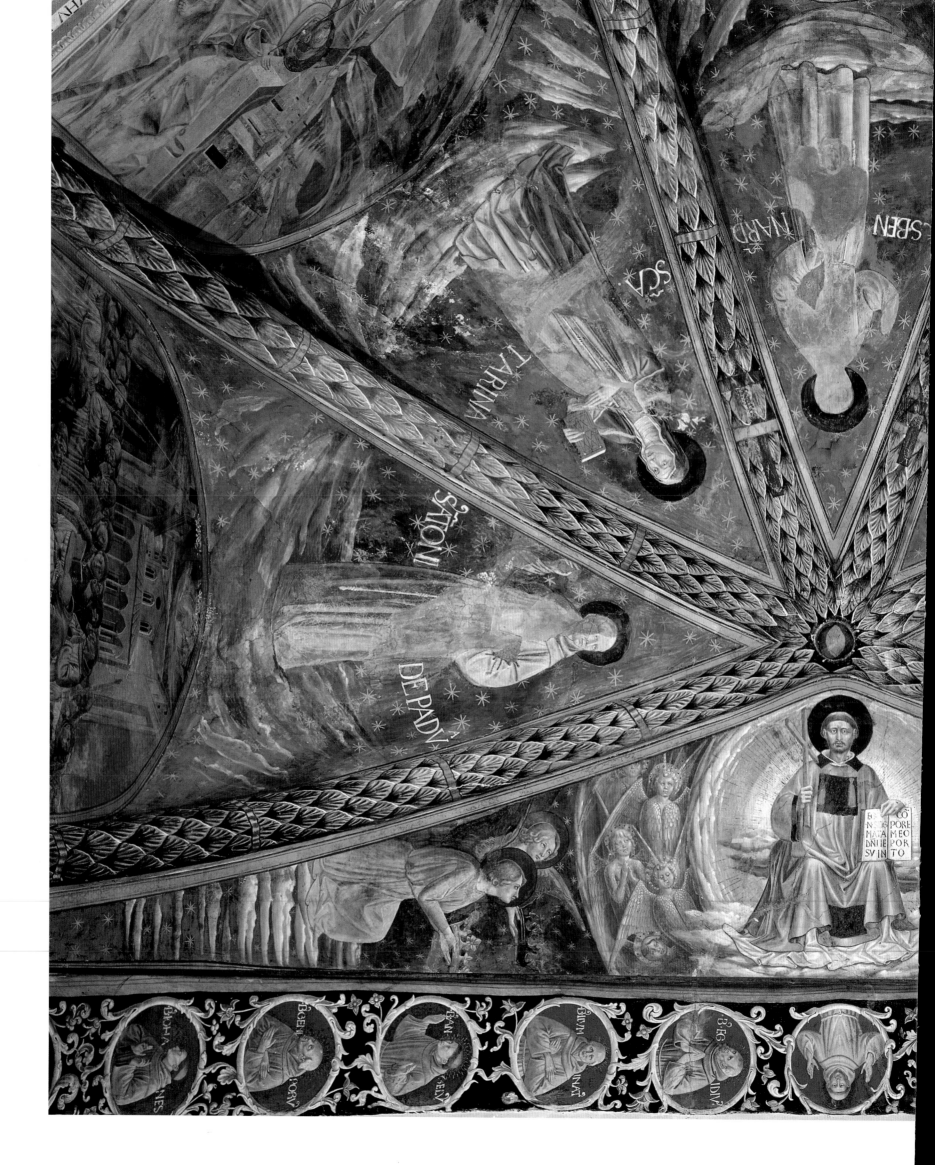

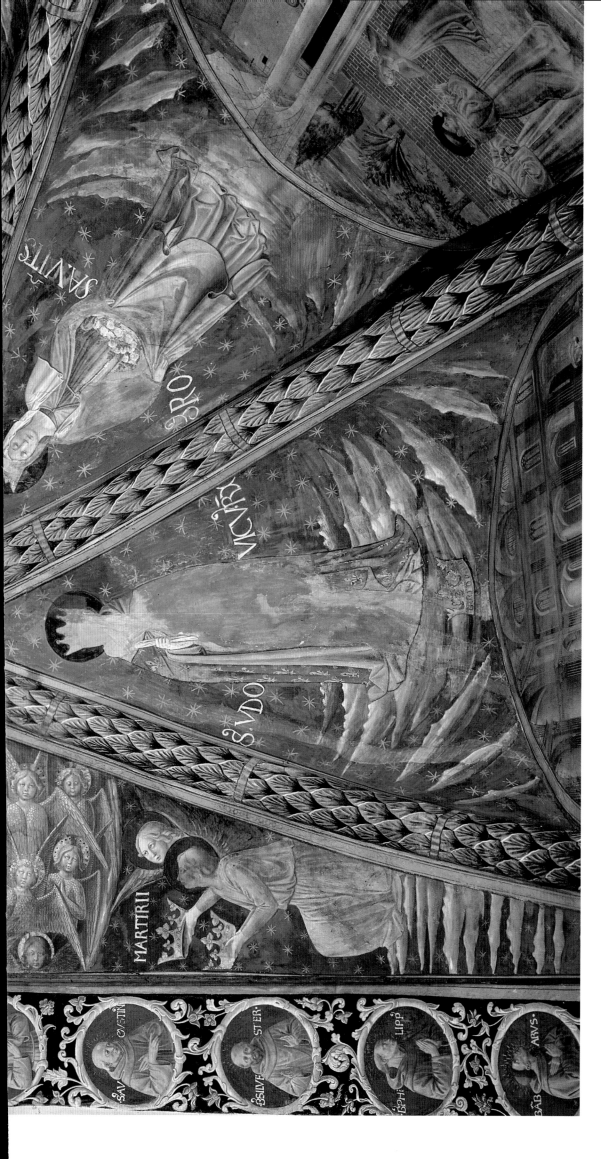

numerous miracles and healings followed. In 1226 St. Francis died and was buried in his native city. Immediately after he was canonized in 1228, work started on the building of the church of San Francesco above his grave.

In about 1290, one of the most extensive cycles on the life of St. Francis was created in the upper church of San Francesco in Assisi. It contains 28 pictures and was to be exemplary for almost 50 years. Not until the mid-14th century did artists begin to vary the representational scheme it presented. The relevance of this cycle here is that Gozzoli knew it and made use of it without following it continuously. Gozzoli differs from his famous model in the choice and sequencing of the scenes. He depicts events from the saint's life. What are missing are the miracles, depicted in Assisi, which Francis worked after his death. However, Benozzo not only broke with the customary chronology, he also proved his inventiveness and independence in the narration of unusual occurrences.

The cycle of St. Francis in Montefalco contains a total of 17 episodes from the life and work of the saint, arranged in a total of 12 pictures and a lost stained glass window. The cycle of pictures extends above the choir stalls along the five walls of the apsidal chapel, in three rows arranged one above the other. In contrast with tradition, they should be read starting with the bottom row, though in the usual manner from left (north wall) to right (south wall). The cycle then continues in the middle row and finishes in the lunettes. This unusual narrative method from the bottom upwards is in-consistent with the method in which wall paintings are produced, for they are always painted from the top downwards. An explanation for the atypical direction of reading is offered by the sequence of the pictures. Starting at the left in the bottom row with the *Birth* and ending at the outermost lunette field with the *Ascension*, Benozzo narrates the saint's life as a journey from the earthly to the divine realms. In keeping with this, the sequence of pictures ends in the six vaulted fields with St. Francis in glory with five saints from the Franciscan order (ill. 15). The architectural structure of the polygonal apse with its umbrella dome forced Benozzo – as is particularly clear in the vault paintings – to adopt a markedly Gothic construction. Nonetheless, there is no shortage of Renaissance pictorial elements such as the perspectively foreshortened cross the saint is holding in his right hand as he walks through the fire.

15 *St. Francis in Glory and Saints* (cf. ill. 14), 1452
Fresco
Vault

In the apsidal chapel's umbrella vault, with angels on either side, St. Francis is enthroned in glory with angels on either side. In the five spandrels, against a star-studded heaven with cirrus clouds, he is surrounded by the most important saints of the Franciscan order. During previous restoration work the names of the saints were repainted incorrectly: S(ANCTUA) A(N)TO(NIUS), St. Anthony of Padua; S(AN)C(T)A CATARINA [sic], St. Clare of Assisi; S(ANCTUS)BERNAR(INUS), St. Bernadine of Siena; S(ANCTA) ROSA VIT(ERBENSI)S [sic.], St. Catherine of Hungary; S(ANCTUS L)UDOVICU(S) R(E)X, St. Louis of France.

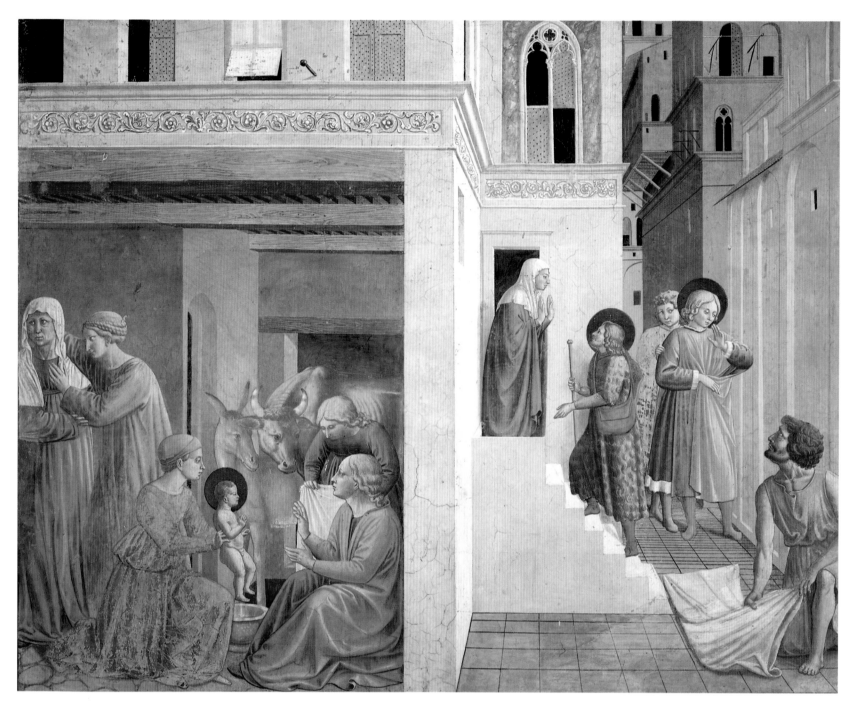

16 *Birth of St. Francis, Prophecy of the Birth by a Pilgrim, Homage of the Simple Man* (cf. ill. 14), 1452
Fresco, 304 x 220 cm

Three events are combined in one here in a sequence which does not match the customary chronology. On the left side of the picture maids are bathing the new-born Francis in a plain room inside a palazzo. The figural scenario and the presence of the ass and ox as representatives of paganism and Judaism are an allusion to the analogy with the birth of Christ.
The contemporary urban scenes and landscapes which Gozzoli used to integrate the individual episodes of the legend of St. Francis are characteristic of the entire cycle.

Painted on the pilasters right and left behind the choir arch are two angels holding banderoles. In addition to the client's name, the Minorite brother Fra Jacopo of Montefalco, there also appears the signature "Benotius Florentinus" and the date of origin, 1452.

The first picture shows three events from the saint's life: on the left the *Birth of St. Francis*, in the center the *Prophecy of the Birth by a Pilgrim* and on the right the *Homage of the Simple Man* (ills. 16, 17). A wall of houses towering up in the center separates the *Birth of St. Francis* from the other two simultaneous scenes. The first takes place inside a building and is determined by the contrasting appearance of the kneeling, sitting and stooping women who are surrounding the child together with an ox and ass. On the left edge of the picture a woman in a red dress is supporting the saint's mother. The circular arrangement on the right conveys an intimacy from which the other two women almost seem to be excluded. The vertical and diagonal com-

positional lines, which are created by the arrangement of the figures and the architecture of the space, meet in the figure of the holy child, which thereby becomes the center of the composition.

By means of disparities between the spatial and figural scale in the two following scenes, Benozzo creates differing levels of time. Francis' mother is standing at the top of a flight of steps. With her raised hands she is turning away the holy man who is identified as a pilgrim by his staff and bag. This meeting – chronologically the earliest event – is emphasized by the lines of the sloping roof and floor tiles, which converge compositionally at the mother's raised hands. It would be difficult to understand this scene if it were not for the explanatory inscription beneath: QUALITER B.F. FUIT DE-NU(N)TIATUS A XRO I(N) FORMA PEREGRINI QUOD DEBEBAT NASCI SICUT IPS(E) IN STAB(U)LO QUALIT(ER) QUIDA(M) FATUU(S) P(RO)STE(R)NEBAT B.F. VESTIME(N)TU(M)

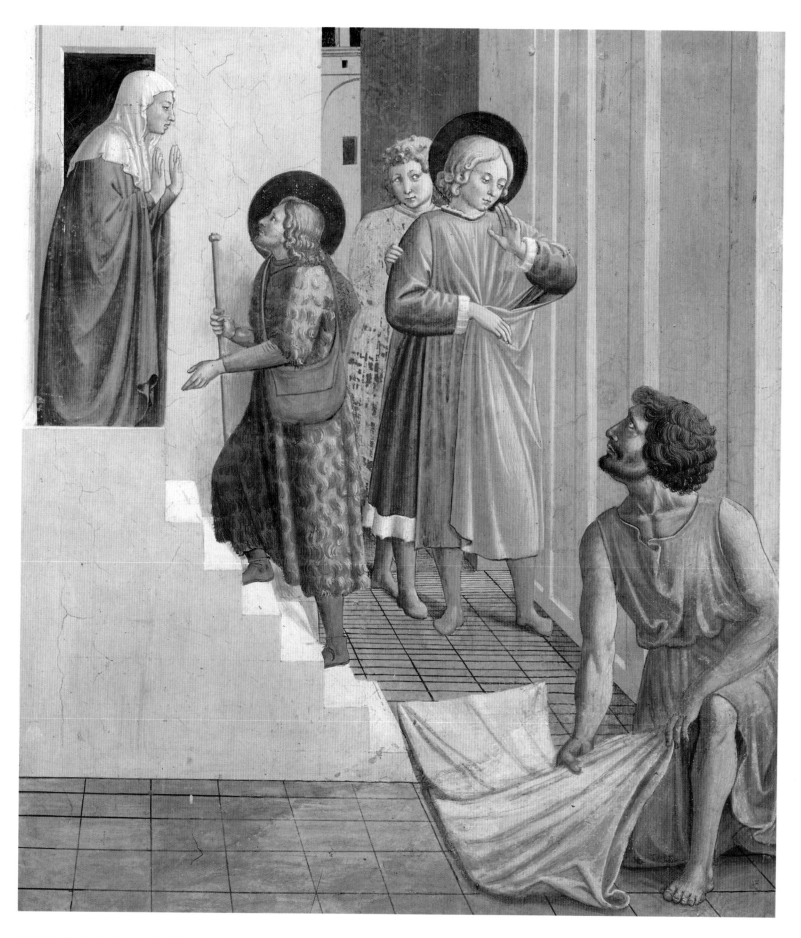

17 *Birth of St. Francis, Prophecy of the Birth by a Pilgrim,*
Homage of the Simple Man (detail ill. 16), 1452

In the center of the picture, Christ in the form of a
pilgrim is prophesying the birth of St. Francis. On the
right a simply dressed man is paying homage to the saint
by spreading out his cloak in front of his house.

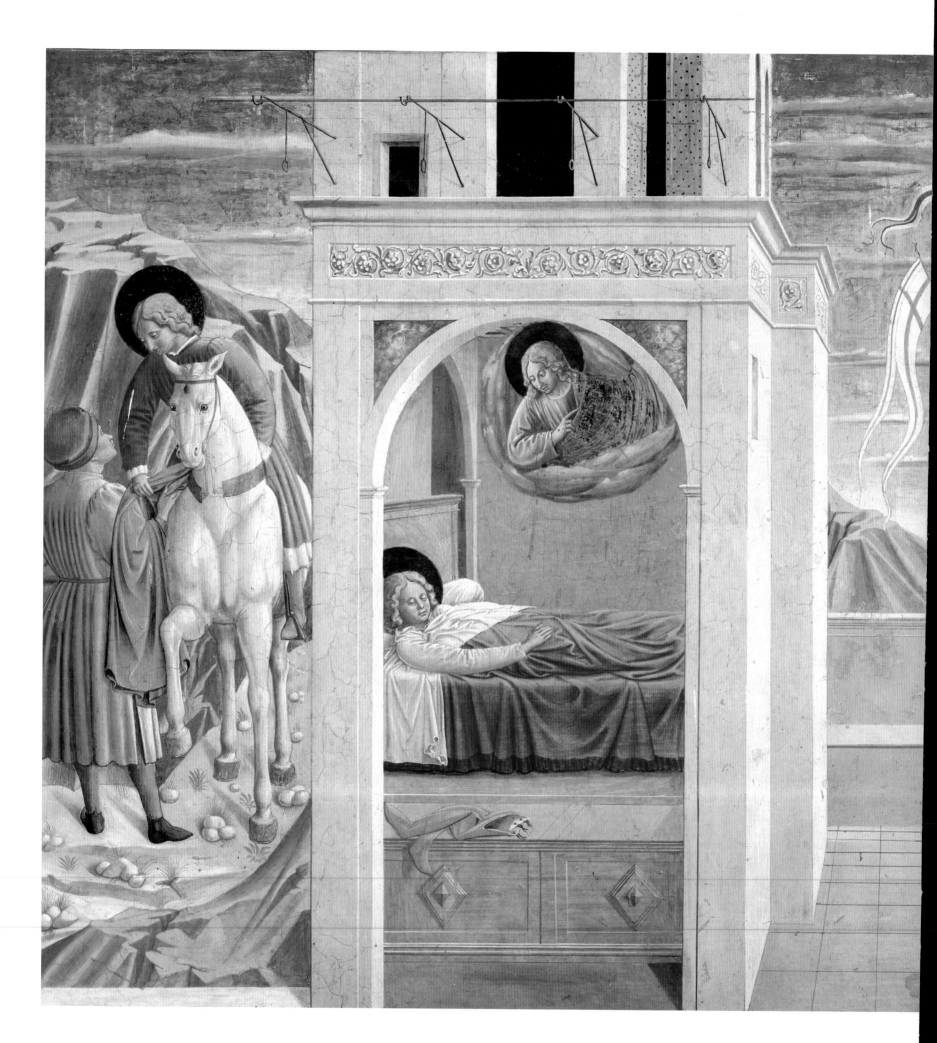

IN VIA – "How St. Francis was announced by Christ in the form of a pilgrim, and that he, like Christ himself, had to be born in a stable. And how a certain simple man spread his clothes out where St. Francis was walking." It is Christ himself, therefore, who is heralding the birth of St. Francis in the form of a pilgrim. On the right an event from the saint's youth has been added. The young Francis is walking along the street accompanied by a boy. Though further in the background than the two figures on the steps, the two figures are depicted proportionally larger. In the foreground of the picture on the right, a poorly clad man is kneeling, looking up to the small window in the palazzo. He is laying his cloak at the feet of Francis. The direction in which the beggar is looking and the right hand that the saint has raised to fend him off indicate the real reason for the homage: it is not directed at the smartly dressed, youthful Francis, but the new-born child, who like Christ was born in sparse surroundings. In official descriptions of his life, the birth of Francis is not mentioned. Only the "Vita e Fioretti", a legend dating from the 14th century which was not included in the official canon of legends about St. Francis, describes his birth in a stable. For that reason, this rarely depicted scene is also missing from the cycle of St. Francis in Assisi.

The ox and ass, as well as the *Prophecy of the Birth* by the holy man, are motifs which create direct links with the birth of Christ and the annunciation to Mary. Even at the beginning of the cycle, analogies are already being created between Christ and Francis. With the deviation from the chronological sequence of events in the picture, Gozzoli is achieving a heightening of the tension within the picture.

The second picture shows *St. Francis giving away his Clothes, Vision of the Church Militant and Triumphant* (ill. 18), two events from the saint's youth. What are conspicuous here are the weightings in the construction of the pictorial space. *St. Francis giving away his Clothes* seems to be pushed to the edge, clamped in between the frame on the left and the central building where the *Vision* is taking place. The well-dressed supplicant who is not, in contrast with tradition, depicted as a beggar is untypical. There can only have been one reason for taking this unusual approach to the theme: St. Francis was not only merciful to the poorest members of society.

The narration of the *Vision* encompasses two spatially transposed areas of the painting. Due to the repeated use of the vine scroll pattern, the building in the foreground can be recognized as St. Francis' parental home. Francis is lying within, asleep on a bed. As he dreams, Christ appears to him in a crown of clouds. He gazes down on the sleeping man and points to the right at a building decorated with numerous coats of arms and flags bearing the Cross. This is, as the inscription below the picture confirms, the castle which Christ shows the young St. Francis in a vision: QUAL(ITER) B.F. DEDIT

18 *St. Francis giving away his Clothes, Vision of the Church Militant and Triumphant* (cf. ill. 14), 1452
Fresco, 270 x 220 cm

This picture shows two events from St. Francis' youth. On the left he is giving his cloak to a supplicant. The latter is not depicted as a beggar but as a well-to-do man. Next to them there is a building whose vine scroll pattern, already visible in the previous fresco, shows the scene of the event to be the saint's parental home.
Christ appears to St. Francis in a dream and shows him the heavenly castle. The building decorated with coats of arms and flags bearing the cross are reminiscent of contemporary Tuscan palaces.

VESTIMENTUM SUU(M) CUIDA(M) PAU(PER)I MILITI NOCTE VERO SEQUE(N)TI OSTE(N)-DIT SIBI XPS MAGNU(M) PALATIU(M) ARMIS MILITARIBUS CUM CRUCIBUS INSIGNITIUM – "How St. Francis gave his clothes to a poor soldier and Christ, during the following night, showed him a large castle decorated with coats of arms and crosses."

This scene is, in terms of form and color, placed in relationship to *St. Francis giving away his Clothes*, for the rock formation that towers up behind the saint also appears in the background of the castle and presumably continues behind his parents' house. That makes the pictorial space appear considerably broader. In addition, the colors of St. Francis' horse, his red garment and green cloak are related to the beflagged castle. The interpretation of this connection suggests itself: "Caritas", the saint's active brotherly love, is one of the three theological virtues and a "pillar" in the castle as a symbol of the heavenly Jerusalem.

The following scene was depicted on a lost stained glass window that originally decorated the narrower central wall of the choir, and which has now been replaced by an unpainted arched window. The theme can be reconstructed thanks to the inscription that has survived beneath the window's slope: QUALITER B. F. IN ECCLESIA SANCTI DAMIANI AUDIVIT CRUCIFIXUM TERDICENTEM SIBI FRANCISCE VADE REPARA DOMUM MEM ET QUIA IAM CADIT VERSA QUANTITATEM PECUNIAE IN QUANDAM FENESTRAM – "How St. Francis heard the crucified Christ in the church of San Damiano say three times: Go, and restore my house!

And as it is already collapsing, throw an amount of money into the window."

Here, therefore, the praying St. Francis was depicted in front of the crucifix in San Damiano, the *Vision of San Damiano* as it is known. The execution of the scene as a stained glass window was a subtle choice, as St. Francis was being requested to throw money in through the church's window.

The *Vision of San Damiano* is followed by the *Renunciation of Worldly Goods* (ills. 19, 20), the last of the scenes from the saint's youth. The scene takes place before the backdrop of a city. The saint's father and his retinue take up two thirds of the foreground. On his left arm he carries his son's clothes, in the right he is holding his belt. A narrow space separates him from Francis, who is seen by the observer in a frontal view at prayer. A bishop is covering the saint with his pluvial, which indicates the religious nature of the scene, for it was worn by priests and bishops on ceremonial occasions other than Mass. The contrasting depiction of the father and son expresses the dramatic nature of their conflict, supported by the arrangement of two opposing groups of figures: the secular group is in movement, the religious one frozen. The explanatory inscription reads: QUALITER B. F. CORA(M) EPISCOPO ASISII REN(UNTIA)VIT PATRI HEREDITATEM PATER-NAM ET O(M)NIA VESTIMENTA ET FEMORA-LIA PATRI REIECIT – "How St. Francis renounces his father's inheritance before the bishop of Assisi and his father, and throws his upper garment and hose down before his father."

The last picture in the bottom row shows the *Meeting*

19 (left) *Renunciation of Worldly Goods and The Bishop of Assisi dresses St. Francis* (cf. ill. 14), 1452
Fresco, 270 x 220 cm

In front of an architectural backdrop of a town, the saint's father is rapidly walking towards Francis. On his arm he is carrying the worldly clothes that his son has cast away. St. Francis is standing opposite his father in prayer, though at the same time facing the observer in a frontal view. The bishop is protectively holding his pluvial in front of the saint. This ecclesiastical garment marks this as a sacred event, for it was worn by priests and bishops on ceremonial occasions other than Mass.

20 (opposite) *Renunciation of Worldly Goods and The Bishop of Assisi dresses St. Francis* (detail ill. 19), 1452

In the last event from the saint's youth, Gozzoli differentiates the two groups from each other: while the secular observers in the father's retinue are depicted in motion, the religious group is in contrast depicted in a statuesque, almost contemplative manner.

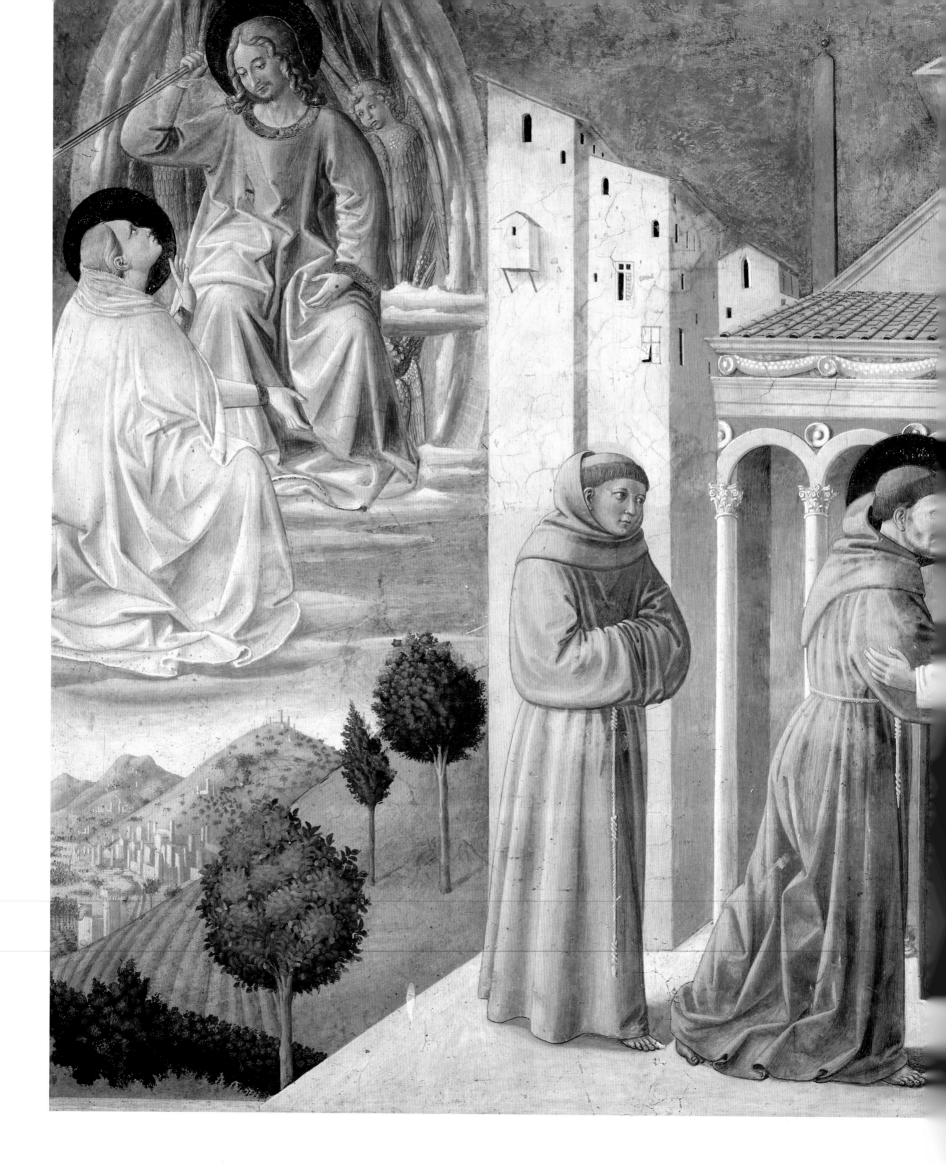

of *St. Francis and St. Dominic* (ill. 21). Benozzo starts with the vision of St. Dominic in the left half of the picture. Christ is about to hurl three spears – the symbols of pride, unchastity and greed – at the depraved world. Mary is attempting to prevent him by pointing to the meeting taking place between St. Dominic and St. Francis. The depiction of the saint is derived from the description written by Thomas of Celano in 1228: "Not particularly large in form; small rather than large, he had a not particularly large, round head, a somewhat long and stretched face, a level and low forehead, not particularly large black, pure eyes, dark hair, straight eyebrows, an even, fine and straight nose, upright, small ears, flat temples (…), close, regular and white teeth, narrow and soft lips, a black, not full beard, a slender neck, straight shoulders, short arms, gentle hands, long fingers." For the first time in this cycle St. Francis bears a tonsure and is dressed in the simple brown habit of a Franciscan, with a cord as a belt. This plain habit clearly distinguishes him from St. Dominic, whose habit is a white tunic with a white scapular with a dark cape over it. In contrast with the rather more lavish Dominican attire, St. Francis' simple habit refers to the ideal of poverty to which he dedicated himself for the rest of his life.

The two founders of orders met in Rome, as indicated by the obelisks which appear on the left side of the church. Benozzo places the scene, which according to legend took place in 1215, in front of a church, presumably Old St. Peter's. The accompanying inscription reads: QUANDO BEATA VIRGO OSTE(N)DIT XPO BEATU(M) FRANCISCU(M) ET BEATU(M) DOMINICU(M) PRO REPARATIONE MUNDI – "How the blessed Virgin pointed St. Francis and St. Dominic out to Christ, for the renewal of the world." This picture concludes the bottom row of the pictures on the right southern wall.

The sequence of pictures continues on the left north wall in the second row, meaning that the next picture is above the *Birth of St. Francis*. It depicts the *Dream of Innocent III and the Confirmation of the Rule* by Pope Honorius III, the successor of Innocent III (ills. 22, 23). The depiction of chronologically separate events and two popes in one picture is designed to do justice to the actual historical facts, which were frequently confused

21 *Vision of St. Dominic and Meeting of St. Francis and St. Dominic* (cf. ill. 14), 1452
Fresco, 304 x 220 cm

This scene is not drawn from the legend of St. Francis but from the life of St. Dominic in the "Legenda Aurea" (Golden Legend). On the left, above a hilly landscape, the vision of St. Dominic is visible. Christ is about to hurl three lances, symbolizing pride, unchastity and greed, at the depraved world. The Mother of God is attempting to stay his anger by pointing at the meeting taking place between the two founders of the mendicant orders.

by painters who depicted the oral confirmation of the rule by Innocent III as having been a written approval. A fluted pillar in the centre of the picture divides it into two halves. This method of structuring the surface of the picture has already been seen in the first fresco. The pope's vision shows a monk hurrying up on the left in order to support the Lateran basilica that is about to collapse. In front of the church a lavish meadow covered with numerous flowers and grasses is spread out. In the fine arts, the legends of St. Dominic and St. Francis were from time to time confused. Sometimes it is Dominic who has the crucial role of supporting the collapsing Lateran basilica. This depiction appears, for example, in two predella panels by Fra Angelico: in the altar showing the *Sacra Conversazione*, 1435/36, now in the Museo Diocesano in Cortona, and in the *Coronation of Mary*, now in the Louvre in Paris.

In addition, Benozzo's method of depiction here gives us an insight into the modernity of his visual language. When compared to a painting by Giotto (1266–1337), it is noticeable that the latter chose a stronger angle of inclination to express the gap between dream and reality (ill. 24). Benozzo made use of a different solution. He placed the dreaming pope in the rear and St. Francis in the front picture plane, and in so doing was making use of a compositional principle that was popular during the Renaissance. The right half of the picture shows the confirmation of the rule taking place inside a palace. The pope has raised his right hand in blessing and in his left is holding an open scroll of parchment which St. Francis has grasped at the lower edge. On the scroll the following words can be read: REGULA ET VITA MINORUM FRATRUM H(A)EC E(ST): D(OMI)NI NOSTRI IHESU XRI SANCTUM EVA(N)G(E)L(IUM) (OB-SERVARE) – "It is the rule and the life of the Minorites to observe the Gospel of Jesus Christ our Lord."

22 *Dream of Innocent III and the Confirmation of the Rule* (cf. ill. 14), 1452
Fresco, 304 x 220 cm

In this first fresco on the second row of pictures, Benozzo combines two events that took place at different times: the dream of Pope Innocent III in 1209, which resulted in the oral confirmation of the rule of the Minorites, and the written confirmation by his successor, Pope Honorius III, in 1226.
In a dream on the left, Pope Innocent III sees a monk hurrying up in order to support the Lateran basilica which is about to collapse.

23 (opposite) *Dream of Innocent III and the Confirmation of the Rule* (detail ill. 22), 1452

A fluted pillar in the center of the picture divides the fresco into two halves. In the scene on the right Pope Honorius III is confirming the order's rules to St. Francis inside a palace.

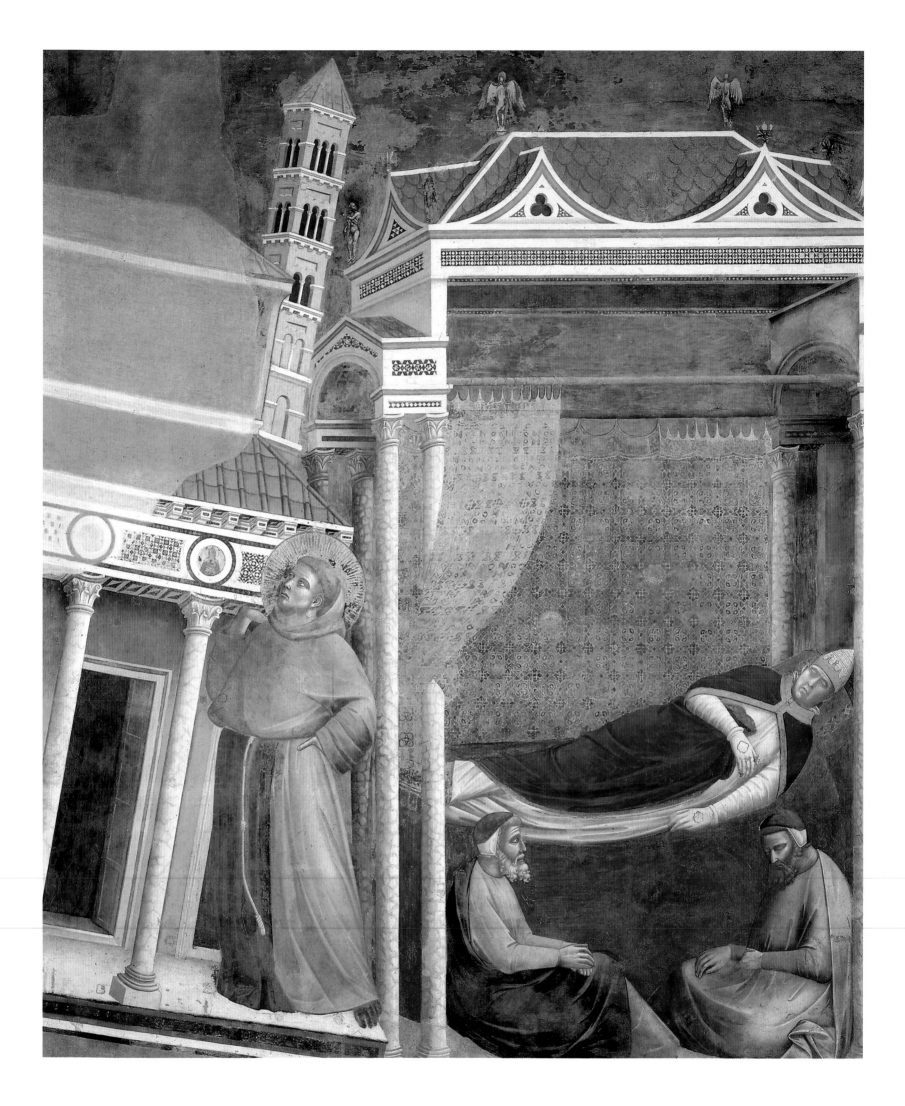

25 (right) *The Expulsion of the Devils from Arezzo*
(cf. ill. 14), 1452
Fresco, 270 x 220 cm

Arezzo, the place the devils are hastily leaving, is
identified by the inscription CIVITAS ARETII on the
city walls. Here Gozzoli has created a contemporary
portrait of the city in his depiction of the church of San
Francesco, the baptistery of Santa Maria Assunta, the
Palazzo Pretorio, the cathedral of San Donato and the
municipal palace.
This is another scene in which the artist deviated from the
familiar scheme: instead of using an architectural
backdrop, he placed the two protagonists in a lavishly
painted landscape.

24 (opposite) Giotto (1266–1337)
Dream of Innocent III, ca. 1296–1298
Fresco, 270 x 230 cm
Basilica superiore di San Francesco, Assisi

Giotto devoted two halves of a picture to his account of
the pope's dream. On the right we see Innocent III
sleeping, and on the left St. Francis supporting the
collapsing Lateran basilica. The painter makes it clear
that the scene on the left is the dream vision by tilting
the scene by a few degrees. Gozzoli's version (ill. 22)
differs distinctly from this depiction of two parallel
scenes. Instead, he places one event before the other: at
the front he shows the dream, and behind it the
sleeping pope.

In the following scene of *The Expulsion of the Devils
from Arezzo* (ill. 25), the saint drives the devils out of the
city. An inscription on the city walls names the place
where the event took place: CIVITAS ARETII. It is not,
however, identifiable solely by the added sign with the
place name, for Benozzo has created a realistic image of
Arezzo. Some of the buildings which stood there during
the artist's life were not built until after the death of
St. Francis. With this picture of the town, familiar
to observers of the time, Benozzo was reminding his
contemporaries of the continuing validity of the saint's
authority.

The small-scale landscape is arranged as if seen from
above. The two figures in the picture – an older
Franciscan monk whose hand is raised in blessing to
heaven, and St. Francis who is kneeling, deep in prayer
– do not blend harmoniously with the landscape but
appear to be standing in front of a backdrop. In
addition, it becomes noticeable that the landscape and
city views are not depicted using a uniform perspective.
In this context it is significant that the two figures cover
the transition in the picture from city to countryside.
The inscription beneath the picture reads: QUANDO
BS. F. EXPULIT DEMO(N)ES DE CIVITATE
ARETII DIVINA POTENTIA ET PACIFICAVIT
TOTU(M) POPULU(M) – "How St. Francis used
divine power to drive the devils out of the city of Arezzo
and brought peace to the entire population."

The *Preaching to the Birds and Blessing Montefalco*
(ills. 26–28) took place in Umbria. The precise
topographical description of the places is noticeable. In

the background on the left, at the foot of the table
mountain, lies Assisi with the fortress and magnificent
monastery church of San Francesco that was not built
until after St. Francis' death. The topography of the
cities is also in accordance with reality: Assisi lies to
the north west of Montefalco. Almost in the center
of the picture, the saint and his companion appear
simultaneously a second time. The two scenes are
compositionally separated by the two figures which are
seen standing in profile. Not until they reach the
background do the two landscapes meet. Various
chronological levels become evident in the conscious
division of the pictorial space. On the wall the city coat
of arms of Montefalco appears. Before St. Francis, four
men are reverently kneeling. The one in the front is
wearing a Franciscan habit and a cap bearing the
inscription M. MARCUS (ill. 27). He is holding a
bishop's miter in his hands. This might be the "Master
Marcus" who towards the end of the 14th century was
the bishop of Sarsina and later of Marsico Nuovo.
Fra Jacopo, who commissioned the work, is the
second kneeling Franciscan. The other people are
presumably members of the Calvi family, which in
the 15th century acted on several occasions as donors
for the church of San Francesco in Montefalco. The
inscription beneath the picture describes what is taking
place: QUANDO B. F. PR(A)EDICAVIT AUIBUS
APUD MEUANEUM DEMU(M) BENEDIXIT
MO(N)TEM FALONE(M) ET P(O)PULU(M) –
"How St. Francis preached to the birds and then blessed
Montefalco and the population."

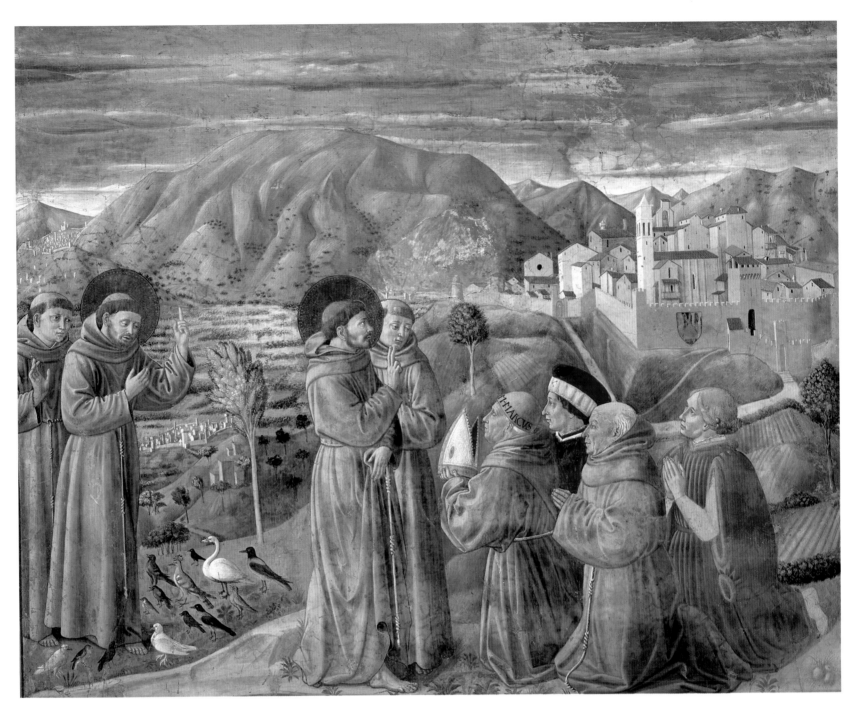

26 Preaching to the Birds and Blessing Montefalco
(cf. ill. 14), 1452
Fresco, 270 x 220 cm

In the left half of the picture St. Francis is preaching to the birds. In the middle distance a view of the Umbrian town of Bevagna can be seen, near to which the preaching to the birds is supposed to have taken place. The mighty Monte Subasio, with a little church half way up, and a view of the town of Assisi, form the background. Francis is pointing upwards to indicate that he is speaking about God. The 13 different kinds of birds, including a hoopoe, a swan, a thrush, a magpie, a pheasant and a dove, underline by their exceptional, unnatural gathering the godliness of the conversation.

The second row concludes with the following fresco. It depicts the extensive interior of a private residence which is furnished with a wooden coffered ceiling and a tiled floor. In the centre of the picture a pillared walkway divides the room into two areas. The left half of the picture is missing considerable sections of paint (ill. 29). The depiction of a person sitting at a table has been almost totally destroyed. Nonetheless, the remaining fragments make it possible to identify him. He must be a Franciscan monk, for the lower part of his monastic attire is still visible. The inscription reads: QUANDO BS. F. FUIT INVITATUS AD PRANDIUM A COMITE DE CELANO ET TU(N)C B. F. PR(A)EDIXIT SUAM MORTEM – "How St. Francis was invited to a meal by the knight of Celano, whose death was prophesied by St. Francis."

The concluding four pictures start in the third row of the right north wall. The picture fields become narrower towards the top, as they are the lunettes of the individual walls. For this reason, and because of the greater distance from the viewer, Benozzo only depicts one event in each

picture in the upper row. There is, however, one exception: the stigmatization takes place in two picture fields. In this way, Benozzo honors St. Francis of Assisi as the most important of the saints bearing the stigmata.

The *Establishment of the Manger at Greccio* (ill. 30), probably the most impressive picture in the cycle, takes place in a church interior that is constructed according to the laws of central perspective. The vanishing point lies behind the third pilaster in the rear wall. The perspective, therefore, is not used in the sense of a "symbolic form", according to which the central motif of the picture – the spiritual closeness of the saint and the Christ Child – would have to appear at the vanishing point. The motionless figures of the faithful and St. Francis and the animals resting in the stable in Bethlehem support the static composition of the picture and give the event an air of sacred solemnity. The inscription added beneath the picture reads: QUANDO BS. F. FECIT REPRESENTATIONEM NATIVITATIS ET AP(P)ARVIT SIBI CHRISTUS IN BRACHIIS – "How St. Francis arranged for a

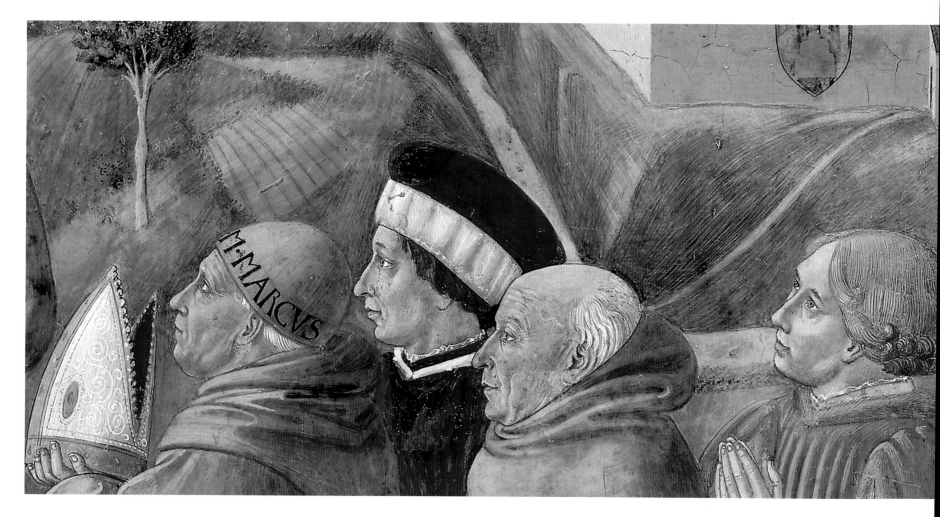

27 *Preaching to the Birds and Blessing Montefalco*
(detail ill. 26), 1452

On the right of the illustration 26 the blessing of Monte-
falco is visible, which is derived from local tradition and is
not mentioned in any legend about St. Francis. The man
kneeling in front of St. Francis and wearing a cap with
the inscription M. MARCUS could be "Master Marcus".

The second Franciscan monk is Fra Jacopo who
commissioned the work. The other people are presumably
members of the Calvi family, which during the 15th
century made several donations to the church of San
Francesco in Montefalco.

28 *Preaching to the Birds and Blessing Montefalco*
(detail ill. 26), 1452

On the town wall the coat of arms of Montefalco
has been mounted. The monastery of San
Francesco was immortalized in the form of the
church with the unadorned façade and oculus
window on the left side of the town.

29 (below) *Death of the Knight of Celano* (cf. ill. 14), 1452
Fresco, 304 x 220 cm

The picture combines three scenes: in the left half of a
pillared hall with two aisles and a coffered ceiling, St.
Francis is prophesying the Knight of Celano's imminent
death and begging him to make his confession. The
person sitting at the table on the left who is no longer
completely visible was probably a Franciscan monk, as the
order's habit is still visible in the lower part of the picture.
The events continue chronologically on the right of the
picture. The nobleman's confession to the Franciscan
monk is followed in the background by his sudden death.

30 (opposite) *Establishment of the Manger at Greccio*
(cf. ill. 14), 1452
Fresco, 304 x 220 cm

The picture shows the birth of Christ being celebrated in
the monastery of Greccio. St. Francis, who is kneeling in
the foreground inside a church, is lovingly cradling the
crib figure of the Christ Child in his arms, thus bringing
it to life. The faithful who have gathered to celebrate mass
notice the miracle and are gazing in reverence and
astonishment at the scene.
The architecture of the church interior is composed of
two different stylistic epochs: the tracery windows and
pointed arches are Gothic architectural forms, while the
fluted pilasters, straight cornices and oculus windows are
architectural elements typical of the Early Renaissance.

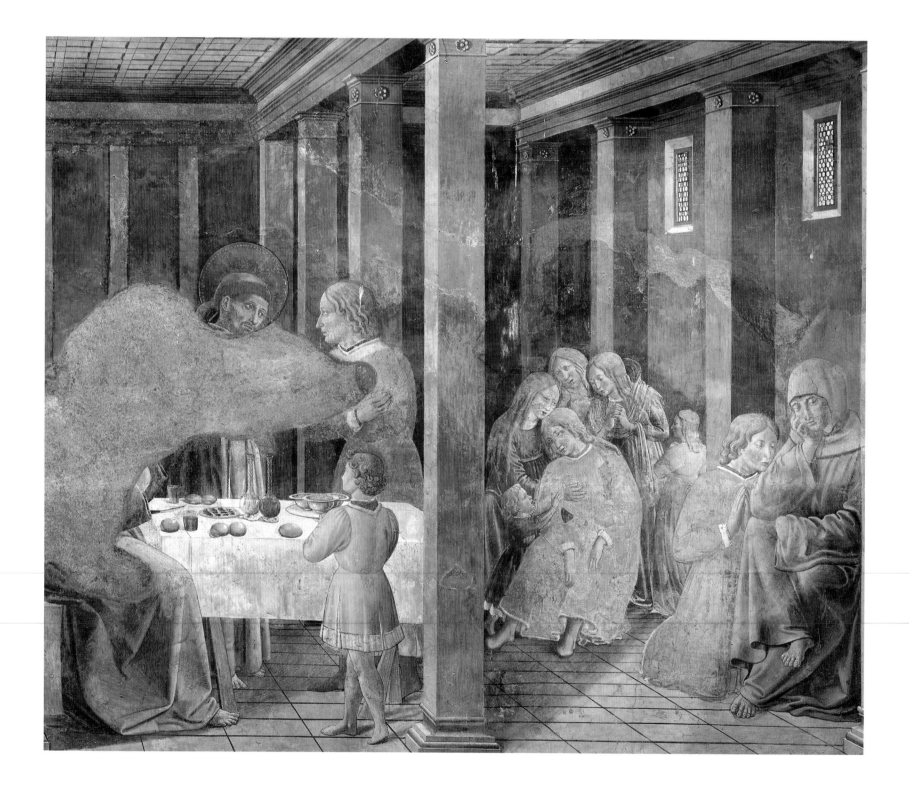

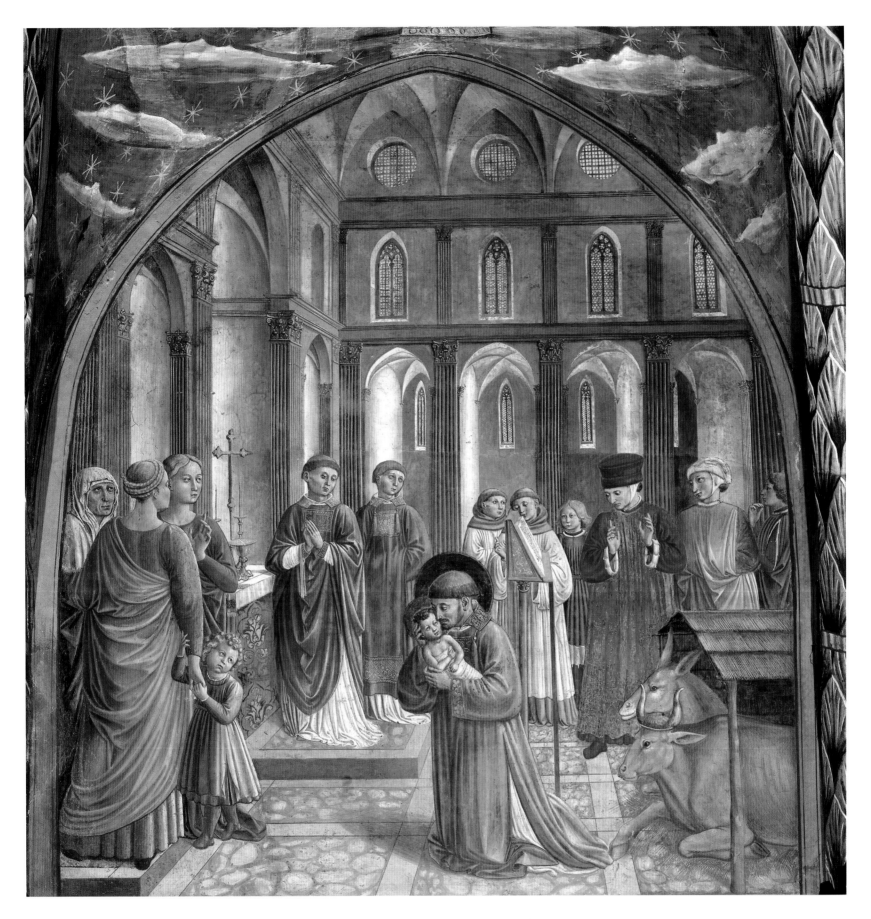

representation of Christmas and the Christ Child appeared in his arms." The legend of St. Francis written by St. Bonaventure tells us about the Christmas celebrations in Greccio. It has been shown that Greccio, which lies a little beyond the southern border of Umbria, near Rieti in northern Latium, was the first place where a manger was set up.

Benozzo connects the *Trial by Fire before the Sultan* (ills. 31, 32) with another event. The dancing girl from the *Fioretti*, who is shown here between the two main figures in the scene, has been ordered by the Sultan to attempt to seduce the saint, and she later converts. The accompanying inscription reads: Q(UA)NDO SOLDANUS MISITUNA(M) PUELLA(M) AD TE(N)TA(N)DUM B.F. ET IP(S)E I(N)TRAVIT I(N)IGNE(M) ET OMNES EXTUPUERUNT – "How the sultan sent a girl to tempt St. Francis, and how he walked through fire and amazed everyone."

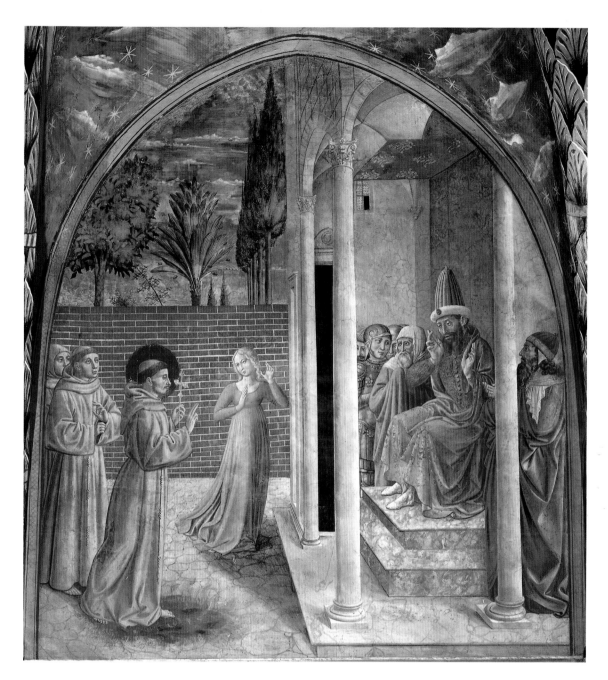

Benozzo connected the small lunette above the
window to the following fresco on the right south wall
(ill. 33). The latter shows the winged Cross floating over
a rock formation. Rays emanate from the Cross
surrounded by seraphs; they converge on the bordering
picture field and the kneeling saint whose hands are
raised. It is the five wounds of Christ that St. Francis
is receiving. Due to the chosen sequence of the scenes,
the stigmatization is given particular prominence. The
rays do not hit the saint directly, as they change
their direction while en route. The inscription reads:
QUANDO BEATUS FRA(N)CISCUS IN MO(NTE)
ALVERNE RECEPIT STIGMATA YHV XRI – "How
St. Francis received the wounds of Jesus Christ on the
mountain of La Verna."

The theme of the last fresco is the *Death and Ascension
of St. Francis* (ill. 34). He lies on a bier in the foreground
as his wounds are tested and witnessed. Behind, the
faithful are celebrating the funeral mass. Above the
church, in the background, two angels are carrying the
soul of St. Francis up to heaven in a glory, as confirmed

by the inscription: QUANDO BEATUS FRANCIS-
CUS MIGRAVIT EX HAC VITA AD DOMINUM –
"How St. Francis went from this life to the Lord."

Finally, 23 medals decorate the narrow strip of wall
between the frescoes and the choir stalls. On the north
and south walls, in a kind of family tree, 20 Franciscan
monks are depicted. They are derived from the "Vitae
Crucifixae Jesu Christi" by Ubertino da Casale, dating
from 1305. There is space for only three medals on the
short strip of wall beneath the window. They show
portraits of three famous Florentines: Dante, Giotto and
Petrarch.

With the exception of the Madonna, no saint has
been painted so frequently in post-medieval times as
St. Francis. In the cycle of St. Francis in Assisi, the main
emphasis of the depiction is in the front picture plane
in which the protagonists are playing their parts.
Benozzo, in contrast, endeavors to set the figures, who
in their posture and gestures refer to essential details,
into a landscape or architectural surrounding. However,
the artist appears to have started by painting the

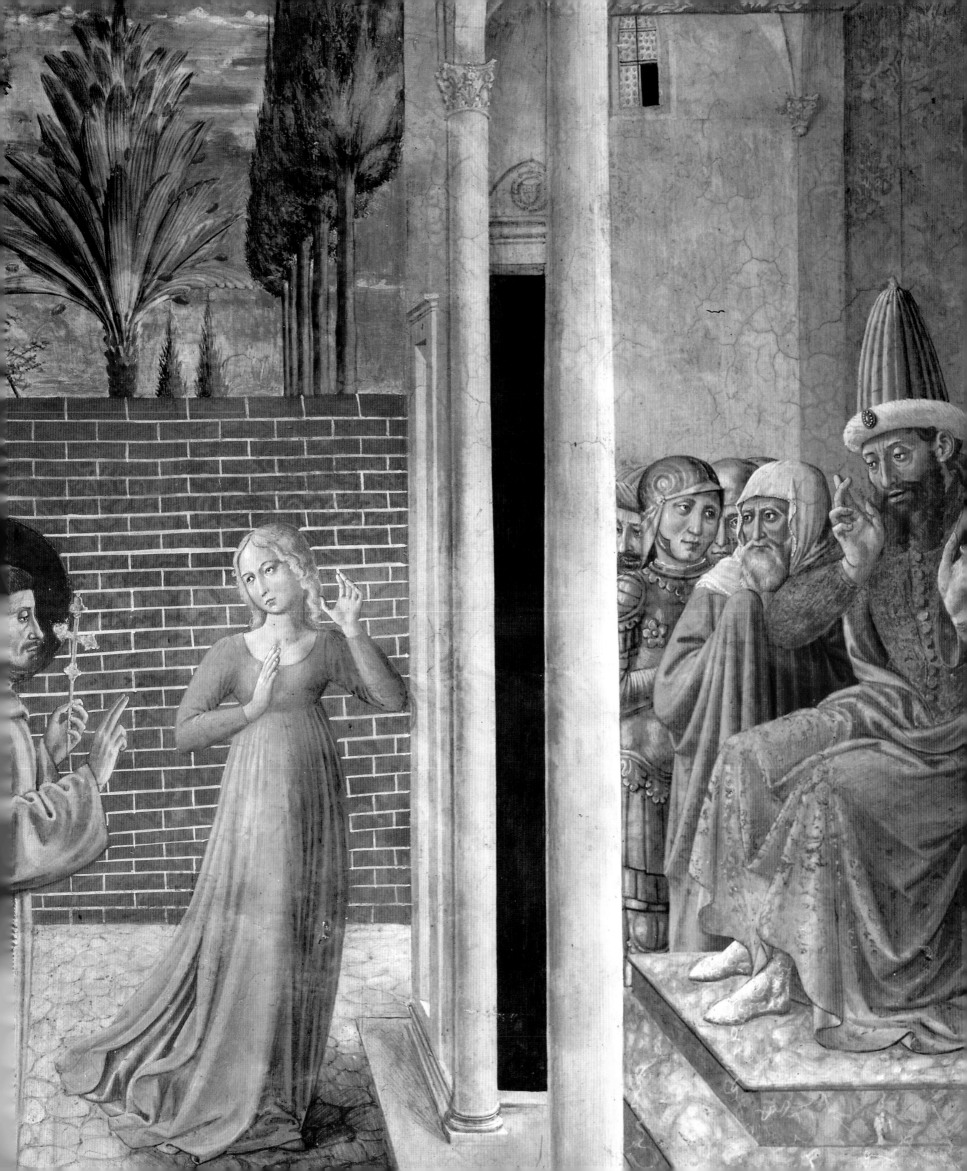

33 (above) *Stigmatization of St. Francis* (cf. ill. 14), 1452
Fresco

Receiving the stigmata was the most important event in the life
of the saint and happened in 1224 on the mountain of La Verna
in Tuscany. Gozzoli has depicted this scene across two wall fields:
the direction in which Francis and the sitting monk are looking,
as well as the cluster of rays, lead us across to a second picture
field above the central lunette of the choir, which is bordered by
the window jamb (ill. 13). Here the Crucifix and seraphs appear,
surrounded by a shining mandorla.

34 (opposite) *Death and Ascension of St. Francis* (cf. ill. 14), 1452
Fresco, 270 x 220 cm

The death and ascension of St. Francis bring the cycle to an end. In
the foreground, the exequies are taking place at St. Francis' death
bed, while his wounds are tested and witnessed. Above the church,
in the background, the soul of St. Francis is being carried up to
heaven by two angels in a glory.
The analogy between St. Francis and Christ in the first scene of the
cycle is changed in this concluding picture to become a relationship
between the saint and Christ.

architecture or landscape, and added the figures later. This creates the impression that the figures are competing with the landscape surrounding them, or are even overwhelmed by it.

The selection of scenes in Montefalco differs from the traditional pattern. Benozzo only depicted scenes from the saint's life from his birth to his death, and omitted the posthumous miracles. He also did not keep to the chronological order of events, instead creating a new thematic order of the saint's life. The lowest row – with the exception of the *Meeting of St. Francis and St. Dominic* – shows scenes from his youth. In the second row his deeds are depicted, and in the third row the proofs of divine mercy. Benozzo places the emphasis in his life of St. Francis on the proofs of divine mercy and the similarities and parallels between his life and Christ's. At the same time, he places the scenes in a contemporary architecture and landscape in order to give his contemporaries a closer understanding of St. Francis.

After completing the cycle of St. Francis, Benozzo painted the first bay in the monastery church's southern side aisle, known as the Chapel of St. Jerome. The main wall shows a painted polyptych, the *Madonna and Child surrounded by Saints* (ill. 35). This creates the illusion that it continues in the fresco painted above it, as if it were a realistic addition in front of the wall. The curtain and the shadows of the pinnacles and triangular gables make a considerable contribution to creating this impression. Benozzo's artistic capabilities here reached the highest level of illusion. It addition, it is remarkable that the artist "placed" the Gothic work within a classical framework which he signed OPUS BENOZII DE FLORENZIA. Above the polyptych Christ on the Cross can be seen surrounded by four angels who are catching the blood dripping from his wounds. On either side below him, St. Dominic and St. Francis are kneeling on the left side, and St. Romuald and St. Sylvester on the right. The walls show St. Jerome in the desert and the martyrdom of St. Sebastian. In the vault the four evangelists appear with their attributes: St. Matthew with the angel, St. Mark with the lion, St. Luke with the ox and St. John with the eagle. On the arch separating the nave Christ delivering the blessing is portrayed. The left pilaster shows St. Bernardine of Siena and the right one St. Catherine of Alexandria.

During his stay in Umbria, Benozzo created an altar painting for the collegiate chapel of St. Jerome in Perugia. The altar painting (ill. 38), now in the Galleria Nazionale dell'Umbria in Perugia, is also known as the *Pala della Sapienza nuova*. It depicts the *Madonna and Child with Saints John the Baptist, Peter, Jerome and Paul*. The panel is bordered by two painted pilasters, each of which contains three standing saints: on the left St. Dominic, St. Francis and St. Peter Martyr, on the right St. Catherine of Alexandria, St. Elizabeth of Hungary and St. Lucia. In the center of the predella is the bust of the crucified Christ with St. Thomas Aquinas, St. Lawrence and the Mother of God on the left side, and St. John the Evangelist, St. Sebastian and St. Bernardine of Siena on the right.

In 1453 Benozzo signed a cycle of nine scenes from the *Life of St. Rosa* for the convent of the same name in Viterbo. His authorship is proved by a document dating from 1462. These frescoes were destroyed during extension work in 1632, but beforehand they were captured in ink drawings by Francesco Sabbatini, and these still exist, in the municipal library in Viterbo.

In the cathedral of Sermoneta to the south of Rome, an altar painting has survived. The picture, painted with tempera on panel, is dated to about 1458. It hangs in the first chapel, dedicated to the Assumption of the Virgin, and shows the Mother of God in glory holding a model of the city of Sermoneta in her lap. The Mother of God is surrounded by the hierarchy of the choirs of angels. Angels are holding four banderoles containing quotations from the Bible. This painting is a type of votive image. These pictures are supplications and demonstrations of gratitude that were normally located at a place of pilgrimage or an altar of mercy. Normally they were used to express gratitude or depicted the reason for which they were donated. The picture was probably commissioned by the wealthy merchant Onorato III Caetani as a votive image to give thanks for the ending of the plague in 1458. In the same year, within the context of the coronation of Pope Pius II, Benozzo produced a series of flags and standards in Rome and then returned to his native city.

35 *Madonna and Child surrounded by Saints*, 1452
Fresco
San Francesco, Cappella di San Gerolamo, Montefalco

In this fresco Gozzoli has created the illusion of a real Gothic winged altar, complete with pinnacles and triangular gables, which shows the Madonna flanked by St. Anthony of Padua, St. Jerome, St. John the Baptist and St. Louis of Toulouse. The impression of a polyptych subsequently placed before the wall is further heightened by the illusory curtain on the left side of the altar painting.

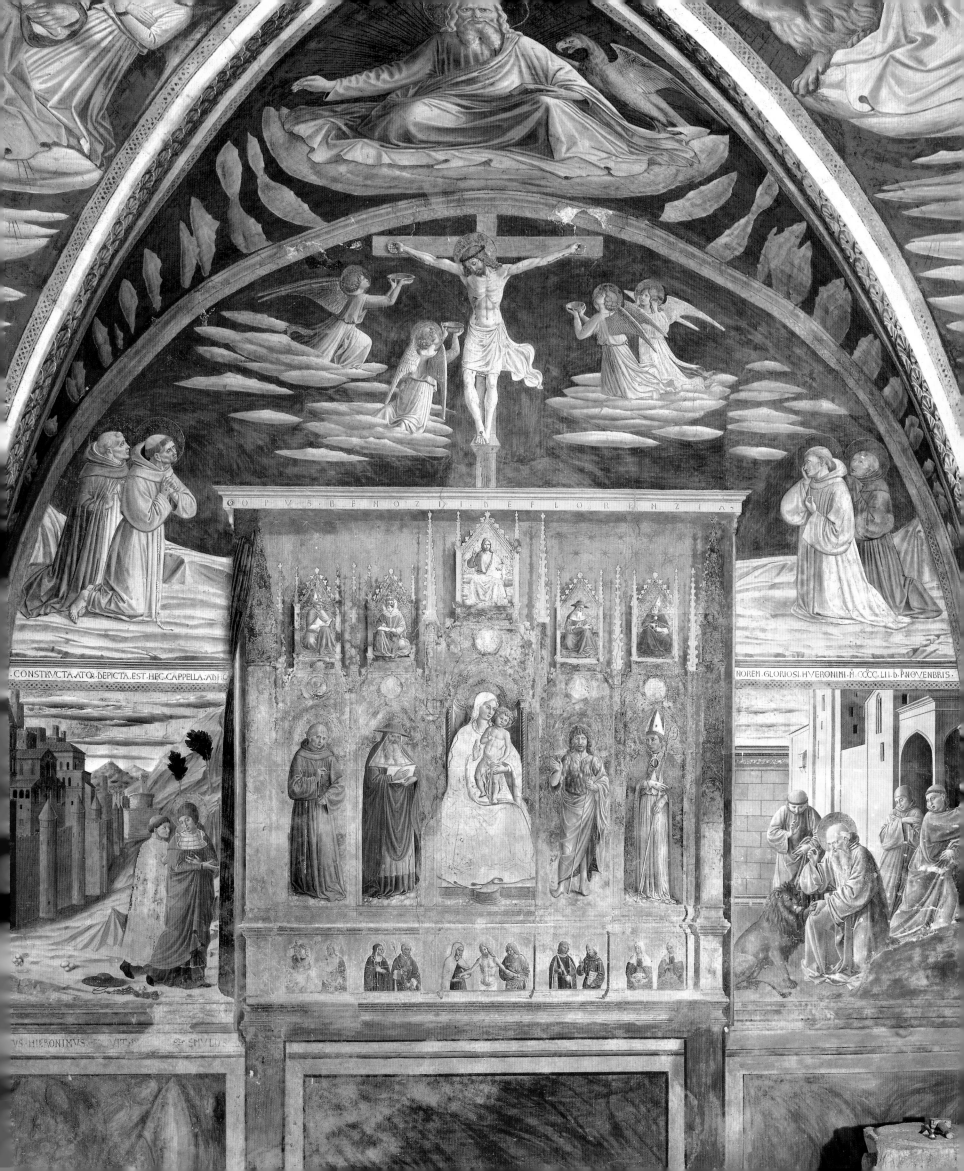

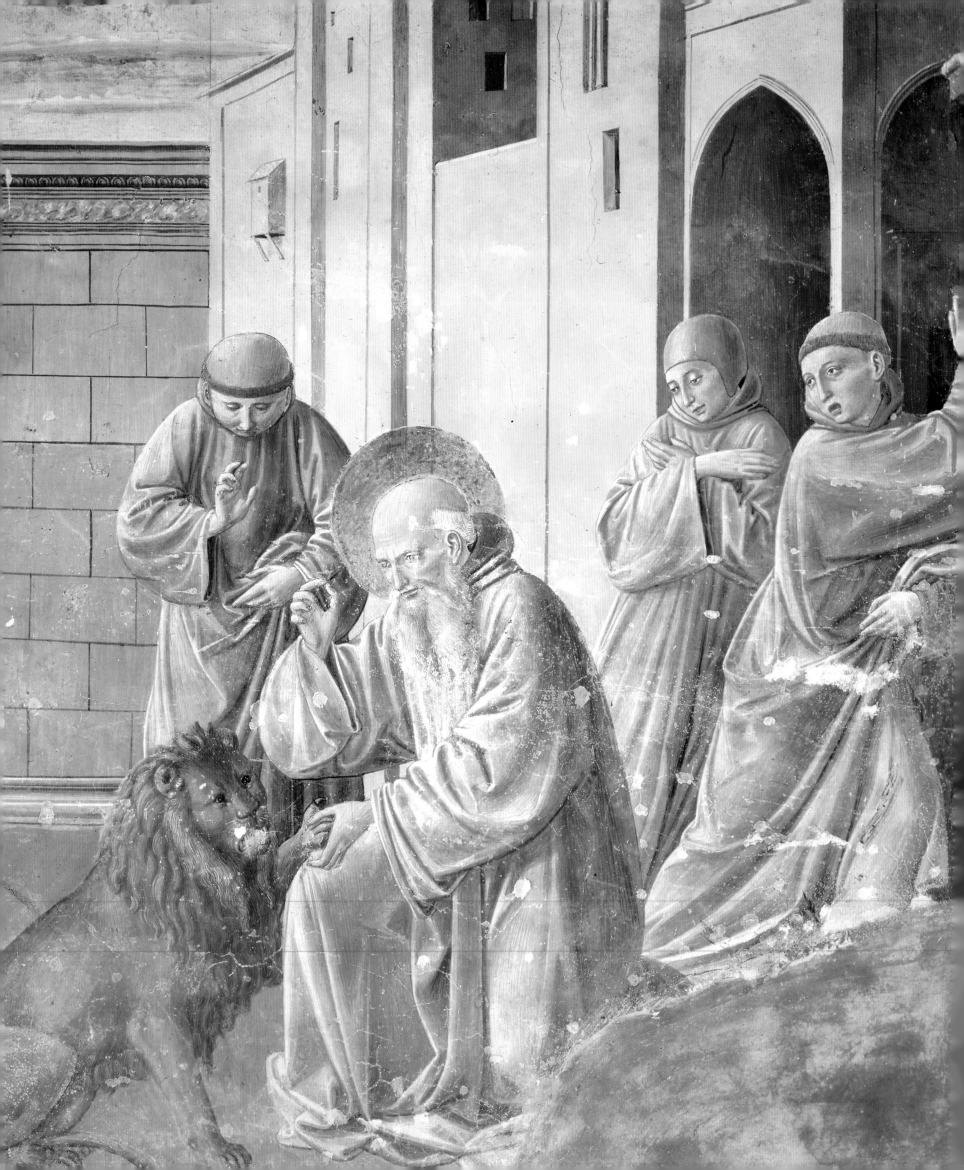

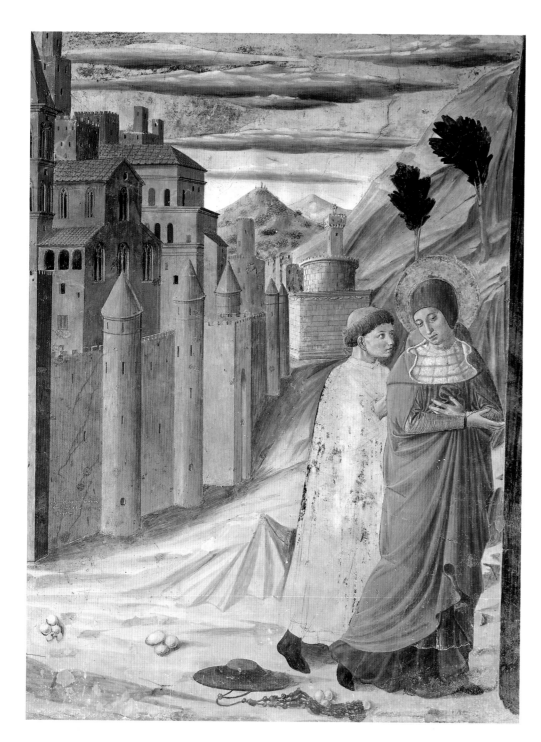

37 (left) *The Departure of St. Jerome from Antioch* (cf. ill. 35), 1452

St. Jerome appears dressed as a cardinal, showing him to be one of the four Latin Fathers of the Church. In the Life of St. Jerome, who was ordained as a priest after spending two years in the desert of Chalcis, it is not however mentioned that he occupied this position.

38 (below) *Madonna and Child with Saints John the Baptist, Peter, Jerome and Paul*, 1456
Tempera on panel, 122 x 212 cm
Galleria Nazionale dell'Umbria, Perugia

The panel painting, complete with side pillars and predella, was commissioned by the bishop of Recanati, Benedetto Guidalotti, who came from Perugia, for the Chapel of St. Jerome in Perugia. The *Sacra Conversazione* combined old and new means of expression: the saints, arranged as mirror images with the Madonna and Christ Child at their centre, are arranged in front of a Gothic-style embossed gold background.

36 (opposite) *St. Jerome pulling a Thorn from a Lion's Paw* (cf. ill. 35), 1452

The altar painting is framed on either side by two scenes from the life of St. Jerome. The scene, customary since the 12th century, in which St. Jerome pulls a thorn out of the paw of a lion asking for help is a symbol of the superiority of Christian charity.

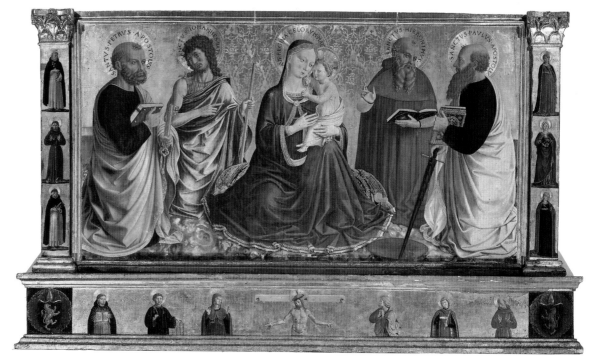

BIBLICAL HISTORY AS A MEANS OF CIVIC SELF-PORTRAYAL

40 View of the chapel, cycle of frescoes, 1459–1461 Palazzo Medici-Riccardi, Florence

Gozzoli was commissioned by Piero de' Medici to cover the almost square main room and the equally almost square choir of the chapel with a cycle of frescoes whose pictorial program was divided into two parts: the *Procession of the Magi* appears on the three walls of the main room, while in the chancel the Adoration of the Child by angels is depicted. Both sections relate in terms of content and form to Filippo Lippi's altar painting of the *Adoration of the Child*.

39 Pictorial program of the chapel (scheme) Palazzo Medici-Riccardi, Florence

The commission to paint the private Medici Chapel brought the artist back to Florence. As early as 1442 Pope Martin V had given the Medicis permission to build a private chapel with a portable family altar. The chapel, in the first floor of the Medicis' private residence, was built by Michelozzo (1396–1472) between 1446 and 1449 and dedicated to the Holy Trinity. It comprises an almost square main room and, one step higher, an equally nearly square chancel. The two are separated from each other by two Corinthian pillars.

Until the expulsion of the Medicis in 1494, the chapel was used to house the so-called *Reliquiario del Libretto*. It contains relics of the Passion and is now in the Museo dell'Opera del Duomo in Florence. Worth mentioning are the double walls, the chapel's secret escape routes which could also be used as a hiding place and place of refuge. The double walls explain the good state of

preservation of the frescoes, which were thus protected from damp. Originally it was relatively dark in the chapel, for the two small oculi only admitted a little light. In the torch and candlelight that illuminated the room, the shining gold and metal layers on the paintings must have had a powerful effect.

The pictorial program of the chapel (ills. 39, 40) is also structured in two parts: the *Procession of the Magi* in the main room (ills. 44–56) and the *Adoration of the Child* in the chancel with the *Angels worshipping* (ills. 41–43) on the side walls. The ceiling is decorated by a diamond-pointed ring in a halo with a loop that bears the motto of Piero de' Medici, *semper,* and within it inside a glory the monogram of Christ, JHS, as used for St. Bernardine of Siena.

The *Procession of the Magi* moves towards Filippo Lippi's altar painting of the *Adoration of the Child*. The original, which was replaced with a copy in 1494, is now in the Staatliche Gemäldegalerie in Berlin. The copy is attributed to the pseudo-Pier Francesco Fiorentino. However, the altar painting does not just depict the *Adoration*, it also shows the Holy Trinity. God the Father, the Holy Spirit and Christ are united on the painting and represent the conception of the Holy Trinity held by the Western Church: the Holy Spirit emanates from the Father and Son. This contrasts with the view held by the Orthodox Church, in which the Holy Spirit emanates from God the Father alone. The picture reflects the debate on general principles that took place between the Orthodox and Western Churches at the Council of Ferrara-Florence in 1439.

In 1659, the Riccardi family bought the Palazzo Medici and undertook some structural changes. This included, in 1689, the building of an exterior flight of stairs leading up to the first floor. For this purpose the entrance to the chapel had to be moved. During the process, two sections of wall were cut out of the south western corner, in the *Procession of the Magus Caspar*. After the stairs were finished, the cut out elements were mounted on a corner of the wall projecting into the room. During the course of this, the oldest king's horse was cut up and mounted on two different segments of the wall. The empty section of wall above the new door now contains a landscape in the style of Benozzo. In

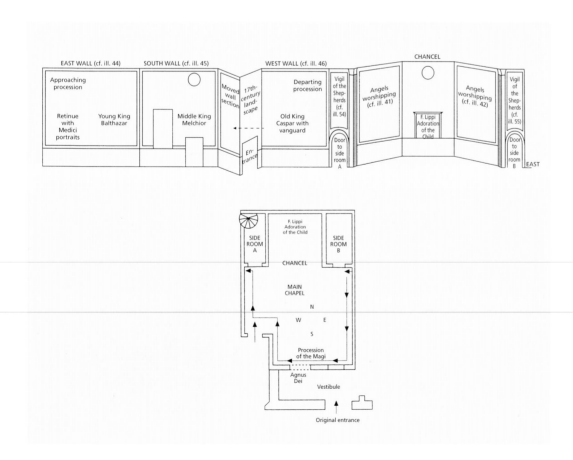

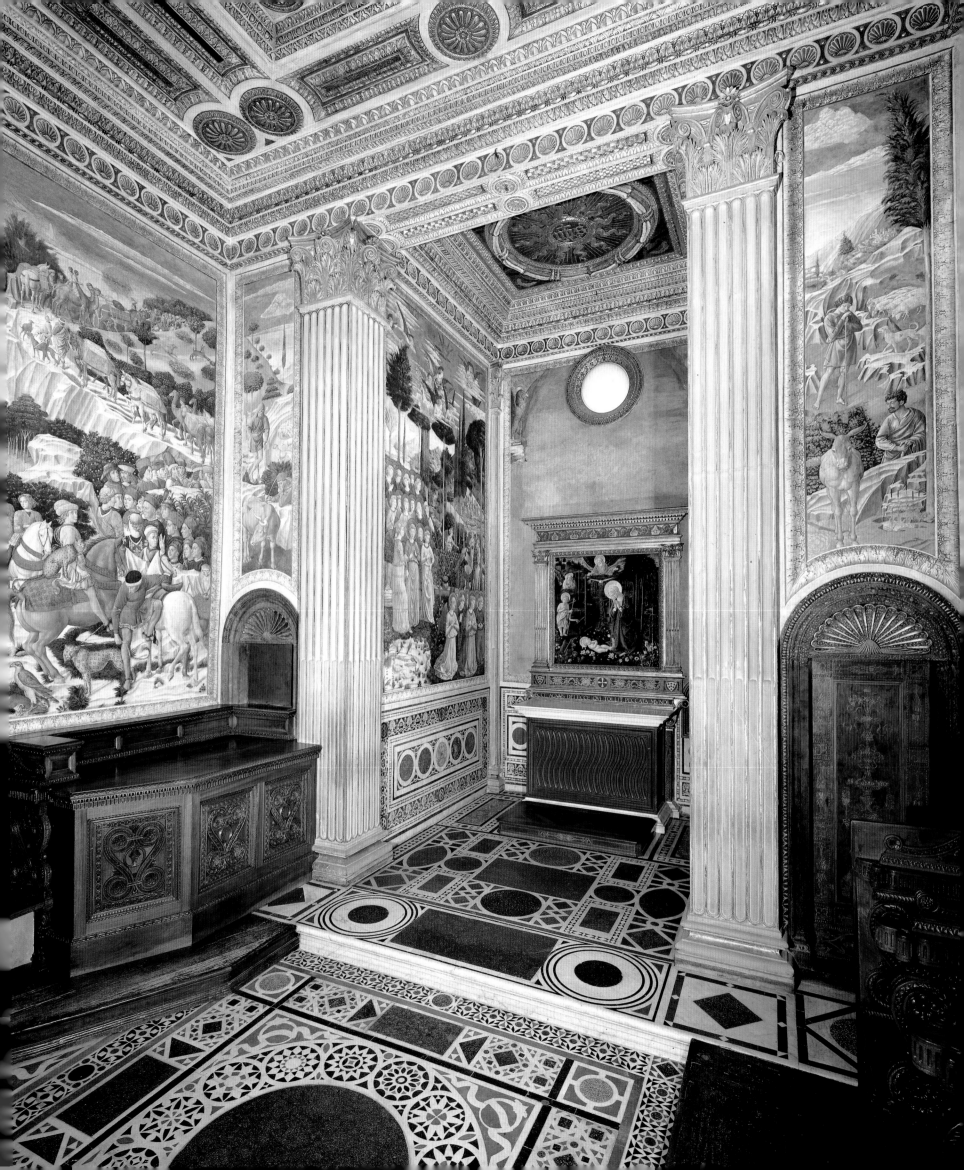

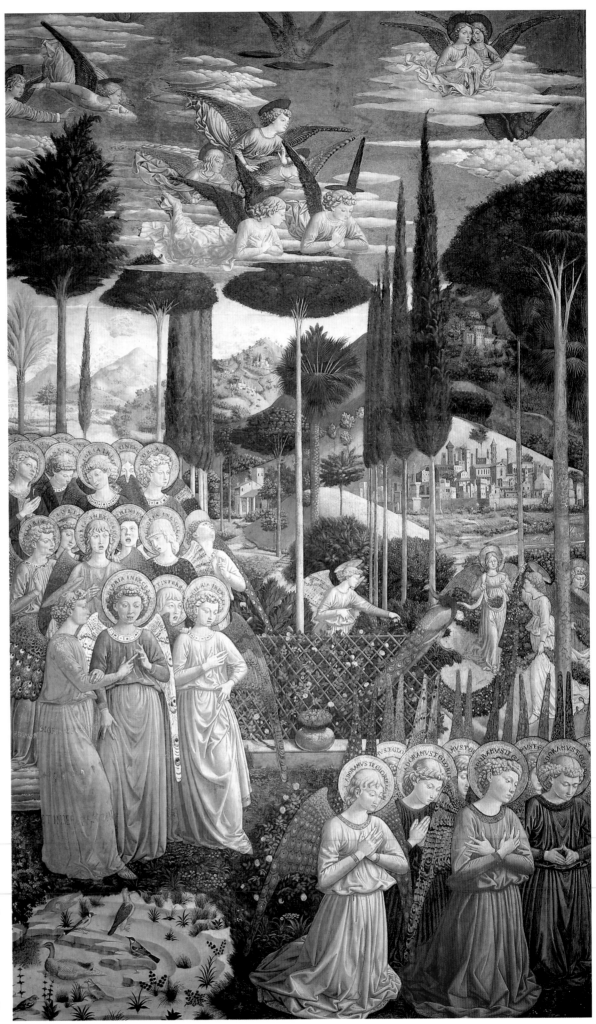

41 *Angels worshipping* (cf. ill. 40), 1459–1461
Fresco
Left side of the chancel, Palazzo Medici-Riccardi,
Florence

In contrast to iconographical tradition, Gozzoli has not
depicted the arrival of the procession but shows the events
in the chronological order in which they happened in the
biblical account of Christmas: the corner pilasters
flanking the choir separate the earthly procession from
the heavenly sphere of the angels. The angels –
unrecognized by the humans – are paying homage to the
Christ Child on the altar painting, while the Three Kings
are still travelling and the shepherds in the fields are yet to
experience the annunciation of the birth.

42 *Angels worshipping* (cf. ill. 40), 1459–1461
Fresco
Right side of the chancel, Palazzo Medici-Riccardi,
Florence

Singing and praying choirs of angels are embedded in a
paradisiacal landscape. The inscriptions on their haloes
praise the new-born child.
In the dark chapel, with the only artificial light coming
from candles and torches, the powerful and shining colors
and the gold and metal layers on the wall paintings must
have created an impressive sight.

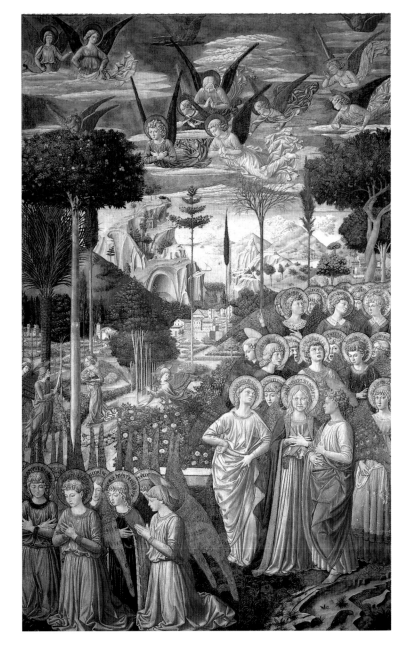

43 *Angels worshipping* (detail ill. 41), 1459–1461

This section once again displays Gozzoli's love of detail.
In addition to the realistically captured meadow flowers,
one can see naturalistically painted birds, including a
robin, a pheasant, a duck and a falcon.

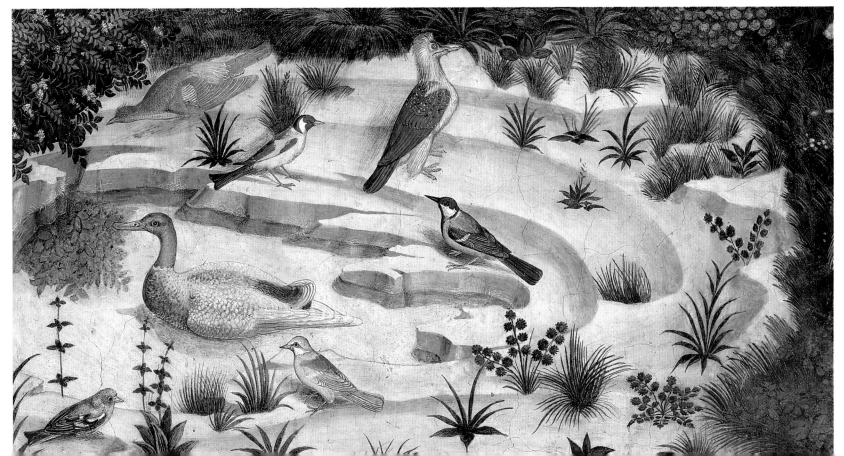

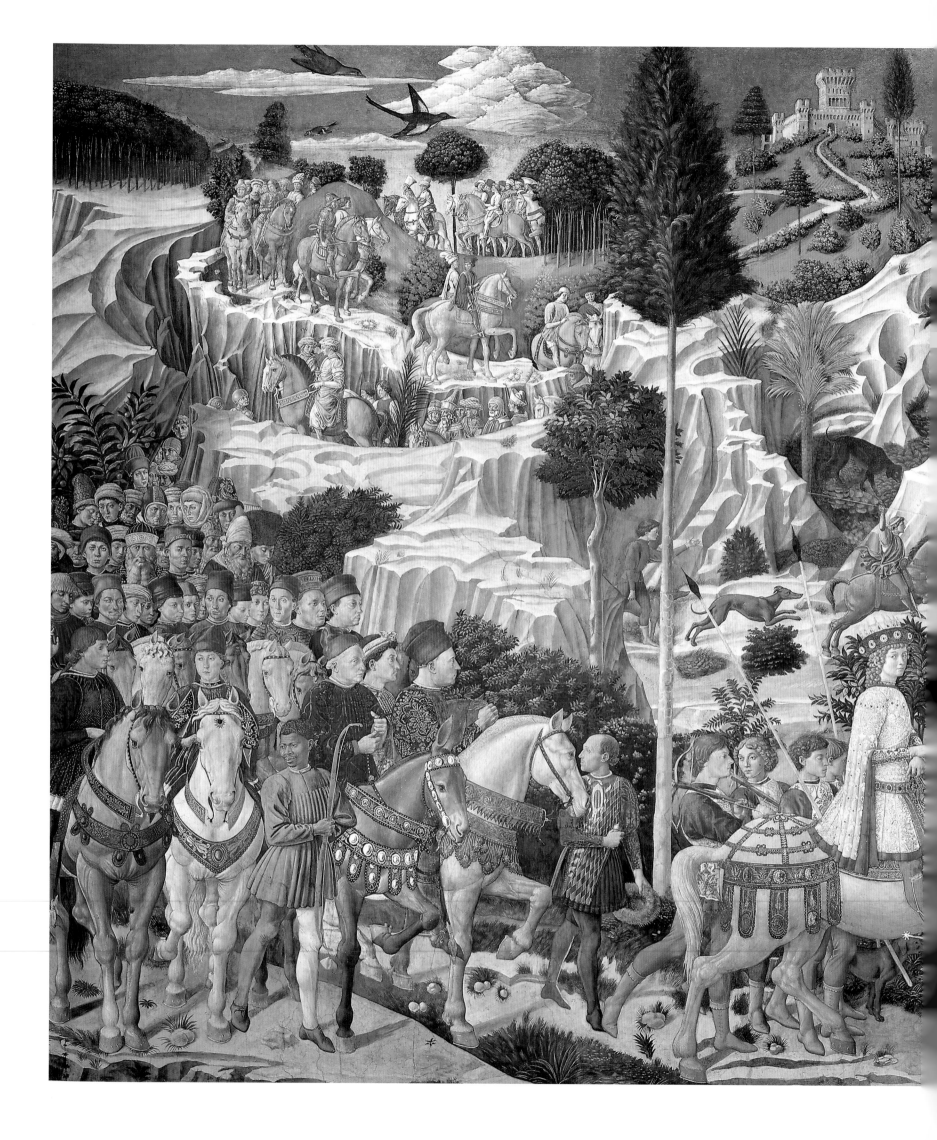

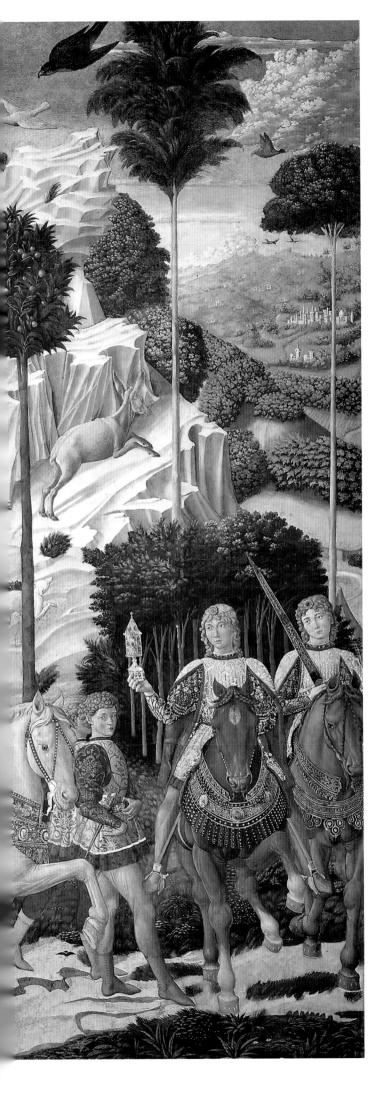

addition, two windows were built on either side of the door, of which only the one on the left still exists. A large window that was integrated into the apse wall in the 19th century was bricked up again in 1929.

The *Procession of the Magi* extends across the east, south and west walls of the main room above the encircling benches. These three walls were painted in about 150 working days, and each represents one of the Three Kings. The east wall leads off with the youngest king (ill. 44), the story continues on the south wall with the middle king (ill. 45), and ends on the west wall with the oldest king (ill. 46). An unusual feature of this depiction is that the procession does not arrive at the manger. The adoration of the Christ Child was reserved for the contemporary observers present in the room, and their prayers were said within the important framework of the procession of the magi taking place on either side.

The sequence of pictures begins with Balthazar, the youngest king. On the horizon his retinue is moving down from the mountains. At the highest point is a small medieval fortress (ill. 47), possibly Jerusalem, where the Three Kings first went. However, the architecture of the complex is reminiscent of the Medici villa in Cafaggiolo, which Cosimo de' Medici commissioned Michelozzo to build in 1451 in the style of a medieval castle. Balthazar (ill. 48), who is looking towards the old king on the opposite wall, is probably not a portrait of Lorenzo de' Medici as was once thought. At the time the work was created, he was just ten years old. Rather, in these features Gozzoli is repeating a portrait formula which he also uses in other places, especially the angels' heads. Comparing the features of Balthazar with those of the portraits makes their qualities as types evident. In addition, it would be unusual to portray a member of the Medici family in so prominent a position. Benozzo was aware that such portraits belonged at the edge, not in the center of the composition. The portraits of the Medicis can, therefore, be found at the front of the young king's retinue. At the head of the group, behind Balthazar, rides Piero de' Medici (1416–1469), who commissioned the frescoes (ill. 49). Benozzo has also immortalized himself in the densely crowded retinue in close proximity to the *familiari*. We know this from the inscription of his name on the red cap. In recent research the two youths in front of Benozzo have been identified as Lorenzo and Giuliano Medici. Acidini Luchinat recognized the former on the basis of a comparison with his portrait in the Sassetti Chapel in Santa Trinità. The characteristic shape of his nose is already clearly recognizable in the portrait in the Medici Chapel. The 11 days spent working on this fresco also suggest that the Medicis were being portrayed in this group. The *Procession of the Magus Caspar*, in comparison, was created in just five days' work. By having themselves depicted in the procession of the Three Kings, the Medicis were demonstrating both their political and their financial power. They had themselves depicted at the end of the procession, as part of the youngest king's retinue, and not as part of the retinue of the oldest king, who is nearest their goal.

44 *Procession of the Magus Balthazar*
(cf. ill. 40), 1459–1461
Fresco
East wall of the chapel, Palazzo Medici-Riccardi, Florence

Each of the three wall fields of the main room is dominated by the figure on horseback of one of the Three Kings, and their sequence matches that in the "Legenda Aurea". On the right wall – as seen from the entrance – the magnificent, ceremonial procession of the youngest king and his retinue snakes down from the mountains through a rocky landscape painted in the antiquated International Gothic style.

49

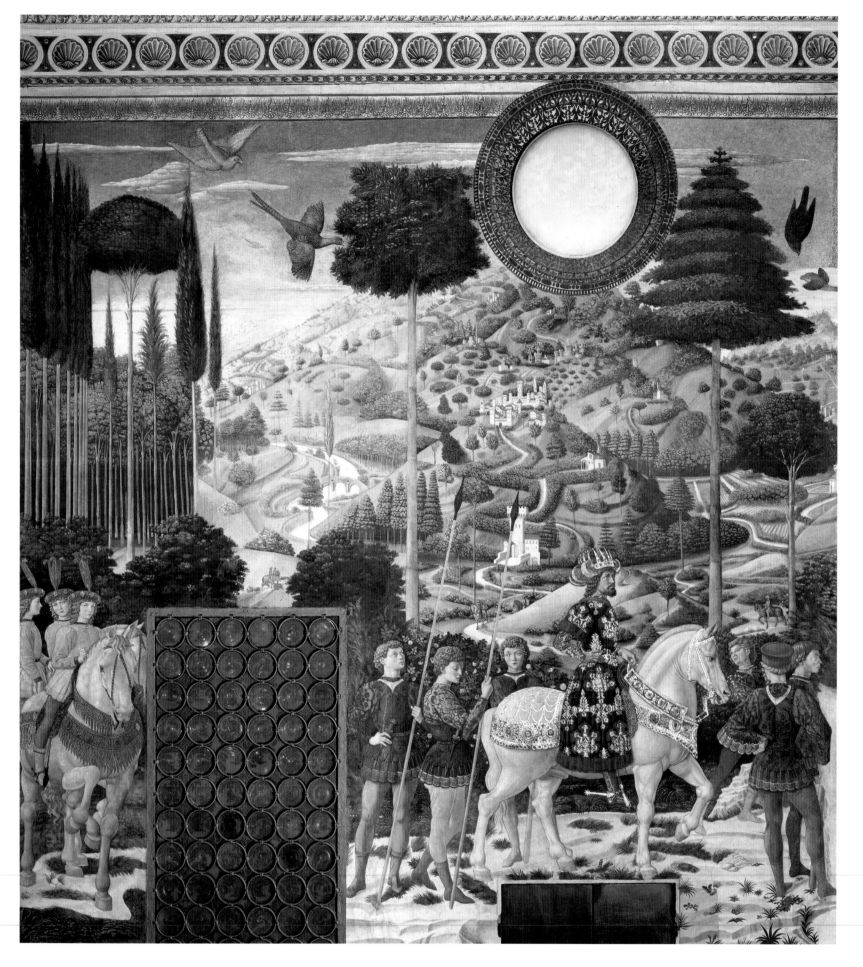

45 *Procession of the Magus Melchior* (cf. ill. 40),
1459–1461
Fresco
Southern entrance wall, Palazzo Medici-Riccardi,
Florence

King Melchior, accompanied by his pages and squires, is gazing
upwards while riding through a hilly Tuscan landscape. He may be
gazing at the Star of Bethlehem, which was possibly located in the
left part of the destroyed entrance wall.

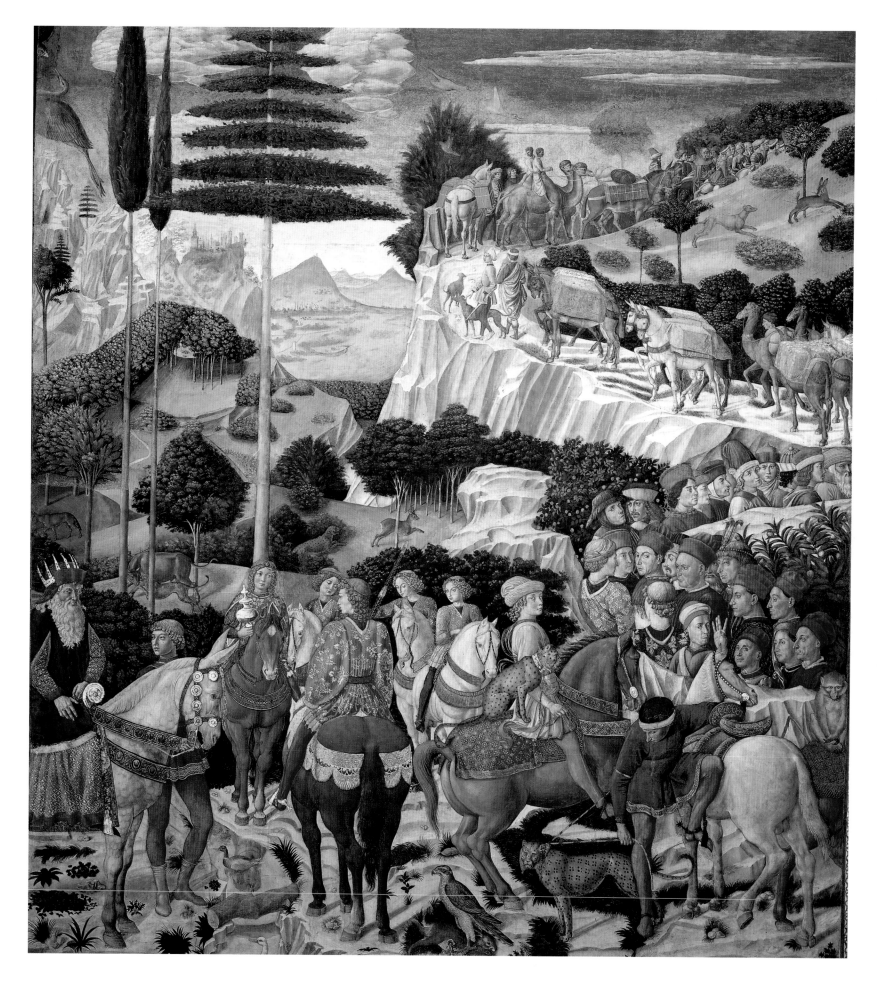

46 *Procession of the Magus Caspar* (cf. ill. 40), 1459–1461
Fresco
West wall of the chapel, Palazzo Medici-Riccardi,
Florence

The oldest king is closest to the goal, the Christ Child on the altar painting. He is therefore followed by the largest procession of pilgrims. The young herald riding before him corresponds formally with the figure of King Balthazar on the opposite wall. On the right edge of the picture the procession's vanguard is making an about-turn and with its heavily laden beasts of burden snaking up a slope towards the goal.

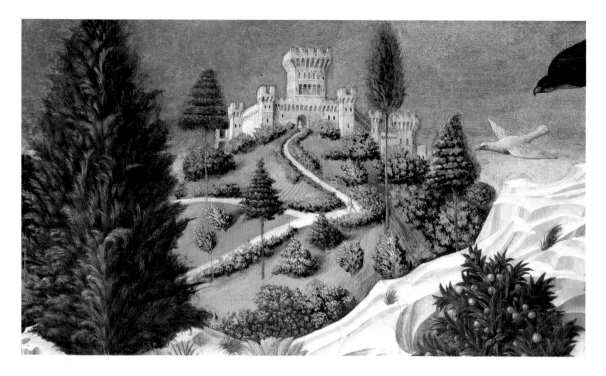

47 (left) *Procession of the Magus Balthazar* (detail ill. 44), 1459–1461

The fortress, in the style of medieval castles, which appears at the highest point of the picture and is the point from which King Balthazar's pilgrimage has set out, is similar to the Medicis' country seat in Cafaggiolo. It is interpreted as Jerusalem, where the procession of the magi started. This was where King Herod had instructed the wise men to search for the child.

48 (below) *Procession of the Magus Balthazar:* King Balthazar (detail ill. 44), 1459–1461

So magnificent a procession with so many figures, which in addition was in a family chapel and not in a public church, was ideally suited for incorporating portraits of famous contemporaries. However, the identification of the youngest king as Lorenzo de' Medici, which can be first proven to have appeared in a travel guide in the late 19th century, is purely a figment of the imagination. Despite the seven spheres of the Medici coat of arms in the oval golden medals on his horse's bridle, such an identification is impossible due to the age of the depicted man – at the time the work was painted, Lorenzo was not yet ten years old.

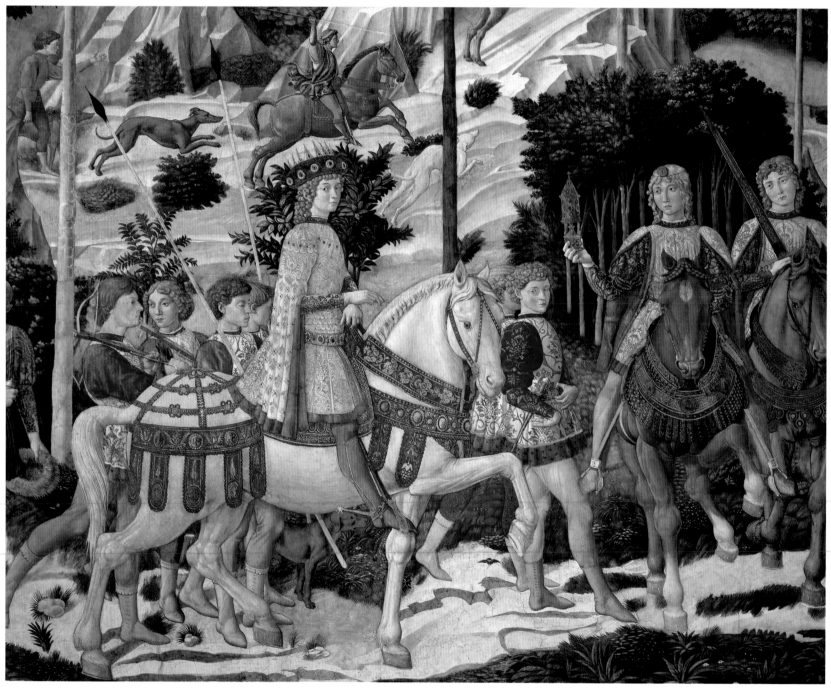

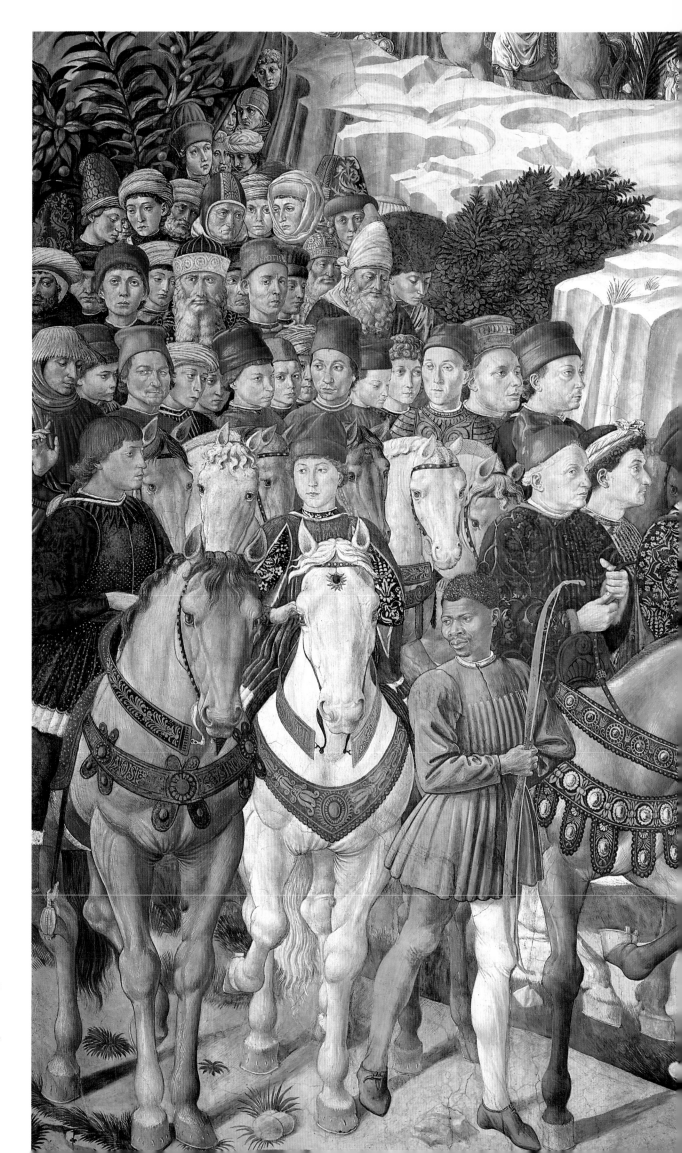

49 *Procession of the Magus Balthazar* (detail ill. 44),
1459–1461

Members of the Medici family are portrayed in the king's
retinue. For example, the man riding on a brown mule
has been identified as Cosimo de' Medici (1389–1464).
Benozzo Gozzoli placed his own self-portrait among the
Medicis. His red cap bears the inscription BENOTII. He
is standing behind the two youths, who, it is now
believed, portray Lorenzo and Giuliano de' Medici.

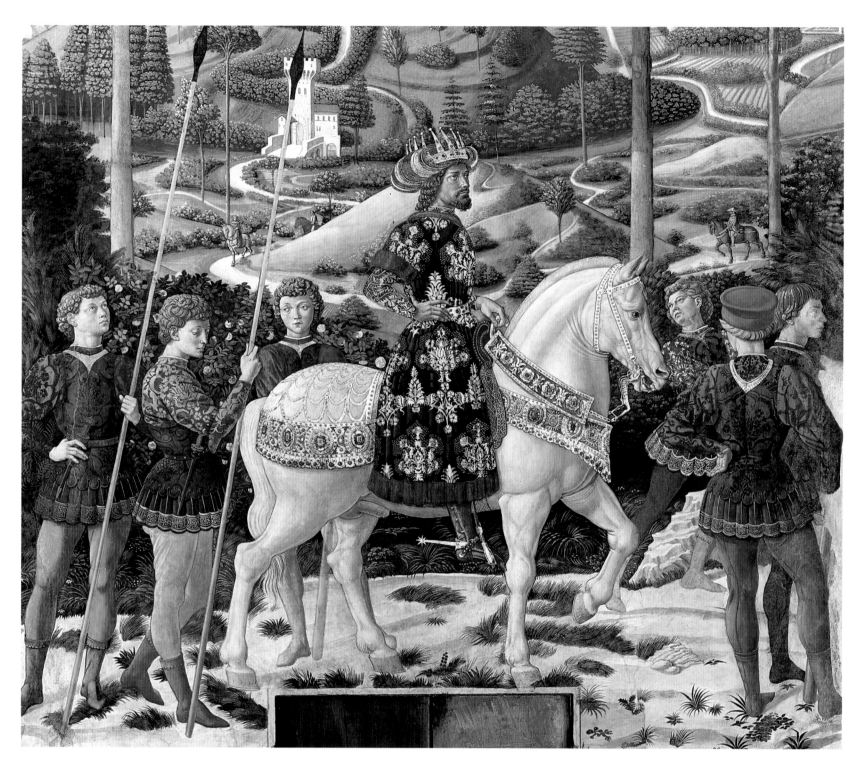

The oldest king, Caspar, is closest to the Christ Child and is accompanied by a large procession. His vanguard is made to appear visually longer due to the about-turn that the procession makes (ill. 51). He is wisely and calmly gazing towards the young king on the opposite wall (ill. 56). His long gray full beard shows him to be from the Middle East, for the Florentines of the 15th century, where a smoothly shaved face was the predominant fashion, considered this to be the decisive characteristic of the Orient. The figure of the old king has been considered to be a portrait of the patriarch of Constantinople. As already mentioned, the identification is based on the context in which the

paintings were produced: the Council of Ferrara-Florence in 1439. The council, which had at first met in Ferrara, was moved to Florence as Ferrara was not able to provide further financial support or security. It was possible to move the council due to financing provided by the Medicis, in particular Cosimo. Since 1438 he had been the *Gonfaloniere della Giustizia* (Standard-bearer of Justice), the head of the eight priors who together formed the constitutional body. Because of this position, Cosimo was able to prepare for the council and the reception of the dignitaries. One of the results was a decisive financial success, a year of high profits for the Medici bank. In this context, therefore, painting the

Nonetheless, individual spaces constructed according to the laws of perspective are not taken into account in the overall composition, as has happened with trees, which are too small, behind the two riders to the right of the youngest king. Altogether, there is an anachronistic spatial arrangement in the rows of both figures and heads. Even the sense of perspective created by diminishing sizes, which was known at the time, is not used here. The oldest king is only half the size of the prominent Florentine figures, which is reminiscent, in the reverse, of the medieval system of sizing figures according to their importance. As a result, Benozzo here appears to have interpreted conservative means of depiction according to the wishes of his client.

Above the original entrance door of the former vestibule, the Lamb of Revelation is depicted with an as yet unopened seal. It is carrying the cruciform nimbus of the victorious Salvator Mundi and is a reference to the relics of the Passion which were kept in the chapel. The pomegranate pattern on the antependium is a symbol of the Resurrection. In consequence, in 1996 Roettgen interpreted the picture above the entrance wall as a sign of the imminent Last Judgment. It was felt that the presence of the donors' portraits, the Passion relics kept in the chapel and the reading of masses would guarantee a place in the next world.

The names of the oldest and youngest kings are frequently confused. This is a result of the allocation of the abbreviation of their names, CMB.

After finishing work on painting the Medici Chapel, Benozzo created an altar painting for the Compagnia della Purificazione della Vergine, who were based close to the Florentine monastery of San Marco. The contract dating from 23 October 1461 stipulated that the work should be completed within one year. The individual parts of the picture are now owned by various museums; the main panel with the depiction of the *Sacra Conversazione* is in the National Gallery in London, the predella composed of five individual pictures showing the *Presentation in the Temple* is in the Johnson Collection in Philadelphia, the painting of *St. Zenobius raising a Child from the Dead* is in the Staatliche Museen Preußischer Kulturbesitz in Berlin, the *Dance of Salome* is in the National Gallery of Art in Washington, *St. Dominic raising a Child from the Dead* is in the Pinacoteca Brera in Milan and the *Fall of Simon Magus* is part of the Royal Collections at Hampton Court in London.

In 1466, the panel painting of the *Mystic Marriage of St. Catherine* was created. The event is being witnessed by St. Bartholomew, St. Lucia and St. Francis. The panel painting was produced for the chapel belonging to the Rustici family in the church of Santa Maria dell' Oro near to Terni, and is now kept in the town's Pinacoteca Comunale.

58 Gentile da Fabriano
Adoration of the Magi (detail ill. 57), 1423

The banker Palla Strozzi, who commissioned the work, had himself portrayed with his son immediately behind the standing youngest king. It is not just the magnificent decoration of the work and the exotic animals which refer to the courtly culture; the kneeling squire fastening the spur of the king presenting his gift is also a chivalrous motif.

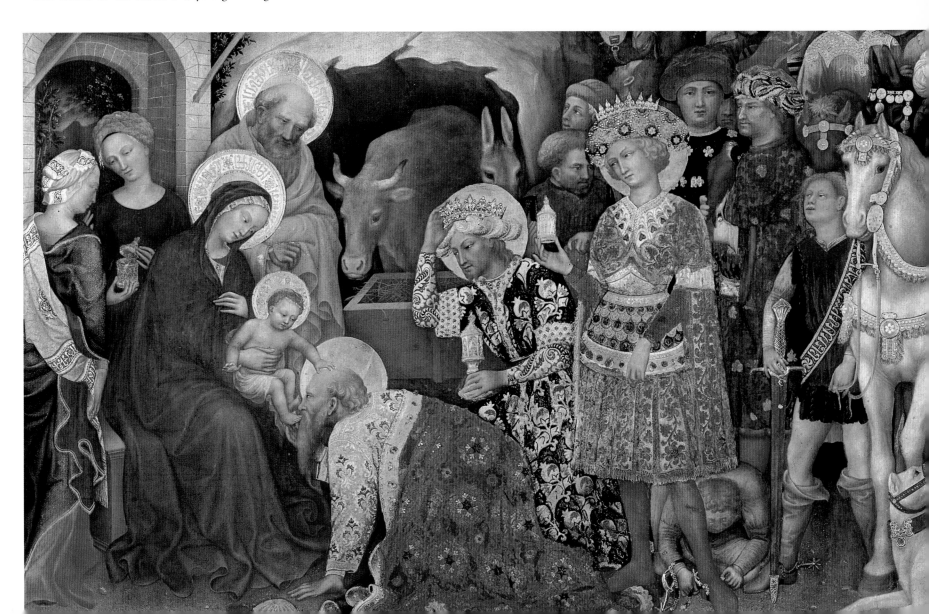

The story of the Three Kings or Magi is recorded only in St. Matthew's Gospel (2:1–12). It tells how the wise men from the east came to Jerusalem following a star in search of "he that is born King of the Jews". They brought three gifts for Christ: gold, frankincense, and myrrh. Due to the number of gifts, it was from the third century onwards assumed that the magi were three men. Throughout the writings of the Middle Ages there are varying interpretations of the gifts. Their symbolic meaning was first explained by St. Irenaeus of Lyon (died ca. 202). According to him, gold was fitting for the king, frankincense for the God, and myrrh for the man in Christ.

Jacobus de Voragine (died 1298) defined the gifts in his "Legenda Aurea" (between 1263 and 1273) as follows: gold for divinity, frankincense for the soul and myrrh for prayer. In the "Gesta Romanorum", a medieval collection of stories about the "Deeds of the Romans", gold symbolizes the wisdom of kings, frankincense humble sacrifice and prayer and myrrh the purity maintained by self-control.

The difference in age of the three magi led in the fourth century to their being interpreted as symbols of the "three ages of man". At a very early stage, Tertullian (ca. 160 – after 220) and St. Ephraem Syrus (died 373) identified the three magi as kings, an identification generally accepted from the sixth century onwards at the latest. Their names, Caspar or Gaspar, Balthazar and Melchior, are given in a translation in the ninth century and were adopted in the "Legenda Aurea".

According to legend, St. Helena (ca. 257–336), the mother of Constantine the Great, brought the relics of the Three Kings to Constantinople. From there they were probably brought to the church of San Eustorgio in Milan in the fourth century by Bishop Eustorgius (bishop from 343–355). Numerous legends arose at this time and the names of Caspar, Melchior and Balthazar first appear. During the conquest of Milan in 1162 by Emperor Frederick Barbarossa, he gave the relics of the Three Kings to his chancellor and archbishop of Cologne, Rainald of Dassel.

59 Nicholas of Verdun (known to have lived 1181–1205)
Tabernacle of the Three Kings, ca. 1181–1230
New oak casket, decorated with gold, silver and copper repoussé and gilded, cloisonné, champlevé, precious stones, pearls, ancient engraved gems and cameos
Height: 153 cm, width: 110 cm, length: 220 cm
Dom, Chor, Cologne

On the front side of the High Gothic tabernacle, the Three Kings and the baptism of Christ are depicted, which can be interpreted as a double Epiphany of Christ. In this tabernacle, in addition to the relics of the Three Kings, those of the soldier martyrs Felix and Nabor and the martyr priest Gregory of Spoleto are also kept.

On 23 July 1164, they were transferred to Cologne Cathedral together with those of the African soldier martyrs Felix and Nabor, where they have been kept in the choir to this day in a magnificent High Gothic reliquary (ill. 59) covered with figures. Their arrival in Cologne brought about a revival in their worship and Cologne became one of the most important places of pilgrimage in the western world, ranking alongside Rome and Santiago de Compostela. To this day in large parts of Germany, the Epiphany on 6 January is accompanied by the "Sternsingen" or star carols, and blessing of homes by the Three Kings. To bless the homes, the symbol of the Three Kings, C + M + B, together with the year, is chalked by the doorways of houses. The Three Kings are the patron saints of pilgrims and travellers and many inns continue to be named after them.

The Adoration of the Magi was already a subject in early Christian art, for example in paintings in the catacombs and sarcophagus sculpture in the fourth century. The iconography is derived from the Adoration of the Barbarians in Roman triumphal art. Early Christian depictions show the Magi with the Enthroned Madonna and the Christ Child. Frequently the gifts are concealed in their hands. The Three Kings also represented the three parts of the earth known

in the Middle Ages. This is why, from the 12th century onwards and more frequently from the 15th, one of the magi was depicted as an African. From the tenth and 11th centuries the Three Kings were identified by means of inscriptions and personal attributes. They are depicted in western art from the 12th and 13th centuries to the 15th century in Adoration scenes: the front king kneels before the Madonna and Christ Child, the second points at the Star and turns towards the third king. In the 14th century, the scene is frequently embellished with genre details and the kings appear in contemporary dress. In the 15th century, because of their gifts, the magi (ill. 60) were motifs popular amongst wealthy citizens who had made their fortunes by conducting unchristian financial transactions. Gold and myrrh were interpreted as worldly gifts. Similarly, the patricians hoped to save their own souls by making Christian donations, such as a painting of the Three Kings (ill. 57). In the 15th century, there was a shift in the main thematic emphasis of the depictions. The Adoration picture gave way to a more extensive description of the journey of the Three Kings with numerous companions.

60 Stefan Lochner (ca. 1400–1455)
Altar of the City Patrons, ca. 1440–1445
Oak, inner panels covered with canvas
Centre panel: 260 x 285 x 14.9 cm
Wings: each 261 x 142 x 14.9 cm
Dom, Marienkapelle, Cologne

The central panel of the picture, which was originally created for the council's chapel, shows the Adoration of the Magi. In the centre of a triangular composition the crowned Queen of Heaven is enthroned with the Christ Child. On either side the oldest and middle king are kneeling, while the youngest king is standing almost unnoticed behind the middle one. Until the 15th century this type of Adoration was the most common iconographical scheme.

The Outstanding Revival of Painted Narratives: the Cycle of St. Augustine

62 (opposite) View of the apsidal chapel of Sant'Agostino, *Cycle of St. Augustine*, 1464/65
Fresco, lunettes: width of base 440 cm, rectangular panels 220 x 230 cm
Sant'Agostino, San Gimignano

As in Montefalco, the life of St. Augustine is narrated as an ascent: the lowest register depicts the education, teachings and travels, the middle one his path to faith, and the lunettes the culmination of his journey through life. The vault symbolizes his ascent to heaven. The lavish framing of the picture fields by means of narrow gold borders and painted pilasters is an innovation in this form.

61 (below) Scheme of the cycle of St. Augustine

By 1463 at the latest, Benozzo had left his native city and moved to San Gimignano for four years, until 1467. He had left Florence because of the plague, for towns at higher altitudes such as San Gimignano were thought to be less at risk. Here, in collaboration with several assistants, he produced his main work, the decorations of the apsidal chapel of the church of Sant'Agostino (1464/65; ills. 61, 62). The single-aisled hall church with three apsidal chapels and an open roof truss, built by the Augustinian canons between 1280 and 1298, is a typical example of the Gothic architecture of the mendicant orders in central Italy.

Benozzo was given the commission by Fra Domenico Strambi, a learned Augustinian monk belonging to the monastery who in 1449 had been given a grant by the town to study theology at the Sorbonne in Paris. The paintings were produced within the contemporary context of the reformation of the monastery of Sant'Agostino. The intention was to merge it with the Augustinian order of San Salvatore in Lecceto near Siena. The choir, being the place where the community of monks assembled, was decorated with a didactic program of the life and work of St. Augustine. The cycle of St. Augustine is one of the main works of Tuscan narrative art dating from the middle of the century. It can take its place alongside the fresco cycle of the *Discovery of the True Cross* (1453/54) by Piero della Francesca (1415/20–1492) in Arezzo and Donatello's (1386–1466) *Passion Pulpit* and *Resurrection Pulpit* (1460–62) in San Lorenzo in Florence.

The cycle depicts 17 scenes from the life of the Father of the Church (ill. 61). When selecting the scenes from the legend of St. Augustine, Benozzo had to create his own iconography without using models, and Domenico Strambi helped him to achieve this. The distinguishing feature of the pictorial program is a simple construction of scenes which shows the protagonists in realistic rural, urban or architectural surroundings. The 17 pictures, which are arranged in three rows, use the traditional horizontal direction of reading, from the bottom left to the top right. Strambi is thought to be the author of the Latin inscriptions which comment on the events in each case. An innovation was the uniform system of architectural frames, in which painted pilasters separate each of the pictures from each other. It represents a direct preliminary stage to Domenico Ghirlandaio's (1449–1494) painted wall structure of several loggia-like storeys.

Benozzo arranged the life of St. Augustine in three sections. In the lowest register he depicts the education, teachings and journeys of the saint. The middle register shows his path to Christian faith, and in the lunette fields the culmination of his journey through life appears. Here, as in Montefalco, the cycle is read from the bottom upwards, and as a result should be interpreted as a painted metaphor of a striving to reach God.

Scheme of the cycle of St. Augustine (ill. 61):

The four Evangelists (cf. ill. 63)

St. Luke

St. Matthew — St. Mark

St. John

Chr. / Ap. (Chancel arch intrados)

A = Martyrdom of St. Sebastian
B = Martyrdom of St. Bartolus

C = Miracle of St. Nicholas of Tolentino
D = Tobias and the Fish

Ap. (Chancel arch intrados)

Lunettes:
- Blessing of the Faithful at Hippo (cf. ill. 79) 14
- Conversion of the Heretic (cf. ill. 80) 15
- St. Augustine's Vision of St. Jerome (cf. ill. 81) 16
- Funeral of St. Augustine (cf. ill. 82) 17

Middle register:
- St. John the Baptist
- Arrival of St. Augustine in Milan (cf. ill. 72) 8
- Scenes with St. Ambrose (cf. ill. 73) 9
- St. Augustine reading the Epistle of St. Paul (cf. ill. 74) 10
- Baptism of St. Augustine (cf. ill. 75) 11
- The Parable of the Holy Trinity and the Visit to the Monks of Mount Pisano (cf. ill. 76) 12
- Death of St. Monica (cf. ill. 78) 13
- Elias

Lower register:
- St. Monica (cf. ill. 83)
- St. Gimignano (cf. ill. 84)
- The School of Tagaste (cf. ill. 64) 1
- St. Augustine at the University of Carthage (cf. ill. 66) 2
- St. Augustine leaving his Mother (cf. ill. 67) 3
- St. Augustine's Journey to Rome 4
- Disembarkation at Ostia (cf. ill. 68) 5
- St. Augustine teaching in Rome (cf. ill. 69) 6
- St. Augustine departing for Milan (cf. ill. 70) 7
- St. Nicholas of Bari (cf. ill. 87)
- St. Fina (cf. ill. 88)

Bottom pilasters:
- St. Sebastian (cf. ill. 85)
- St. Bartolus (cf. ill. 86)
- St. Nicholas of Tolentino (cf. ill. 89)
- Raphael and Tobias (cf. ill. 90)

A B C D

PILLAR NORTH WALL EAST WALL SOUTH WALL PILLAR

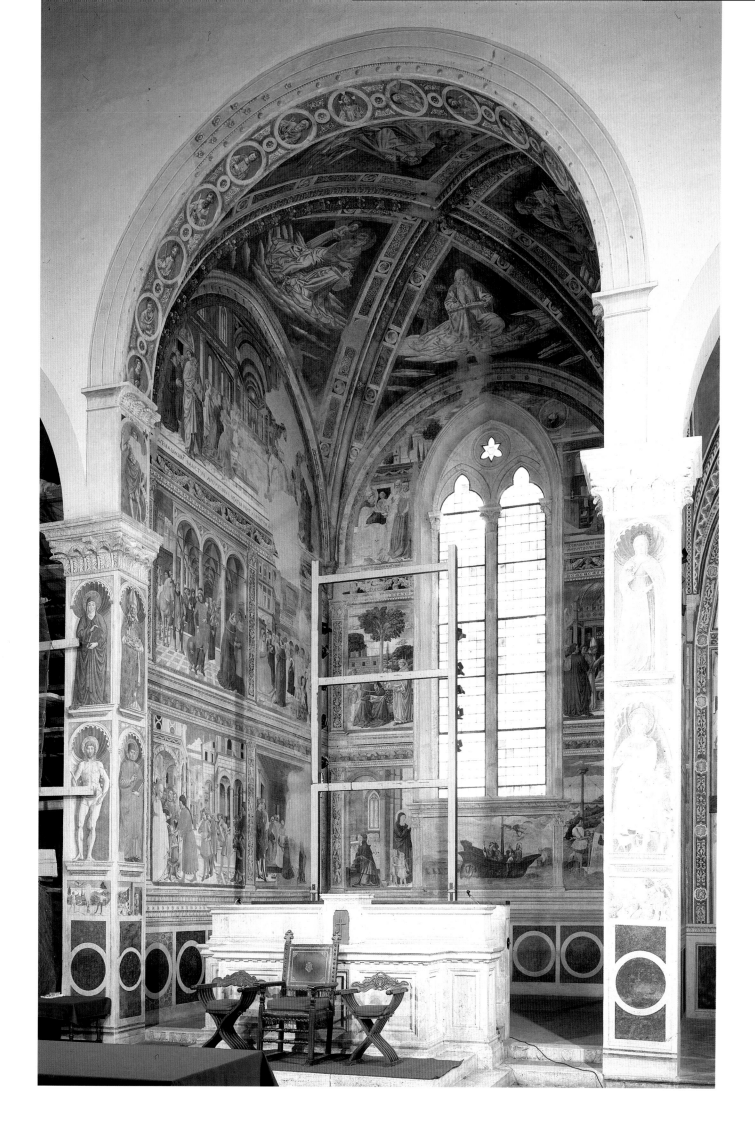

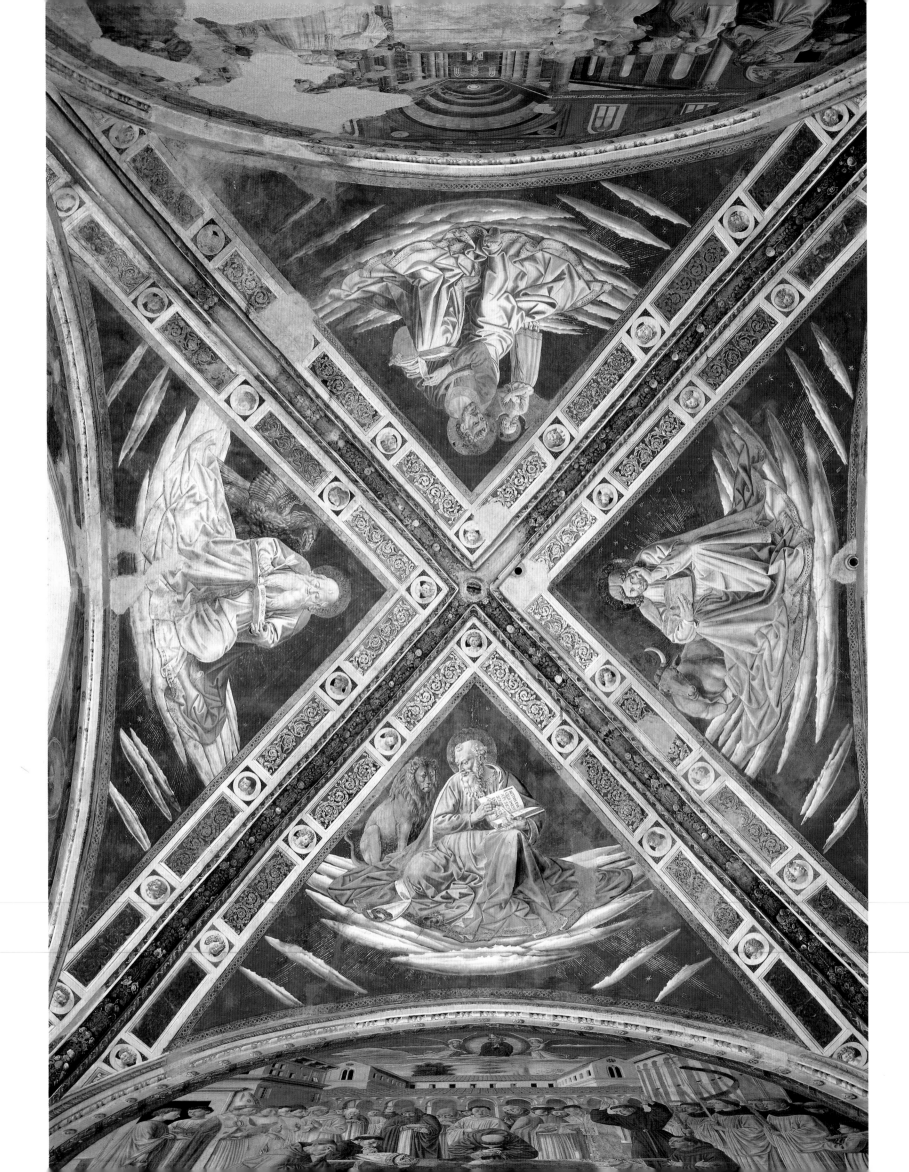

63 (opposite) *The Four Evangelists* (cf. ill. 62), 1464/65
Fresco
Vault of apsidal chapel of Sant'Agostino, San Gimignano

The four Evangelists symbolize the kingdom of God, and
they are depicted on the four fields of the groin vault in
the process of reading or writing down their works: St.
Mark is shown with the lion, St. Matthew with the angel,
St. Luke with the ox and St. John with the eagle. The
concentrically painted clouds create the impression of a
circular vault.

64 (above) *The School of Tagaste* (cf. ill. 62), 1464/65
Fresco, 220 x 230 cm
Apsidal chapel of Sant'Agostino, San Gimignano

On the left the young Augustine's first day at the
elementary school in Tagaste is depicted, and on the right
his quickness and eagerness to learn. Within the family
group his mother, St. Monica, is highlighted by means
of a golden halo which obeys the laws of perspective.
Particularly characteristic of this cycle is the city view with
buildings in the style of the Early Renaissance, including
depictions of some that really exist.

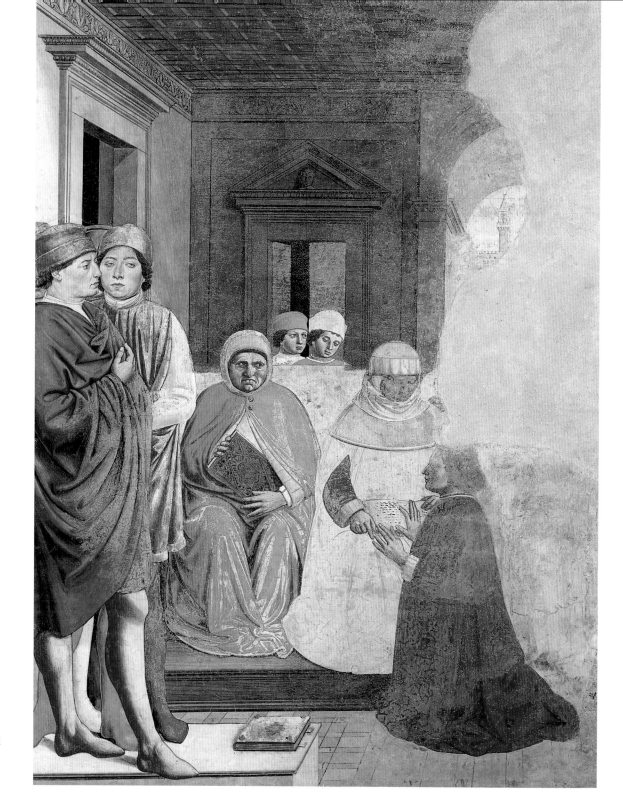

66 (right) *St. Augustine at the University of Carthage* (cf. ill. 62), 1464/65
Fresco, 220 x 230 cm
Apsidal chapel of Sant'Agostino, San Gimignano

This picture field shows St. Augustine starting at the University of Carthage, where he was to study the liberal arts. As in the first picture, the interior here is also depicted entirely in the style of the Italian Early Renaissance.

65 (opposite) *The School of Tagaste* (detail ill. 64), 1464/65
Apsidal chapel of Sant'Agostino, San Gimignano

In places Gozzoli added genre details to his depiction of the life of St. Augustine: on the right side, in a simultaneous scene in front of a columned loggia, the teacher is punishing a small pupil by delivering birch strokes to his bare backside. The laziness of other pupils is contrasted with the quickness to learn of the little Augustine, who is walking at the teacher's side and eagerly studying a small slate with Greek letters. The other pupils who are present at the scene appear to be taking no notice of it.

The vaulting shows the four Evangelists (ill. 63) on concentrically painted clouds, creating the impression of a circular vault.

As in the cycle of St. Francis in Montefalco, the cycle of St. Augustine does not depict any miracles or posthumous events, but portrays the saint as a student, teacher and scholar. This corresponded to the new humanist opinion of the Father of the Church, who combined classical learning, a high regard for Plato and the art of rhetoric with the religious zeal of Christianity. St. Augustine was born in 354 in Tagaste (Numidia, now Algeria), the son of Patricius, a pagan, and the Christian Monica. The father did not have any decisive influence on him, though that of the mother was to prove to be a lasting one.

The first scene, *The School of Tagaste*, relates to his *Confessions*. This, probably his best-known work, was written between 397 and 401. The picture shows him starting school at the elementary school of Tagaste (ills. 64, 65). The teacher walking towards the young Augustine is greeting him by gently caressing his face. In the simultaneous scene on the right the teacher is punishing a pupil while the little Augustine is attentively studying a school slate with Greek letters on it. From the scale of the buildings and figures it can be seen how far the pictorial space extends backwards. In this way Benozzo creates a counterweight to the arrangement of the figures parallel to the picture in the foreground. The inscription tells us that Augustine made considerable advances within a short space of time in the Latin school of Tagaste, and emphasizes the Latin element that dominated his education.

The fresco with *St. Augustine at the University of Carthage* (ill. 66) has been severely damaged.

67 (left) *St. Augustine leaving his Mother* (cf. ill. 62),
1464/65
Fresco 220 x 230 cm
Apsidal chapel of Sant'Agostino, San Gimignano

St. Augustine's mother appears twice in this fresco: on the
left she is kneeling in a church interior which is furnished
with a Gothic tracery window and a Gothic polyptych.
Her position precisely matches that of St. Augustine in
the previous picture field. On the right she is sadly
supporting her head and blessing her son with her raised
hand.

68 (opposite) *Disembarkation at Ostia* (cf. ill. 62),
1464/65
Fresco, 220 x 230 cm
Apsidal chapel of Sant'Agostino, San Gimignano

In this picture field, showing the arrival of St. Augustine
at the harbor of Ostia near Rome, it is particularly clear
how Gozzoli, in contrast to his earlier fresco cycles, chose
a close-up composition for his frescoes, particularly in the
lower register. This makes it possible for the figures in the
foreground to appear as if on a stage. In contrast to the
real events, though, Gozzoli moved the scene to a
typically Tuscan hilly landscape.

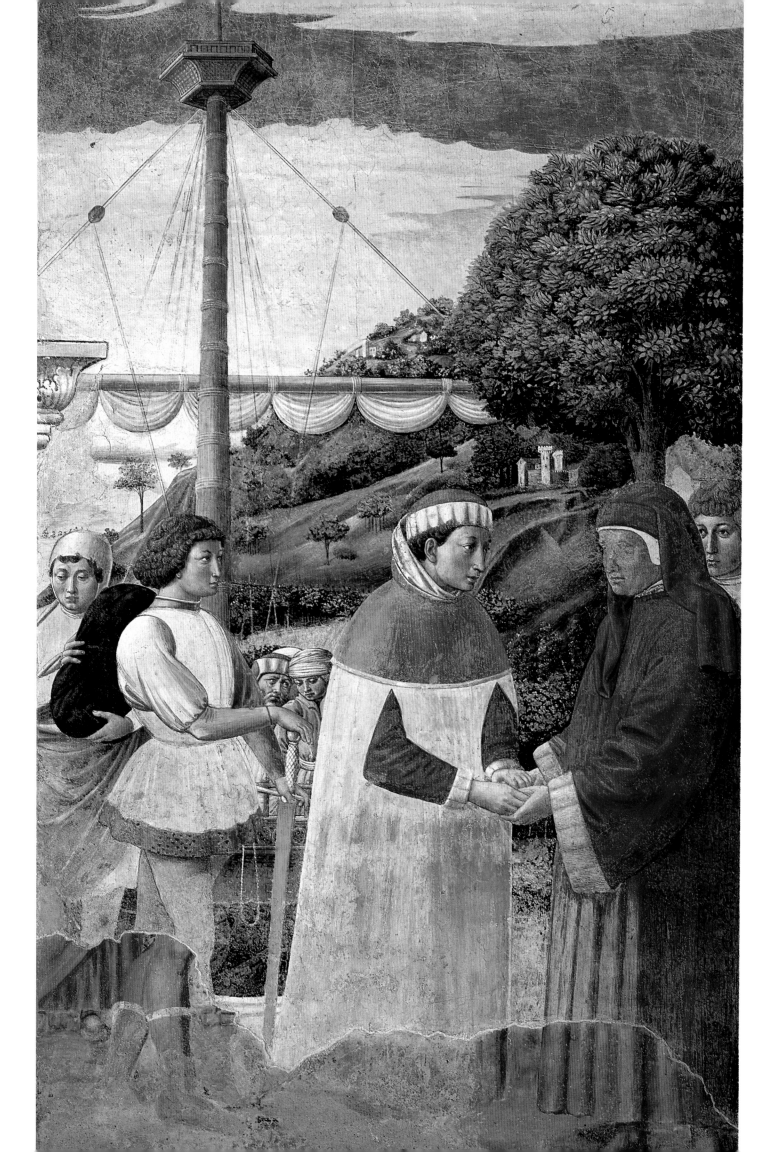

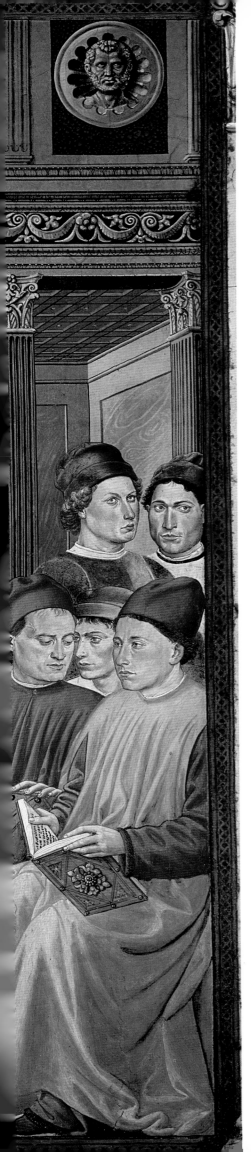

St. Augustine is kneeling on the right side in front of two seated scholars. Between them, in the background, appear two youthful figures framed by a classical pediment portal. In 371 St. Augustine went to the University of Carthage in order to study the liberal arts. These can be subdivided into the trivium of grammar, rhetoric and logic, and the quadrivium of arithmetic, geometry, astronomy and music. In his encyclopaedia work "Satiricon" (ca. 450), Marcianus Capella stated that there were seven liberal arts. In Carthage, Augustine became familiar with Cicero's philosophical treatise "Hortensius", and this led to his first conversion, when he adhered to Manichaeism. This was a dualistic philosophy founded by the Persian Mani (216–273), which comprised the battle between light and darkness, between good and evil. In the two first pictures, the *School of Tagaste* and the *University of Carthage*, the figural scenes appear within a perspectively painted architecture typical of the Early Renaissance. In contrast to Montefalco, the figures and architecture here form a harmonious whole.

The fresco on the east wall behind the altar was severely damaged and was restored in the 18th century. It depicts *St. Augustine leaving his Mother* (ill. 67). The figure of St. Monica, absorbed in prayer, on the left side of the picture is an almost exact quotation of the motif of St. Augustine in the previous fresco.

St. Augustine made his journey to Rome in 383. The following fresco shows both this scene and his *Disembarkation at Ostia* (ill. 68). Augustine left his native country as he was disappointed by the fantastical mythology of the Manichaeists and finally abandoned this philosophy.

The scene of *St. Augustine teaching in Rome* (ill. 69) shows the saint as an older man and scholar of rhetoric. Compared to Augustine's start at the *School of Tagaste*, Benozzo gave the scene an appropriate distance from the observer. The arrangement and scale of the figures underline the perspective indicated by the floor tiles. The parallel lines converge on the figure of the saint. The two listeners sitting to the right of him are repeated on the left as almost mirror images, thereby supporting the balance of the spatial composition. The pictorial space opens out towards the teacher. The dog sitting on the floor in the foreground is given a predominantly negative status in the Bible. The Fathers of the Church, in contrast, valued it as a guard and loyal shepherd, and it was interpreted as a symbol of the preacher.

St. Augustine had left Rome in the autumn of 384 in order to take up the position of municipal teacher of rhetoric in Milan. *St. Augustine departing for Milan* (ills. 70, 71) is depicted by Benozzo in the manner described in the *Confessions*, as a pilgrimage in search of the true faith. It is thought that the figure on the right edge of the picture is a self-portrait of the artist. The gestures and facial expressions clearly express reserve, while at the same time his left hand is pointing at the travelling saint. Above the train of pilgrims two angels are holding an inscription which names the client and artist: ELOQUII SACRI DOCTOR PARISINUS ET ENGENS, GEMINGNACI FAMA DECUSQUE

69 *St. Augustine teaching in Rome* (cf. ill. 62), 1464/65
Fresco, 220 x 230 cm
Apsidal chapel of Sant'Agostino, San Gimignano

St. Augustine is depicted as a scholar of rhetoric in a perspectively constructed interior. On either side listeners are arranged almost as mirror images. The parallel lines of the floor tiles converge on the face of the saint, thus drawing one's attention to him. In the foreground a little dog is sitting, who was considered by Fathers of the Church to be a guard and loyal shepherd, and was interpreted as a symbol of the preacher.

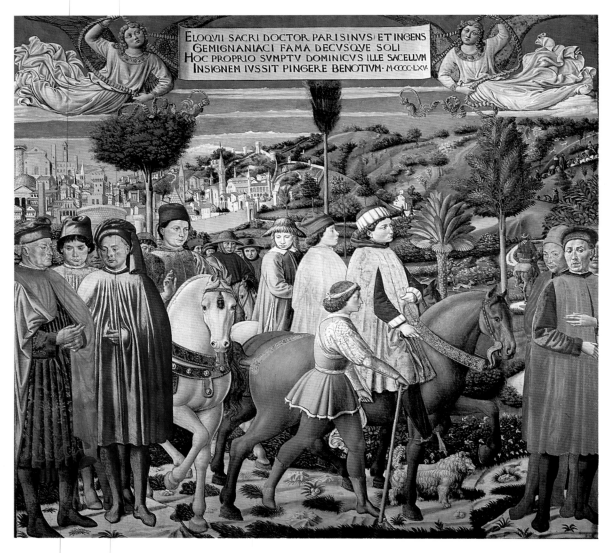

ELOQVII SACRI DOCTOR PARISINVS ET INGENS
GEMIGNANIACI FAMA DECVSQVE SOLI
HOC PROPRIO SVMPTV DOMINICVS ILLE SACELLVM
INSIGNEM IVSSIT PINGERE BENOTIVM· M·CCCC·LXV·

70 *St. Augustine departing for Milan* (cf. ill. 62),
1464/65
Fresco, 220 x 230 cm
Apsidal chapel of Sant'Agostino, San Gimignano

The last picture in the lower register shows the saint's
departure from Rome in order to take up the position of
municipal teacher of rhetoric in Milan. As in the Medici
cycle before it, Gozzoli has also portrayed secular and
religious personalities in the large group of figures. It is
thought that the individual features of some citizens are
those of contemporaries. On the right edge of the
picture, the painter has immortalized himself in a light
red garment.

SOLI, HOC PROPRIO SUMPTU DOMINICUS
ILLE SACELLUM INSIGNEM IUSSIT PINGERE
BENOTIUM. MCVVVLXV. – "As a teaching preacher
in Paris and as an important [man], the fame and credit
to the country of Gimignano, that Dominicus had this
holy tabernacle painted at his own expense by the
famous Benozzo. 1465."

The next picture in the second row on the left shows
the *Arrival of St. Augustine in Milan* (ill. 72). In front of
a columned loggia, which is reminiscent of the Loggia
dei Lanzi (between 1376 and 1381) with three bays
in Florence, St. Augustine appears in several small
simultaneous scenes. Here Benozzo makes a more de-
cisive use than he did in Montefalco of the opportunities
of emphasizing the scenes in the picture by means of
the architecture: in one place, the saint is standing in front
of a column, and at another between two columns.

The fresco showing the *Scenes with St. Ambrose*
(ill. 73) depicts St. Augustine hearing the bishop
preaching in Milan. Here, too, St. Augustine is depicted
twice: on the left he is talking with the seated St.
Ambrose. On the right side St. Augustine has taken his
seat at the edge of the picture before a niche. At this
point the fresco is unfortunately severely damaged. The
two scenes are clearly separated from each other by the
construction of the picture. The preaching of St.
Ambrose made it possible for St. Augustine to overcome

the Manichaeist criticism of the Bible by means of
allegorical biblical exegesis and Neoplatonic intellec-
tuality. St. Ambrose caused Augustine finally to convert
to Christianity.

In the following fresco, St. Augustine (ill. 74) hears a
voice in the seclusion of a garden commanding him to
"take up the book and read". Accordingly, he takes up
the epistle of St. Paul to the Romans, and starts reading
Romans 13:13 ff., which warns sinners to "put ye on the
Lord Jesus Christ, and make not provision for the flesh,
to fulfil the lusts thereof." On the right his intellectual
friend Alypius is reaching out to him with his hand. Two
old friends, on the left side, are keeping their distance
from his on account of his change of faith. The phrase
coined by St. Augustine, "credo ut intelligam, intelligo
ut credam" – "I believe that I might understand, and
understand that I might believe" – appears to have been
visually translated into this picture.

The *Baptism of St. Augustine* (ill. 75) was, according
to the "Legenda Aurea" or Golden Legend, carried out
at Easter 378 by St. Ambrose in Milan with the words
"te Deum laudamus" (we praise you as [our] God), to
which St. Augustine replied "te Dominum confitemur"
(we recognize your as [our] Lord). This liturgical hymn
of thanksgiving, the "Te Deum", is mentioned in the
"Legenda Aurea" as being a song of praise between
St. Ambrose and St. Augustine. In the medieval liturgy,

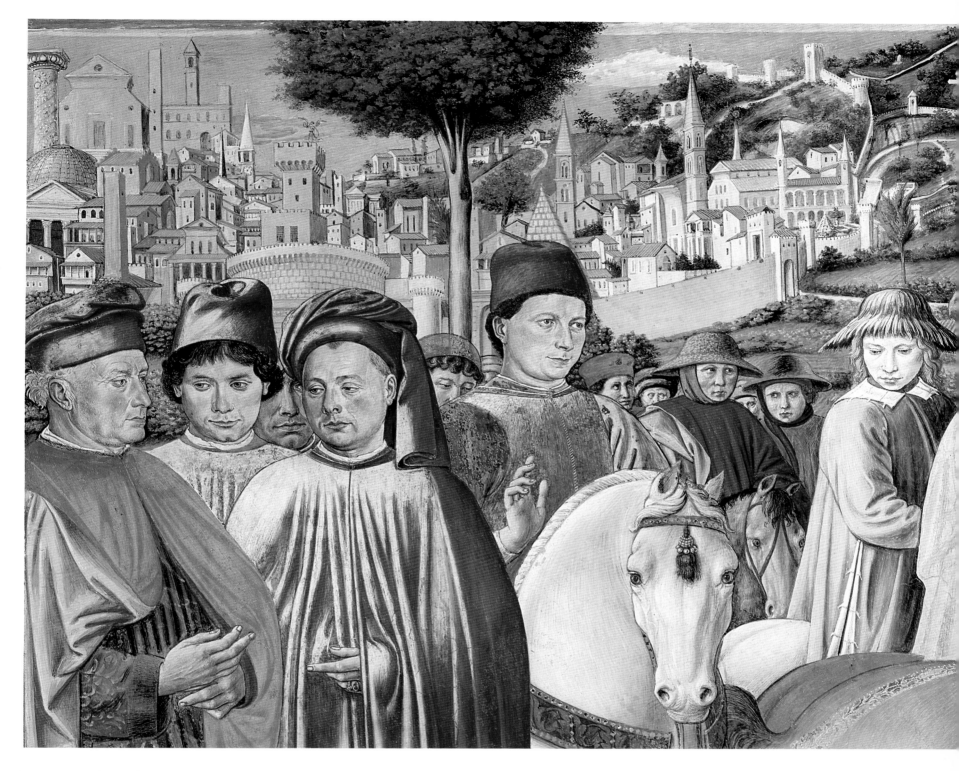

71 *St. Augustine departing for Milan* (detail ill. 70),
1464/65

The city view in the background can be identified as
Rome by the presence of buildings such as the pyramid
tomb of Gaius Cestius on the right side and the Pantheon
on the left.

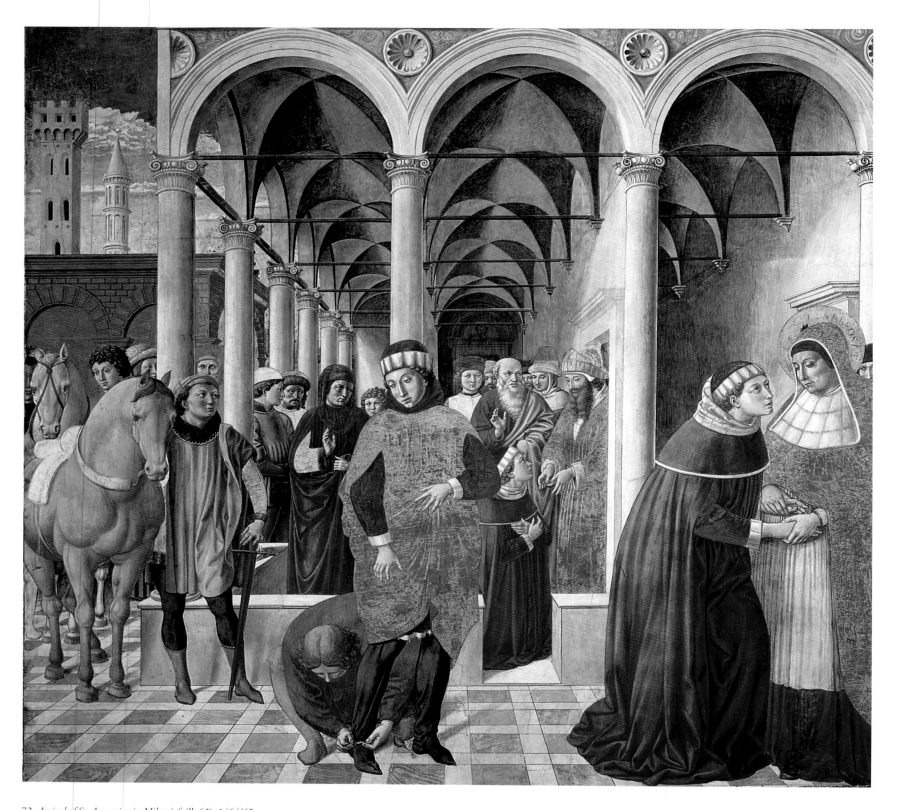

72 *Arrival of St. Augustine in Milan* (cf. ill. 62), 1464/65
Fresco, 220 x 230 cm
Apsidal chapel of Sant'Agostino, San Gimignano

In the *Arrival of St. Augustine in Milan*, Gozzoli once
again combines three scenes from the legend of St.
Augustine as simultaneous events. On the first occasion
St. Augustine appears before a columned loggia
reminiscent of the Loggia dei Lanzi in Florence, with its
three bays. A servant is helping him take off his riding
clothes. In the background, the saint is kneeling before a
Muslim scholar. In the foreground on the right we can see
St. Augustine being greeted by St. Ambrose.

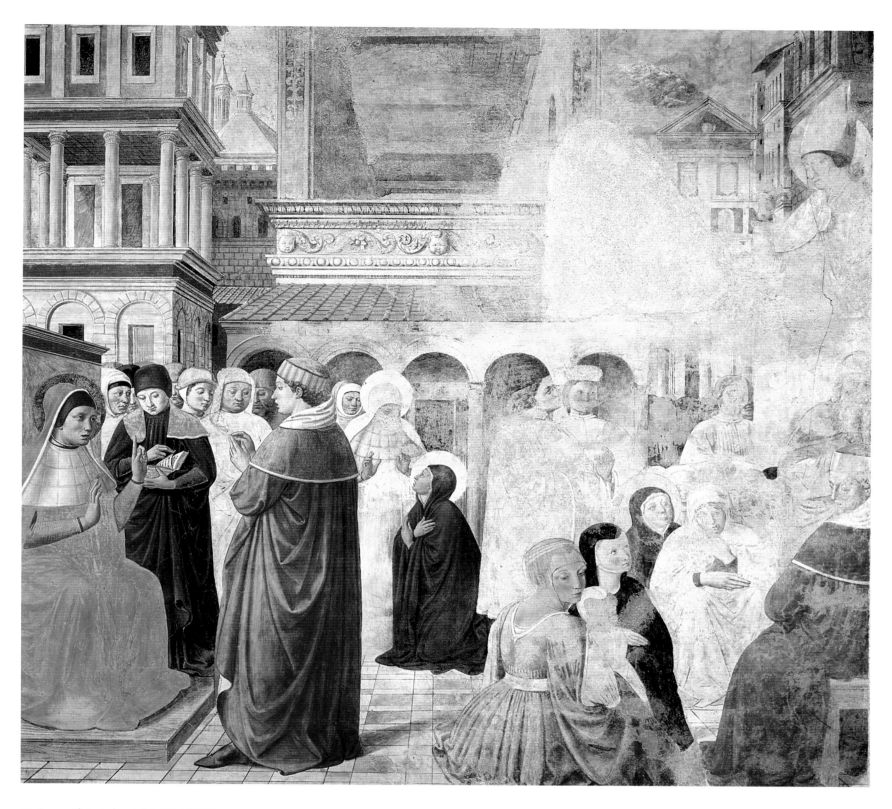

73 *Scenes with St. Ambrose* (cf. ill. 62), 1464/65
Fresco, 220 x 230 cm
Apsidal chapel of Sant'Agostino, San Gimignano

Once again two scenes from the life of St. Augustine are
depicted: in the left picture field he is in conversation
with St. Ambrose, and on the right he is sitting in the
foreground in front of a niche and is meditating on the
preaching of St. Ambrose. St. Ambrose, who converted
Augustine to Christianity, played an important part in the
saint's life.

74 *St. Augustine reading the Epistle of St. Paul* (cf. ill. 62),
1464/65
Fresco, 220 x 230 cm
Apsidal chapel of Sant'Agostino, San Gimignano

The "garden scene", as it is known, shows the saint in the
seclusion of a garden, absorbed in reading the Epistle of
St. Paul. According to tradition, this is where he heard the
voice of a child repeatedly telling him, with the words
"tolle, legge", to read the Gospels. On the right his friend
Alypius is approaching and reaching out his hand.

Within the fresco:

TE DEV LAV DAM
TED OMINV CO FIEM

ADI PRIMO DAPRILE MILLE CCCC LXIIII

75 *Baptism of St. Augustine* (cf. ill. 62), 1464/65
Fresco, 220 x 230 cm
Apsidal chapel of Sant'Agostino, San Gimignano

St. Augustine is seen at the very moment he is baptized,
kneeling in prayer before the pillars of a baptistery behind
a rectangular basin filled with water, on which the
picture's date of origin has been recorded: ADI PRIMO
DAPRILE MILLE CCCCLXIIII (1 April 1464). He is
surrounded by his followers, including his mother who is
standing behind him. The clergyman holding the newly
baptized man's clothing is thought to be a portrait of
Domenico Strambi, the man who commissioned the
cycle.

76 *The Parable of the Holy Trinity and the Visit
to the Monks of Mount Pisano* (cf. ill. 62), 1464/65
Fresco, 220 x 230 cm
Apsidal chapel of Sant'Agostino, San Gimignano

On the left side of the picture Christ appears in the form
of a boy who is attempting to transfer all the waters of the
ocean into a small hollow using a spoon. When St.
Augustine, who was meditating on the mystery of the
Holy Trinity, explained to the boy how pointless his
actions were, the latter replied that thinking about the
mystery of the Holy Trinity was even more fruitless.

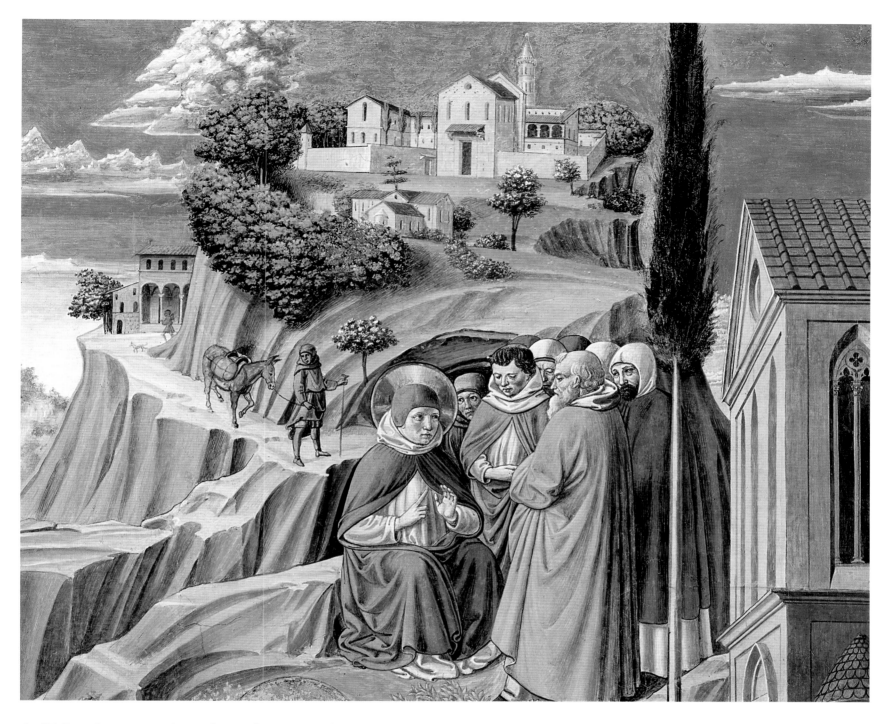

the "Te Deum" was sung as the conclusion of Matins, the midnight office, and on ceremonial liturgical occasions. The melody is one of the oldest Gregorian chants. The architecture of the baptistery, with an individual pilaster for each of the figures in the picture, emphasizes the religious dignity of the event.

In the next fresco (ill. 76), a boy on the left is attempting to use a spoon to transfer all the waters of the ocean into a little hollow. The episode is described in an apocryphal letter of Cyril of Jerusalem, and shows that the client was a particularly good expert on literature concerning St. Augustine. In the letter Cyril writes that St. Augustine, while thinking about the Trinity, met a small child on the beach who was attempting to ladle out the oceans using a spoon. When St. Augustine explained to him how impossible his plan was, the boy replied by telling him that the mystery of

the Holy Trinity was also not something that could be comprehended by the human mind. The scene is a parable of the unbridgeable gap between faith and reason.

In the middle distance, St. Augustine is sitting surrounded by a circle of monks on a bare path leading to a monastery on the top of the mountain (ill. 77). The *Visit to the Monks of Mount Pisano* is depicted for the first time in this fresco, emphasizing its uniqueness. In the foreground on the right, St. Augustine is giving the rule of the order to the hermit monks. He is wearing the dress of Augustinian hermits, a black habit with a pointed hood, leather belt and shoes. There is no historical proof of St. Augustine's journey to Tuscany. The event is also not mentioned in the *Confessions*. However, oral tradition has it that St. Augustine stayed in Tuscany after his mother's death. Due to grief at the

77 *Visit to the Monks of Mount Pisano* (detail ill. 76), 1464/65

In the center St. Augustine is surrounded by some monks. The bare path leads up to a monastery on the mountain top, possibly a reference to the medieval legends according to which St. Augustine built a monastery and entrusted it to monks whom he met in the forest. The scene in the foreground on the right depicts the confirmation of the rule of the hermits on Mount Pisano. It is an attempt to show that Tuscany was the area where the order of Augustinian hermits was founded.

78 *Death of St. Monica* (cf. ill. 62), 1464/65
Fresco, 220 x 230 cm
Apsidal chapel of Sant'Agostino, San Gimignano

This picture field, showing the praying St. Monica on her
deathbed, once again contains a portrait of the client. He
is the man standing next to the death bed on the right
wearing the blue cap. Above, St. Monica appears in a
small glory of angels in which her soul is being carried up
to heaven. In the background on the right one can,
through an open colonnade, see the departure of
St. Augustine for Numidia.

QVEMADMODV SANCTVS AVGVSTINVS STATIM POST ASSVNTVM EPIS ... OPVS BENED

loss of his mother, he is said to have forgotten to write it down. According to tradition, St. Augustine visited the hermit monks of Mount Pisano. This legend was very popular as it suggested that the Augustinian hermits had originated in Tuscany. In fact, St. Augustine founded his community in the fourth century in northern Africa. The rule of the Augustinians, dating from 388/389, is the oldest Western monastic rule. In 12 short chapters it lays down the fundamentals of monastic life. The goals of the monastic community are poverty, brotherly love, obedience, prayer, reading the Scriptures, work and apostolic work: a life characterized by seclusion and humility.

Not until 1256 did Pope Alexander (1254–1261) found the order of Augustinian hermits by combining several Italian groups of hermits who had been living according to the rule of St. Augustine since 1243.

The *Death of St. Monica* (387; ill. 78) in Ostia is combined with the departure for Carthage in the last picture of the second row. Here the client, Domenico Strambi, has also allowed himself to be immortalized. He is standing on the right next to the death bed, as we are told by the initials in the frame: F D M Paris, Frater Dominicus Magister Parisinus.

The next picture occupies the lunette field on the north wall and is as wide as the two pictures beneath it put together. The badly damaged fresco shows the *Blessing of the Faithful at Hippo* (ill. 79).

The little lunette field to the left of the window depicts the *Conversion of the Heretic* and Manichaeist presbyter Fortunatus (ill. 80). The event is described in the "Legenda Aurea" and refers to the many conversions made by St. Augustine and his successful battle against heresy.

The lunette field on the right shows *St. Augustine's Vision of St. Jerome* (ill. 81) with the former depicted as a scholar. This type of depiction was based on late classical pictures of authors and became extremely important in the 15th century. It was used by famous masters such as Botticelli (1444/45–1510) and Ghirlandaio (1449–1494) for their paintings in the Ognissanti monastery in Florence.

The last scene showing the *Funeral of St. Augustine* (ill. 82) appears in the lunette field on the south wall. The construction of the picture is clearly reminiscent of the *Death of St. Francis* in Montefalco, but because of the open columned loggia in the background it has a more harmonious composition. As in Montefalco, the

79 *Blessing of the Faithful at Hippo* (cf. ill. 62), 1464/65
Fresco, width 440 cm
Apsidal chapel of Sant'Agostino, San Gimignano

In a perspectively constructed church interior St. Augustine is blessing the faithful of Hippo kneeling on the left side. On the severely damaged right side, he can still be recognized by his bishop's miter. The church interior contains numerous references to known works of art from the Early Renaissance. For example, on the door lunette on the left edge of the picture there is a terracotta group in the style of Luca della Robbia (ca. 1400–1482).

80 *Conversion of the Heretic* (cf. ill. 62), 1464/65
Fresco
Apsidal chapel of Sant'Agostino, San Gimignano

The narrow lunette field to the left of the chapel window
depicts the conversion of the heretic Fortunatus. Here St.
Augustine is depicted as a bishop, though he is wearing
the habit of the Augustinian hermits beneath his surplice.
The scene, which is described in the "Legenda Aurea", is
representative of the many conversions which St.
Augustine made during the course of his life.

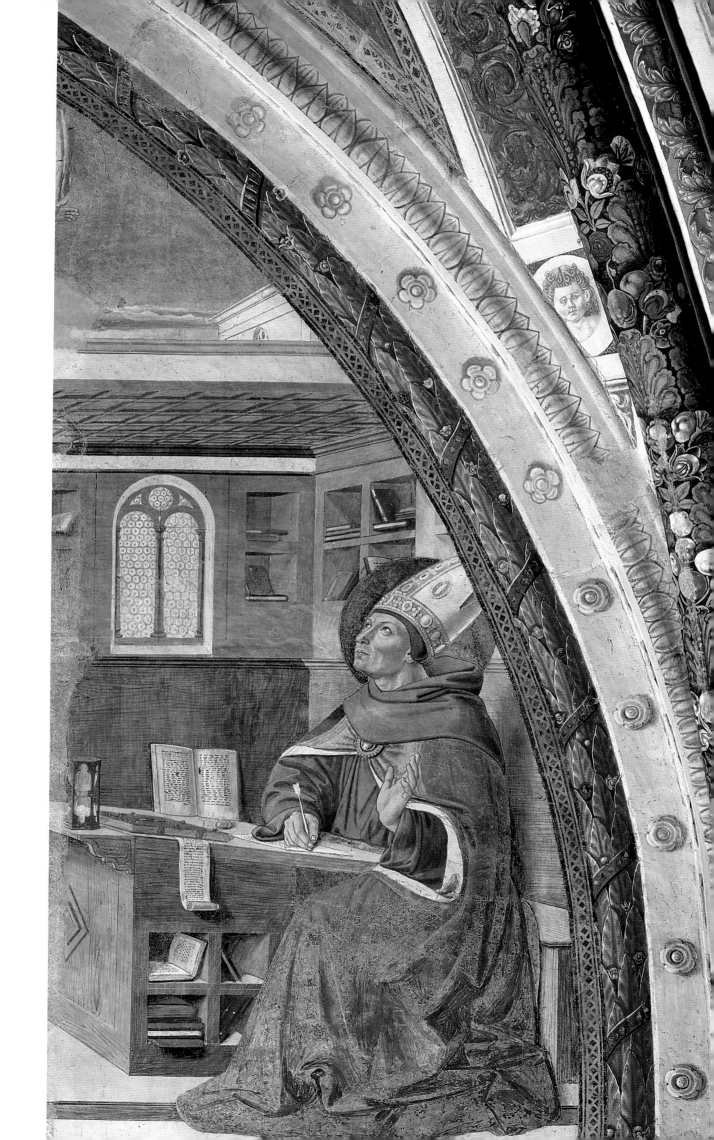

81 *St. Augustine's Vision of St. Jerome* (cf. ill. 62),
1464/65
Fresco
Apsidal chapel of Sant'Agostino, San Gimignano

As St. Augustine writes a treatise in his cell, he enters
into a mystic communication with St. Jerome. The
fresco is constructed as a picture of a scholar,
showing the saint in his study.

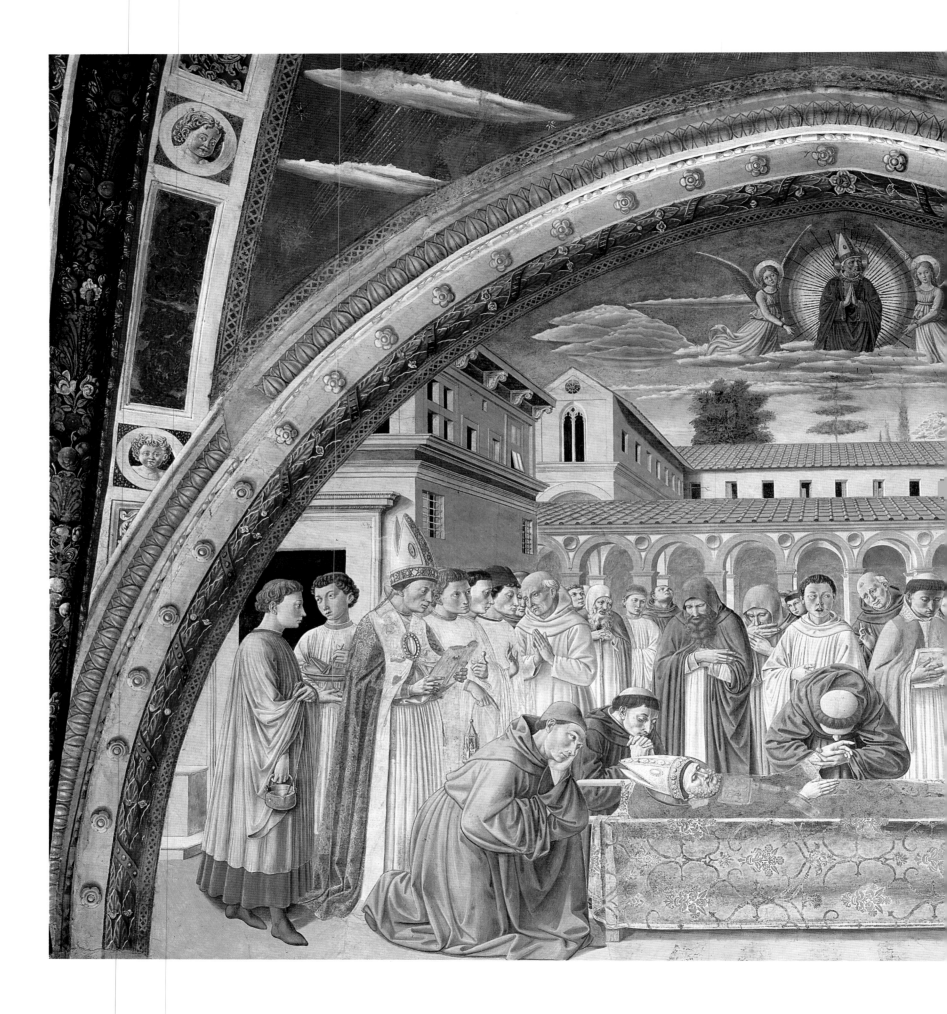

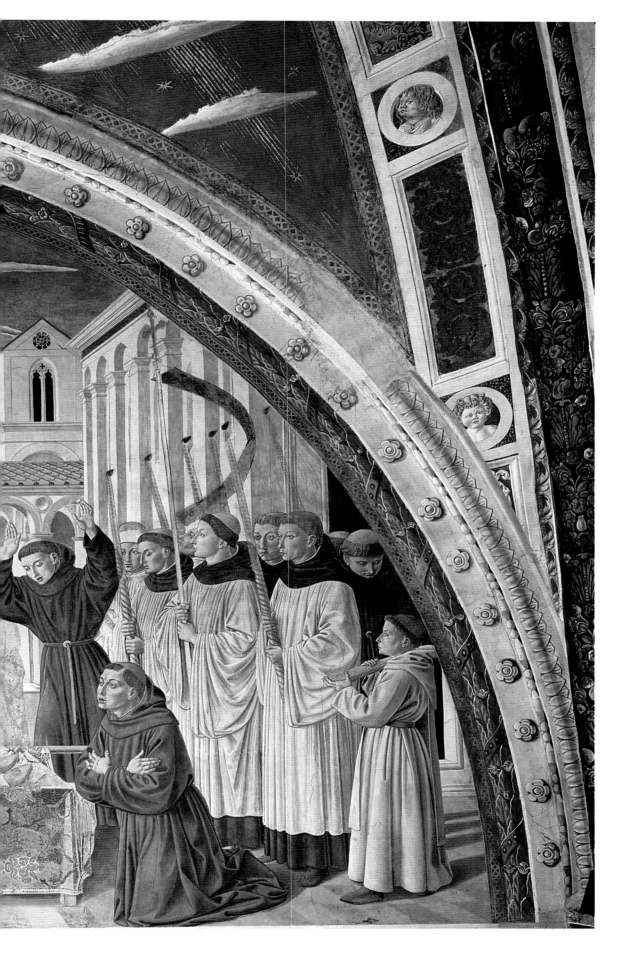

dead man's bier is standing in the foreground. The loggia behind the mourners is a quotation of the *Ospedale degli Innocenti* (orphanage) which Filippo Brunelleschi (1377–1446) started building in Florence in 1419. The orphanage, which is situated in the vicinity of the monastery of San Marco, would certainly have been known by Benozzo, for the innovative columned architecture that the building used soon spread right across Europe. It is all the more astonishing, however, that in this picture pillars instead of columns are supporting the arches, in keeping with a requirement in Leon Battista Alberti's (1404–1472) famous treatise "De Re Aedificatoria" (On Architecture), written in 1451.

The two entrance pillars to the chapel round off the fresco paintings with four saints in niches on each side. The impression of painted sculptures is contradicted by the garments which extend beyond the painted architecture. On the northern pillar are *St. Monica* (ill. 83), *St. Sebastian*, *St. Bartolus* and *St. Gimignano* (ill. 84), the bishop of Modena, had protected the castle of San Gimignano from attacks by Attila in 450. The little town, which had originally been called Silvio, then renamed itself after the saint.

St. Sebastian (ill. 85), who according to St. Ambrose came from Milan, suffered his martyrdom in Rome at the end of the third century. His worship experienced a revival from the 14th century onwards, when his aid was invoked against outbreaks of the plague.

St. Bartolus (ill. 86) was born in San Gimignano in 1228 and lived as a member of the Third Order of Franciscans in the monastery of San Vito in Pisa. Himself a leper, for 20 years he ran the leper home in Cellole near San Gimignano, where he died in 1300.

On the southern pillar *St. Nicholas of Bari*, *St. Fina*, *St. Nicholas of Tolentino* and *Raphael and Tobias* are depicted. *St. Nicholas of Bari* (ill. 87), also known as St. Nicholas of Myra, was the bishop of Myra in Lycia (now in Turkey) and died in about 350. His relics, which were stolen in 1087 by pirates, were brought to Bari where a mortuary chapel was built.

St. Fina (ill. 88) died in 1253 when just 15 years old. Her short life is said to have been filled with miracles. Despite her poverty she was charitable and had a heroic capacity for suffering. She is only depicted in the San Gimignano area.

82 *Funeral of St. Augustine* (cf. ill. 62), 1464/65
Fresco, width 440 cm
Apsidal chapel of Sant'Agostino, San Gimignano

The *Funeral of St. Augustine* concludes the cycle of frescoes in the lunette field on the south wall. The composition of the fresco is closely related to that of the *Death of St. Francis* in Montefalco, but appears more balanced due to the long, open loggia in the background. This is an adaptation of Brunelleschi's *Ospedale degli Innocenti* in Florence.

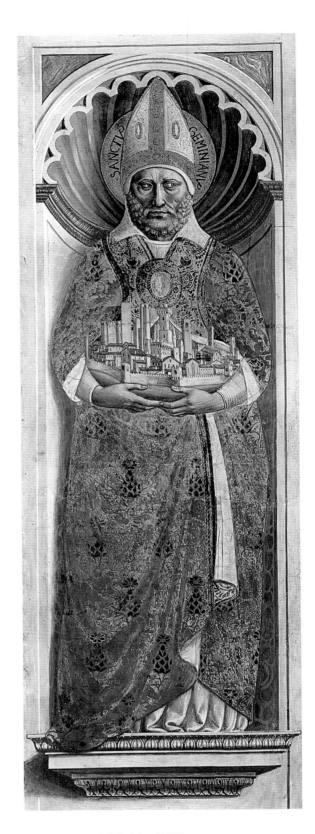

83 *St. Monica* (cf. ill. 62), 1464/65
Pillar
Apsidal chapel of Sant'Agostino, San Gimignano

The eight saints on the sides of the two entrance pillars represent an important addition to the life of St. Augustine. Their portraits are placed in niches in order to create the impression that they are sculptures.
St. Monica, the mother of St. Augustine, is in contrast to customary iconography holding a book instead of a rosary. This may be a reference to her son's eagerness to study, for he learnt about the Christian faith from his mother.

84 *St. Gimignano* (cf. ill. 62), 1464/65
Pillar
Apsidal chapel of Sant'Agostino, San Gimignano

The patron saint of San Gimignano was a local saint, and he is holding a realistic view of the town in his hands. According to legend, he is supposed to have protected it from Attila's attacks while he was bishop of Modena. This prompted the little town, formerly called Silvio, to change its name to Gimignano.

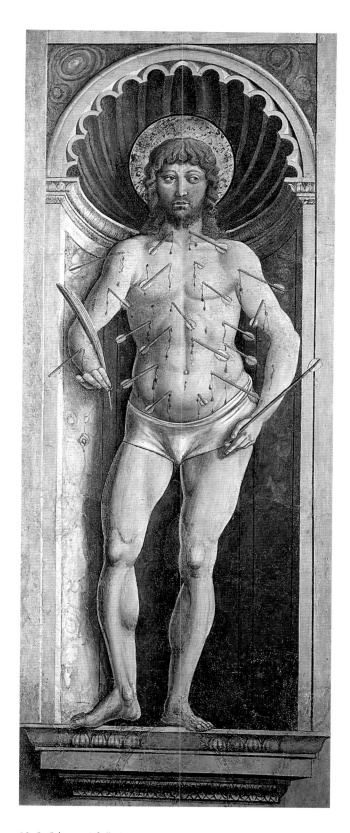

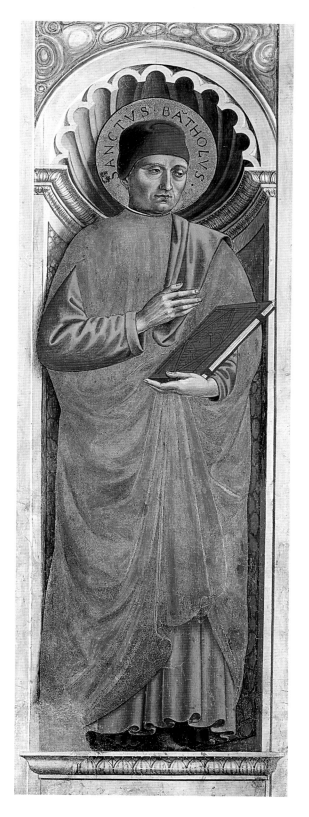

85 *St. Sebastian* (cf. ill. 62), 1464/65
Pillar
Apsidal chapel of Sant'Agostino, San Gimignano

St. Sebastian, one of the 14 auxiliary saints, is holding an
arrow and a palm frond, attributes which identify him as
a martyr. As an auxiliary saint in time of plague, his
worship became increasingly important from the 14th
century onwards. In keeping with the other pictures in
the lower register, the composition includes a "historia"
which relates to the life of the saint.

86 *St. Bartolus* (cf. ill. 62), 1464/65
Pillar
Apsidal chapel of Sant'Agostino, San Gimignano

St. Bartolus, the patron saint offering protection from
infectious diseases, came from the vicinity of San
Gimignano and was also depicted here for that reason.
He was born in San Gimignano in 1228 and lived as a
member of the Third Order of Franciscans in the
monastery of San Vito in Pisa. Himself a leper, for
20 years he ran the leper home in Cellole near San
Gimignano, where he died in 1300.

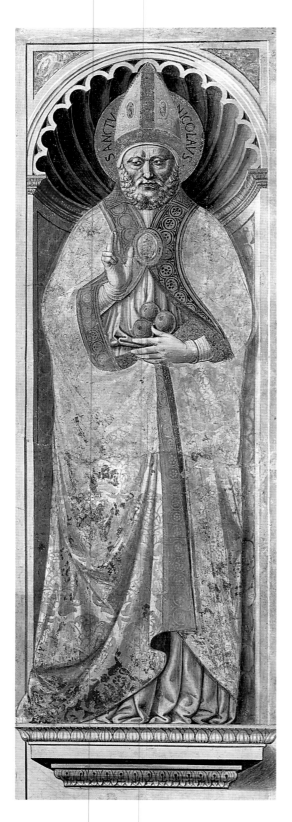

87 *St. Nicholas of Bari* (cf. ill. 62), 1464/65
Pillar
Apsidal chapel of Sant'Agostino, San Gimignano

St. Nicholas was the bishop of Myra in Lycia (now in
Turkey), which is why he is also known as Nicholas of
Myra, and he died in about 350. His relics were stolen
from Myra by pirates in 1087 and brought to Bari, which
explains the saint's official name. He is holding three
golden balls in his hand, which according to the so-called
legend of the virgins he gave to three impoverished girls
so that they would have a dowry befitting their station
and would not be disgraced.

88 *St. Fina* (cf. ill. 62), 1464/65
Pillar
Apsidal chapel of Sant'Agostino, San Gimignano

St. Fina is only depicted in the area around San
Gimignano. Though she died in 1253, aged just 15 years,
her short life is said to have been filled with miracles.
Despite her poverty she was charitable and had a heroic
capacity for suffering. Gozzoli has depicted the virgin
with her characteristic attribute, the roses.

89 *St. Nicholas of Tolentino* (cf. ill. 62), 1464/65
Pillar
Apsidal chapel of Sant'Agostino, San Gimignano

St. Nicholas of Tolentino, who was not canonized until
1446, was one of the most popular saints of the order of
Augustinian hermits, which he entered in 1255. The
attribute he is holding is a white lily, a symbol of the
purity of his mind.

90 *Raphael and Tobias* (cf. ill. 62), 1464/65
Pillar
Apsidal chapel of Sant'Agostino, San Gimignano

The picture type of the archangel Raphael and Tobias first
appeared in the 15th century. The event depicts a parable
of God's mercy: Tobias, who was sent out on a journey by
his blinded father, is being protected and guided by the
archangel Raphael. When Tobias washes his feet in a river,
he is frightened by a large fish, which he catches and guts
on the advice of the angel. The innards prove to be a
medicine which he can use to restore his father's sight.

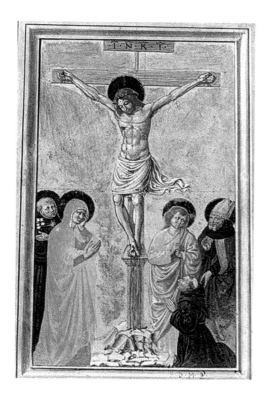

92 *St. Sebastien Intercessor* (detail ill. 91), 1464

On the small devotional picture of the *Crucifixion* on the lower frame of the fresco, the donor portrait of Domenico Strambi can be seen on the right. This is proven by his initials FDMP (Frater Dominicus Magister Parisinus).

91 (opposite) *St. Sebastian Intercessor*, 1464
Fresco, 523 x 248 cm
Nave of Sant'Agostino, San Gimignano

In contrast to iconographical tradition, St. Sebastian is dressed in this *Pestbild*, a painted prayer against the plague. The worship of this saint, who it was hoped would offer his protection against the infectious disease, reached new heights with the outbreak of the plague in the spring of 1464.

St. Nicholas of Tolentino (ill. 89) was one of the main representatives of the Augustinian hermit order, into which he was received in 1255.

The depiction of the archangel *Raphael and Tobias* (ill. 90) is a type of picture which did not appear until the 15th century. Raphael is leading little Tobias by the hand, who in turn is carrying a large fish. The event is drawn from the apocryphal book of Tobias and is a parable of God's mercy. Sent by his blinded father to relatives, the young Tobias meets the archangel on the way. The latter advises him to catch a fish and use the gallbladder, liver and heart as a medicine for his father's illness. The travels of the young Tobias and his guardian angel Raphael became one of the favorite themes of Italian art in the Quattrocento. The two are frequently also accompanied by a dog – as is the case in Benozzo's version of the theme. Other examples of the setting of the scene in a landscape can be found in the works of Botticelli (1444/45–1510) and Perugino (1448–1523).

The iconographical program of the cycle of St. Augustine is derived from a variety of sources. 11 scenes (1, 3, 4, 5, 6, 7, 8, 9, 10, 11, 13) are based on the "Confessions", and four of the scenes are also mentioned in the "Legenda Aurea" (3, 9, 10, 11). Two scenes (15, 17) are based solely on the "Legenda Aurea". Three (2, 12, 14) were drawn from a Latin program planned by the Augustinian hermit Jacques Legrande (1315–1415) for a cycle of 48 scenes that was never carried out. The cycle of St. Augustine is similar in many respects to the cycle of the same name of 26 pictures (1422–24) in Sant'Agostino in Gubbio by Ottaviano Nelli (ca. 1370–1444). All the themes are identical, with the exception of the visit to Mount Pisano, which is depicted here for the first time.

One additional note on the cycle of St. Augustine is that it was created after the frescoes for the Medici Chapel. When compared with the first cycle of wall paintings in Montefalco, the artist's palette had undergone a considerable change. The luminous quality of the colors had become distinctly more intense. This is particularly true of the red and blue in the garments and sky. Without the intermediary stage of the Medici Chapel, this development would be just as difficult to understand as Benozzo's increasing tendency to include narrative details. In addition, the architectural backdrops, definitely more clearly constructed, are structured more rationally and are more closely connected to the figures in the pictures. The final point concerns the way Benozzo depicted figures, for he was increasingly endeavoring to produce a more individual physiognomy.

The true content of the frescoes becomes obvious when one takes the historical situation at the time into account: Domenico Strambi, an acknowledged scholar on St. Augustine, was not able to carry out the reformation of the monastery in San Gimignano. Instead, he had the scholastic ideals and the faith that had been revived by the observants depicted in the form of wall paintings. The cycle shows both exhortation and instruction by means of the example of the venerable

father of the order, who had gained salvation through his faith and striving for religious insight. The theme of about half of the pictures is St. Augustine's quickness to learn and his ideals as seen by the observant movement. At the same time, Domenico Strambi's pictures convey goodwill towards the observants.

In conclusion one should mention the surviving sketches for the cycle of St. Augustine. They used to be owned by Vasari and are now in the Hessisches Landesmuseum in Darmstadt, Germany, and the Fogg Art Museum in Cambridge, Massachusetts in the United States. They are hasty sketches which outline the figural arrangement within the space without taking the architecture or details into account.

For the same church, Benozzo created a votive fresco showing *St. Sebastian Intercessor* (ill. 91) on the southern nave wall. This work was painted during the outbreak of the plague in 1464, as we are informed by the inscription on the saint's pedestal. This would mean that Benozzo interrupted the painting of the apsidal chapel in order to produce this picture. The outbreak of the plague caused a rapid increase in depictions of St. Sebastian where the saint is clad only in a loincloth and tied to a tree or column. Here he is standing dressed on a pedestal. God the Father, surrounded by angels holding arrows in their hands, appears above the saint's head. He is about to hurl the arrow he is holding at the world. Mary and Christ are kneeling before him as intercessors. Christ is pointing to the open wound on his side and Mary is baring her breast in order to remind God of their sacrifices for the Christians and move him to be lenient. The prayer of St. Sebastian is keeping off God's arrows which are breaking behind him, thus protecting the people crowded at his feet.

Benozzo painted another fresco with the same theme, the *Martyrdom of St. Sebastian* (ill. 93) on the inner entrance wall of the collegiate church of Santa Maria Assunta in San Gimignano. On this occasion the saint is depicted in accordance with the iconographical tradition of Italian art during the 15th century. The work was commissioned by the city government in February 1465, six months after the plague epidemic. St. Sebastian was an auxiliary saint, together with St. Roch and, since the 17th century, St. Charles Borromeo. More rarely St. Christopher, St. Anthony, the patron saints of physicians Cosmas and Damian, and St. Rosalia, St. Pirmin, St. Gregory the Great and St. Thecla were called on in times of plague.

During his stay in San Gimignano, Benozzo restored the fresco of the *Maestà* by Lippo Memmi (active during the first half of the 14th century) dating from 1317: the two outer figures and the inscriptions, which had been damaged by the building of two doors, were repainted. On the right inscription Benozzo immortalized his restoration work: BENOTIUS FLORENTINUS PICTOR RESTAURAVIT ANNO DOMINI 1467.

A fresco showing Christ on the Cross with St. Jerome and St. Francis kneeling beneath together with the donor – possibly the *podestà* of San Gimignano – was produced for the corridor in the Palazzo Comunale of San Gimignano. The fresco, which was taken down in

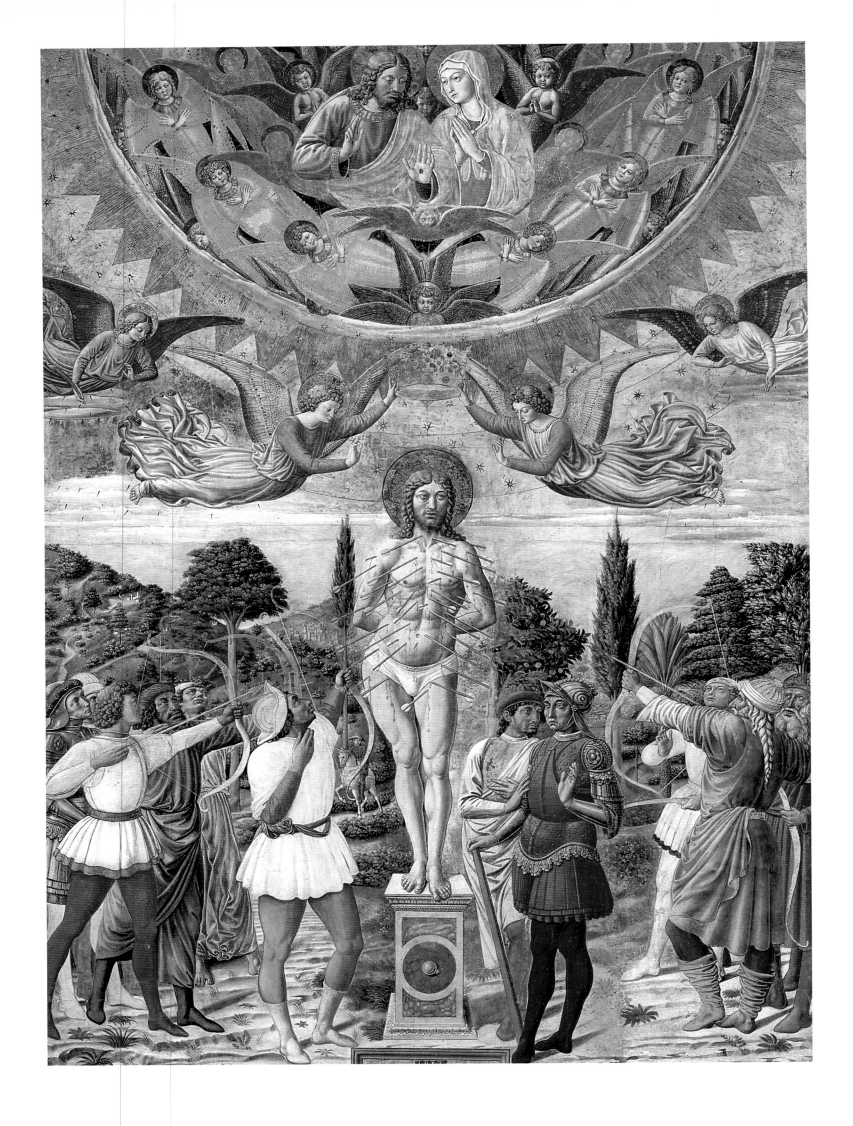

93 (opposite) *Martyrdom of St. Sebastian*, 1465
Fresco, 525 x 378 cm
Collegiata, Interior entrance wall, San Gimignano

On the second *Pestbild* Gozzoli depicts the martyrdom of
St. Sebastian using the traditional iconography of Italian
art during the 15th century. The saint provided artists
with an opportunity to depict a nude, which is why the
theme was particularly popular from the Renaissance
onwards. The arrows which his tormentors are pointing at
him symbolize a sudden illness (Psalms 7:13 ff.). The
similarity of a body transfixed with arrows and that of a
plague victim makes the choice of Sebastian as a plague
saint appear plausible.

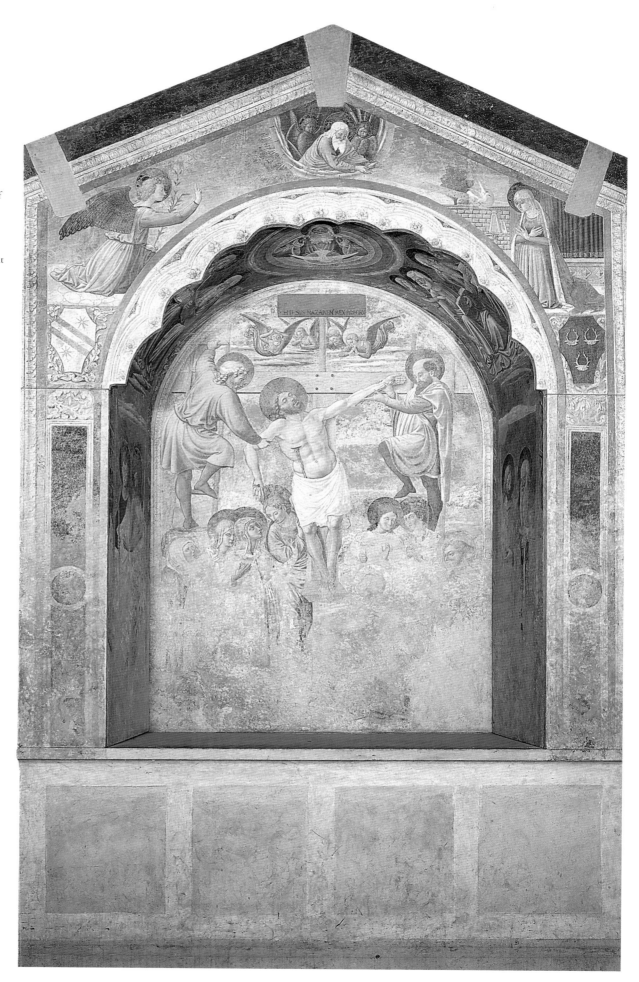

94 (right) *Tabernacle of the Condemned*, 1464/65
Frescoes transferred to canvas
Overall view, Palazzo Pretorio, Cappella san Tommaso,
Certaldo

The so-called tabernacle *dei Giustiziati* ("Condemned"), a
small building similar to a temple, was originally located
near the Agliena river at a place where those condemned
to death would be led past it. Its inner and outer walls are
decorated with scenes from the Passion of Christ and the
martyrs.

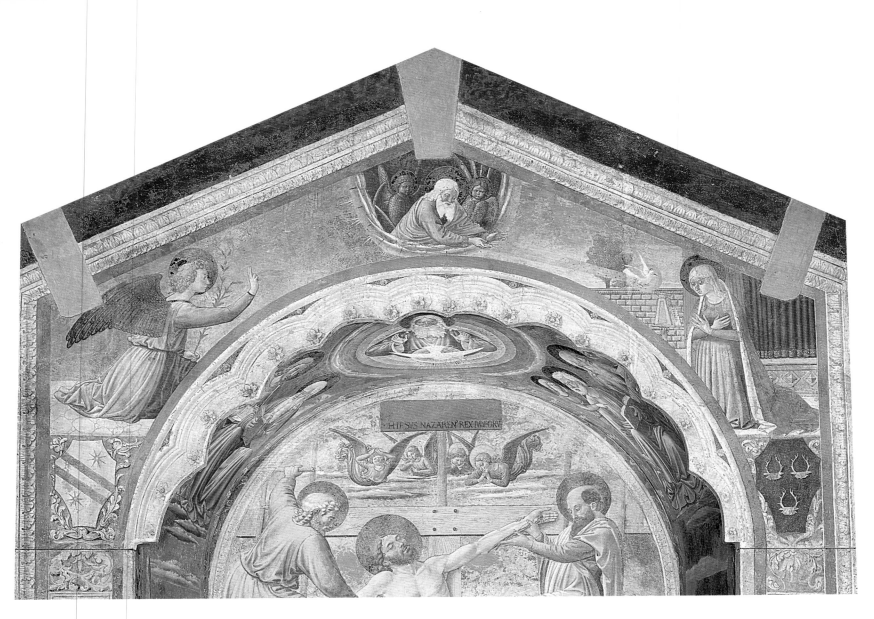

1893, is now in the town's Museo Civico. It is highly likely that Benozzo created it at the same time as restoring the *Maestà*.

Benozzo spent the years of 1464 and 1465 in Certaldo near to San Gimignano. There he created a tabernacle that used to stand close to the bridge over the River Agliena. People condemned to death were led past it, which gave it its name, "dei Giustiziati", the *Tabernacle of the Condemned*. In 1958 the frescoes (ills. 94–97) were taken down and displayed in the chapel of San Tommaso in the Palazzo Pretorio in Certaldo. The theme of the pictures is the sufferings of Christ and the martyrs. The outer face of the arch shows the *Annunciation* (ill. 95). The main wall of the tabernacle's interior depicts the *Descent from the Cross* (ill. 96). Joseph of Arimathea and Nicodemus are standing on ladders and taking the body of Christ down from the Cross. There is no sign on Christ's face of the torments he has suffered. Only the open wound on his side, from which blood is still flowing, reminds us of his Passion. The scene is witnessed by some apostles, St. Mary Magdalene and the Mother of God. Due to the fact that the tabernacle was open to the elements, this picture has been severely damaged. In the vault God the Father and the Holy Spirit appear between the Evangelists Luke and John (ill. 97) on the left and Matthew and Mark on the right.

On either side of the fresco on the damaged interior walls are the figures of two saints.

A panel painting dating from his stay in San Gimignano depicts the *Madonna and Child between St. Andrew and St. Prosper* (ill. 98). The statue-like, balanced composition is broken up by the cross of St. Andrew, which is standing diagonally to the ground. Benozzo completed the painting on 28 August 1466, as we are informed by the signature and date on the picture. A second inscription names the client, the priest "Hyeronimus Nicolai". The altar painting is now kept in the town's Museo Civico.

For Pisa Cathedral Benozzo painted the panel painting of the *Triumph of St. Thomas Aquinas* (ill. 99), which according to Vasari was originally located behind the archbishop's throne. It was requisitioned during the occupation by Napoleon and since 1812 has been owned by the Louvre. Vasari stated that the pope depicted was Sixtus IV (1471–1484), for which reason the painting cannot date from before 9 August 1471, the date on which he was elected pope.

In the upper, rounded picture field Christ appears in glory between St. Paul, Moses and the Evangelists. Beneath him St. Thomas Aquinas (1225–1274) is enthroned, holding three open books on his lap. He is holding a fourth out towards the observer so that one can

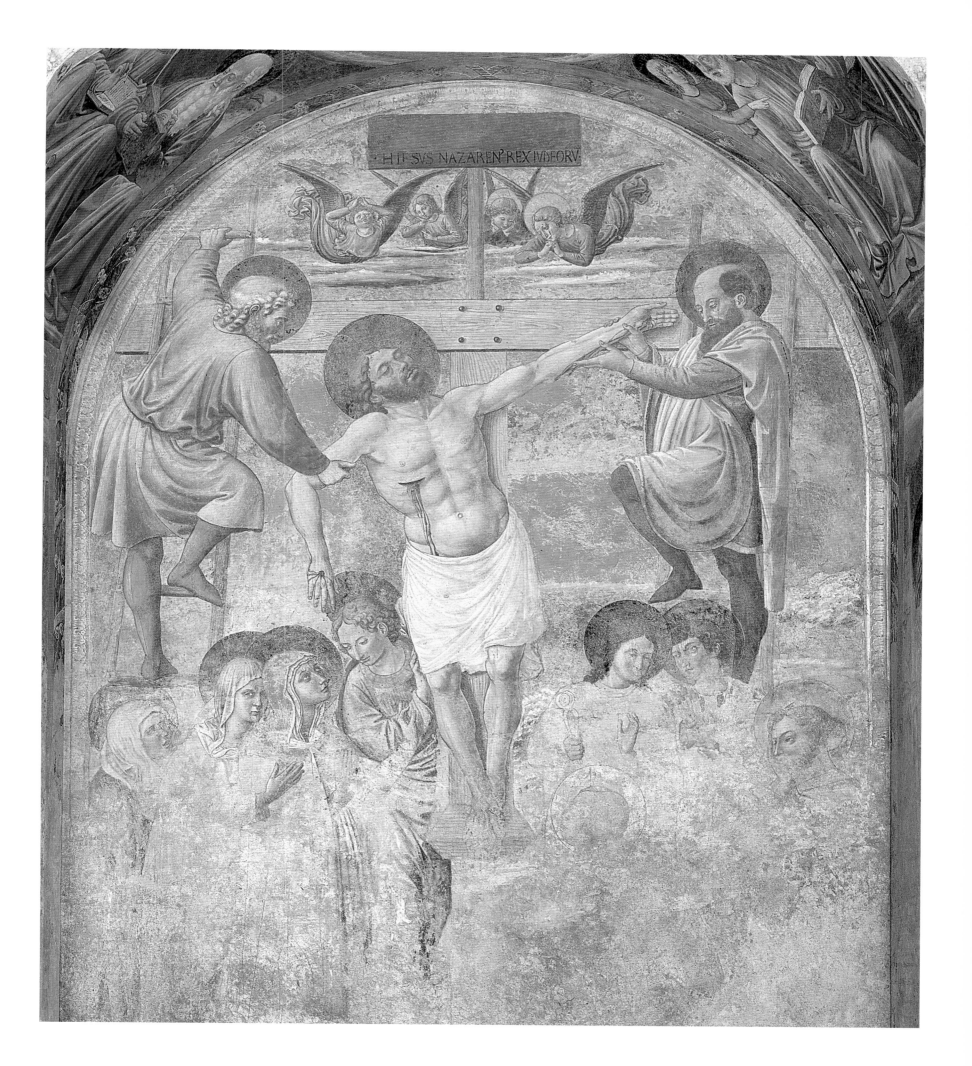

97 *The Evangelists Luke and John* (detail ill. 94), 1464/65
Vault

The two Evangelists, identified by their attributes
(St. Luke with the ox and St. John with the eagle), are
absorbed in writing and reading the Gospels. By means of
the well planned change from primary to complementary
colors Gozzoli was able to give the picture a warm mood
with respect to its colors.

read its words, the incomplete first sentence of the
"Summa Contra Gentiles", a missionary handbook
whose theme is the dialogue with the pagans. Amongst
other things it describes Averroes (1126–1198) as
corrupting the writings of Aristotle. Averroes was an
Arabic philosopher and theologian who wrote com-
mentaries on the ancient Greek philosopher's works. He
taught about the eternity of the world and the unity of
God, a contradiction of the Christian teachings about the
Trinity. Hence, Averroes is depicted in the picture lying
at the feet of St. Thomas, who has proved him wrong in
his writings. Benozzo was familiar with the quotation
from the "Summa Contra Gentiles", as it is already
written on the book carried by St. Thomas Aquinas in his
depiction in the Chapel of Pope Nicholas in Rome.

Aristotle, on the left, and Plato, whose body of
thought St. Thomas Aquinas combined with Christian
teachings, are standing on either side of the enthroned
St. Thomas. The lower part of the picture shows the
pope surrounded by bishops, cardinals and monks of
various orders.

The composition is derived from a prototype of this
depiction created by Lippo Memmi with the assistance
of Francesco Traini (active between 1321 and 1345).
The large panel painting (375 x 258 cm) in the church
of Santa Caterina in Pisa, which was produced in about
1323, probably on the occasion of St. Thomas Aquinas'
canonization, would certainly have been known by
Benozzo, who produced two panel paintings for this
church. Even without this stimulus it is impressive how
Benozzo used the composition of his figures alone to
create clear spatial sizes and relationships. St. Paul and
Moses should be mentioned in the upper field. By
means of differences in body postures and arrangement

96

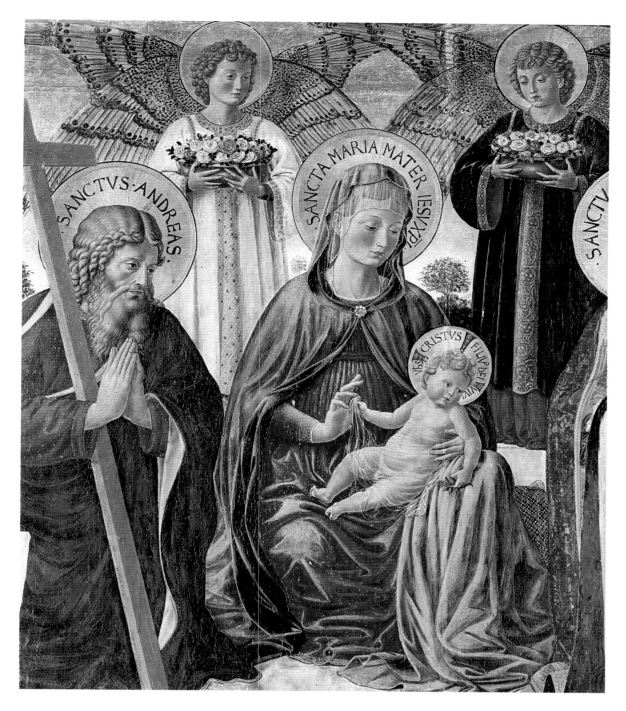

98 Detail of *Madonna and Child between St. Andrew and St. Prosper*, 1466
Tempera on panel, 137 x 138 cm
Museo Civico, San Gimignano

A wooden Latin cross is leaning against the shoulder of the praying St. Andrew. The attribute of the *crux hastata*, which was widespread in Italian painting into the 15th century, was used as a triumphal cross in contrast to the cross of St. Andrew (*crux decussata*) or Saltire, which was X-shaped and used as a symbol of the saint's martyrdom.

of figures, Gozzoli leads us up to the gloriole in two rising rows. In the central field the view in which Averroes is presented to us is a surprise. He is lying on his stomach at the feet of St. Thomas Aquinas. This unusual aspect forced the artist to make elaborate foreshortenings. At the front edge of the picture, in the lowest part of the picture, two figures seen from behind are sitting. They connect on the right with the group gathered about the pope.

In about 1473 Benozzo created the *Procession of the Magi* (ill. 100) in a niche in the small oratory that lies to the left of the northern side of the entrance to the cathedral in Volterra. The fresco was used as a background picture for a terracotta group of the *Adoration* produced by the della Robbia workshop. The Three Kings are riding without a lavish retinue.

In 1484 the *Tabernacle of the Madonna delle Tosse*

(ill. 101) was created, and it originally stood on the road between Castelfiorentino and Castelnuovo Val d'Elsa. In addition to the date of origin, an inscription names the prior of the monastery of Castelnuovo as the client who had it built in December 1484 in honor of the Virgin. In 1853 a Neo-Gothic chapel was built around the tabernacle in order to transform it into an oratory. Together with the tabernacle *della Visitazione*, the "Visitation", it was put on display in 1987 in the library in Castelfiorentino following a restoration.

The focal point of the *Madonna delle Tosse* is formed by a wall fresco which creates the illusion of a lavishly framed altar painting with a predella. In order to support this impression, Benozzo painted a small pointed picture on the lower frame showing the face of Christ, just as if it had been added at a later stage in the manner of a votive picture. The altar painting (ill. 102) depicts the *Maria*

99 (left) *Triumph of St. Thomas Aquinas*, 1471
Tempera on panel, 230 x 102 cm
Musée du Louvre, Paris

The inscription beneath the glory containing Christ expresses
his agreement with the theological writings of St. Thomas
Aquinas: BENE SCIPSISTI DE ME, THOMMA ("You have
written well about me, Thomas"). The saint is enthroned in the
center between Aristotle and Plato. At his feet lies the Arabic
scholar Averroes, whose writings he refuted. In the lower part of
the picture a group of clergymen can be seen on either side of
the pope, who according to Vasari is Sixtus IV.

100 (opposite) *Procession of the Magi*, 1473
Fresco
Duomo, Volterra

The fresco in a niche in the small oratory once formed the
backdrop for a representation of the birth of Christ produced by
the della Robbia workshop. The composition can be explained
by the original arrangement: the procession of the Three Kings,
who are here riding side by side without an elaborate retinue, is
moving away from this terracotta group. Today the original
Adoration group is located in a different niche.

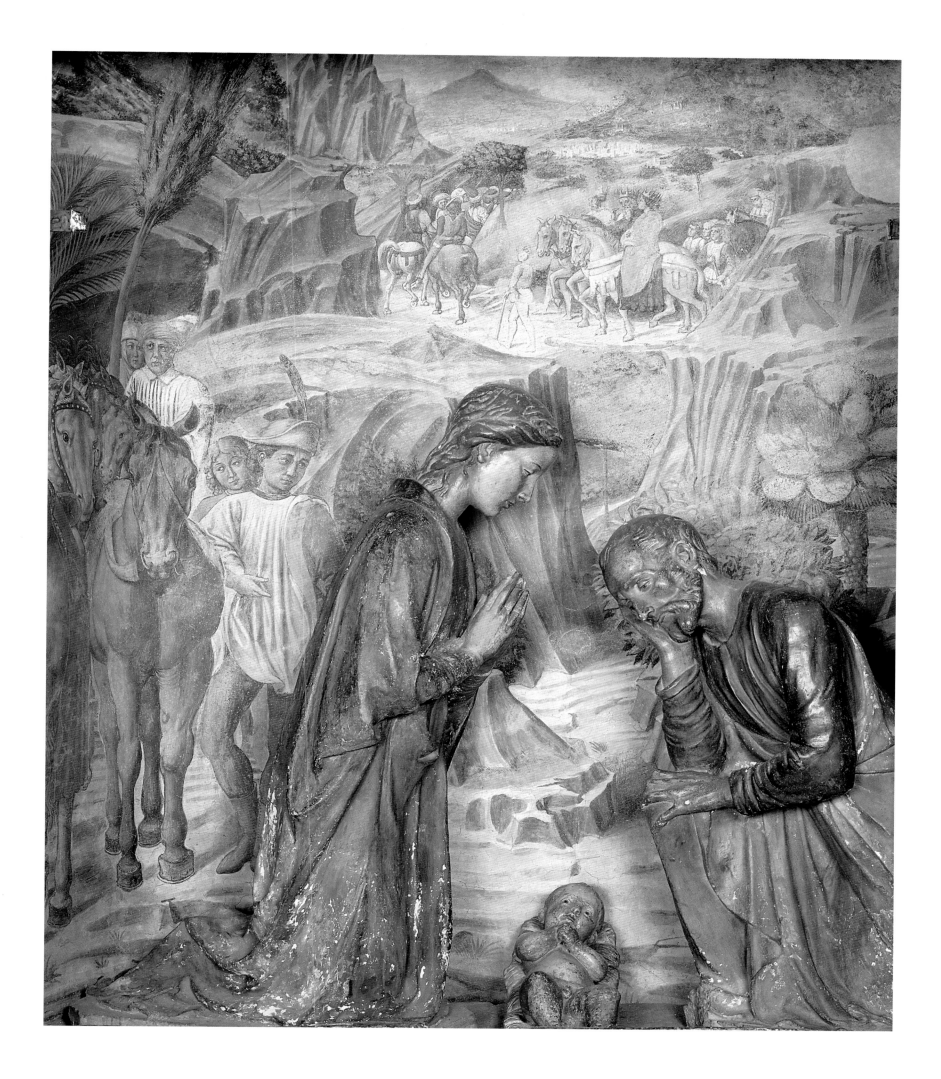

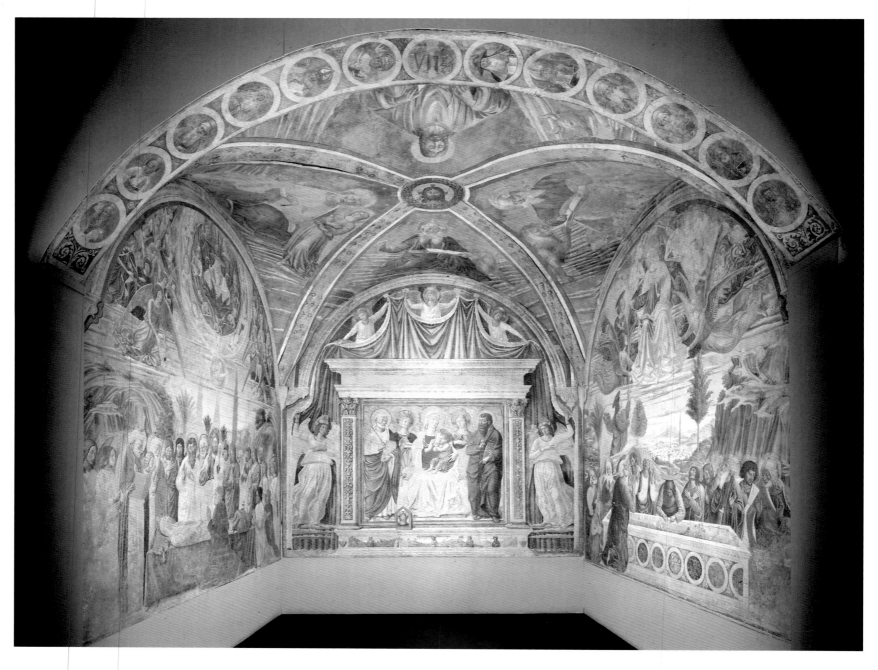

101 Overall view of the *Tabernacle of the Madonna delle Tosse*, 1484
Transferred frescoes
Biblioteca Comunale, Castelfiorentino

The tabernacle, whose paintings were taken down in 1987, restored and mounted on a wall in the town library, depicts the *Maria lactans* in the centre surrounded by saints, with the *Death of Mary* on the left and the *Assumption of the Virgin* on the right side walls.

lactans, Mary feeding her child. The curtain held by angels increases the impression of a real altar panel painting. This artistic staging, which makes use of several levels of reality, undoubtedly marks the high point amongst all the skillful effects that Benozzo made use of in his works. In the four cells of the groin vault the *Four Evangelists* can be seen, with the *Face of Christ raising His Hand in Blessing* (ill. 103) on the vault boss.

The left wall of the tabernacle shows the *Death of Mary*, with the *Assumption of the Virgin* and *Mary lowering her Girdle* on the right. In the scene on the left (ill. 104), a narrow strip of landscape above the mourners divides the earthly from the heavenly sphere in the upper third of the picture. Here God the Father appears in a glory of angels, beneath which the dove of the Holy Spirit is hovering.

In the foreground of the *Assumption of the Virgin* (ill. 105) is an empty sarcophagus in the classical style, decorated with sections of marble in various colors. The apostles are gazing in astonishment into the empty coffin and up to heaven (ill. 106). Amongst the apostles

two in particular stand out, for their faces are painted in an extreme foreshortening. Such a figural construction is reminiscent of Gozzoli's contemporary, Andrea del Castagno (1421–1457), with whose fresco of the *Holy Trinity* (ill. 107), in the church of Santissima Annunziata in Florence, he would surely have been familiar. Here too the so-called *scorci*, the term given to foreshortening in Renaissance art theory, can be found.

The development of central perspective represented the scientific and theoretical side, its application the practical one. The chosen degree of complexity displayed the skill and ability of an artist to produce a perspectival depiction. In his apostle faces, Benozzo demonstrated that he had a masterly understanding of the technique. Corresponding to the opposite wall painting, heaven and earth are here also separated by a narrow strip of landscape. The Mother of God is enthroned, surrounded by angels, opposite God the Father and the Holy Spirit.

The second tabernacle *della Visitazione*, which is now

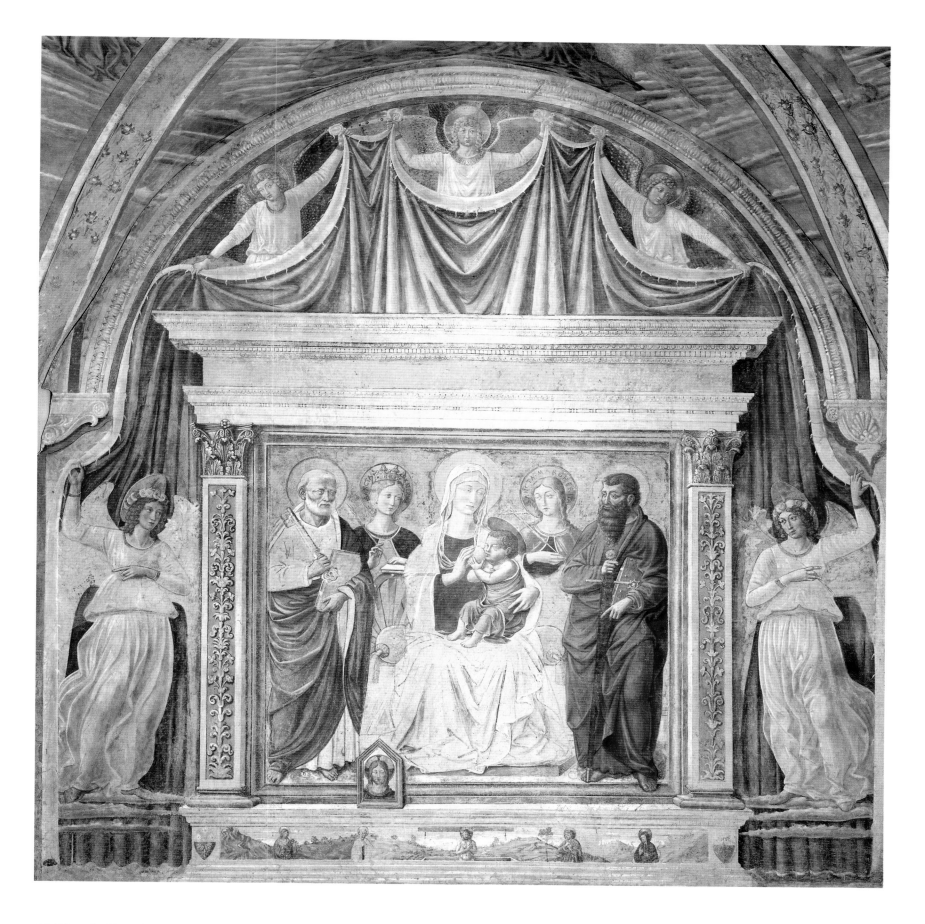

102 *Tabernacle of the Madonna delle Tosse:* Maria lactans (cf. ill. 101), 1484

In the centre of the tabernacle the image of *Maria lactans*, the Madonna breastfeeding the Child, is depicted. This type of Madonna was common from the late Middle Ages onwards. She is surrounded by St. Peter with the keys and a book, St. Catherine with a broken wheel, St. Margaret with a cross and St. Paul with a sword and book. In order to create the impression of a real altarpiece, several angels are holding a gathered curtain around the altar painting. At the bottom edge of the picture, as if placed there quite by chance, Benozzo has painted a small pointed panel painting showing the face of Christ.

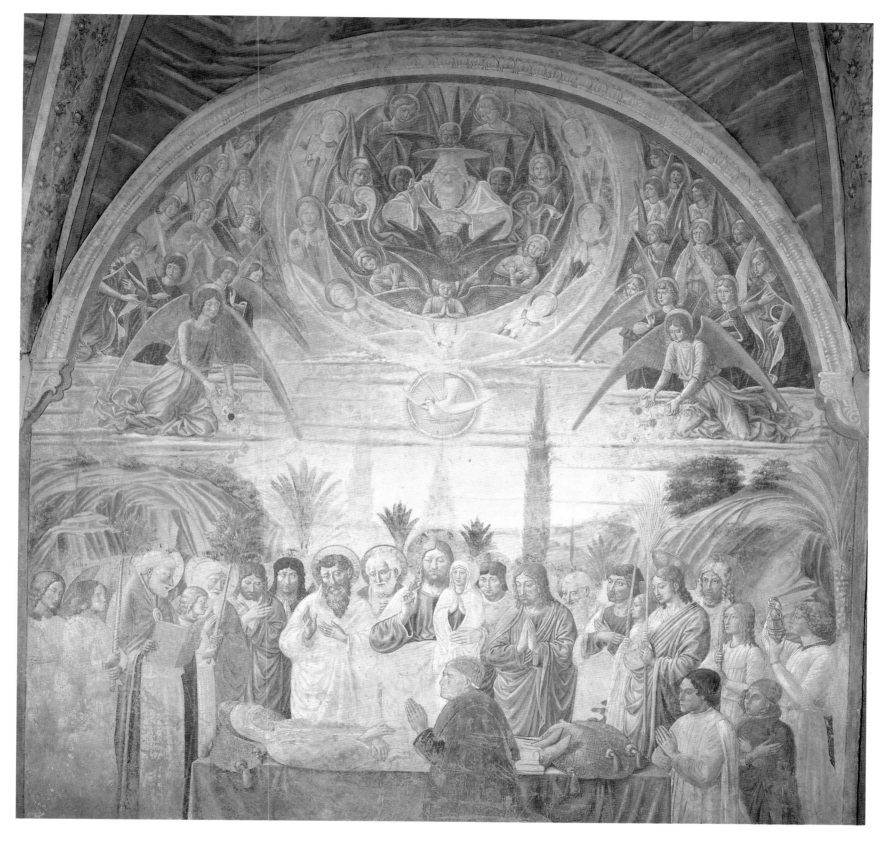

103 (opposite) *Tabernacle of the Madonna delle Tosse:*
four Evangelists (cf ill. 101), 1484

The vault shows the four Evangelists writing or reading
the Gospels. The vault boss is decorated with a picture of
Christ giving his blessing.

104 (above) *Tabernacle of the Madonna delle Tosse:* death of Mary
(cf. ill. 101), 1484

The Madonna is laid out on a catafalque behind which the
mourners are lined up. In the centre Christ is holding the soul of
the dead Mary in his arms. The donor and two young men –
probably relatives of the client – are kneeling in front of the death
bed. Above the mourners a narrow zone of landscape divides the
earthly from the heavenly sphere containing God the Father in a
glory of angels.

105 *Tabernacle of the Madonna delle Tosse:* Assumption of the Virgin (cf. ill. 101), 1484

The composition of the opposite wall painting precisely repeats the construction of the first scene: the catafalque and the empty sarcophagus correspond to each other, as do the strip of landscape used to separate the earthly and heavenly spheres, and God the Father and the Madonna being carried up to heaven by angels. As on an earlier altarpiece (ill. 9), Gozzoli has also combined the Assumption of the Virgin with a depiction of Mary lowering her Girdle.

106 (below) *Assumption of the Virgin* (detail ill. 105), 1484

The mourning apostles are looking either into the empty coffin or up towards heaven. Noticeable features include the haloes painted in perspective and the faces painted as viewed from below.

107 Andrea del Castagno
Holy Trinity, ca. 1455
Fresco, 300 x 179 cm
Santissima Annunziata, Florence

In the center St. Jerome is standing as an atoning
penitent. With his head slightly back and his eyes gazing
upwards, the vision of the Holy Trinity has revealed itself
to him. The lion, his attribute, can also see the vision.
The bold foreshortening which Castagno used to depict
God the Father and Christ clearly posed him some
difficulties. The artist later covered the body of Christ
with red cherubs. As he made this alteration *al secco*, the
paint flaked off during the course of the years, so that we
can now see more of the original, failed depiction than
Castagno actually intended.

108 Detail of *Tabernacle of the Visitation:*
Annunciation: the archangel Gabriel, 1491
Transferred fresco
Biblioteca Comunale, Castelfiorentino

The angel of the Annunciation is kneeling in front of
the buildings of a town and pointing upwards where
God the Father is sending out the Holy Spirit. The lily
in his left hand is the symbol of the virginity and
purity of Mary.

109 Detail of *Tabernacle of the Visitation:* Annunciation:
Mary, 1491
Transferred fresco
Biblioteca Comunale, Castelfiorentino

The paintings on this tabernacle, which originally stood
near to the convent of Santa Maria belonging to the nuns
of St. Clare, were taken down because of the severe
weathering. For example, the area above the arch's outer
face has been almost entirely destroyed. We can still see
the angel and Mary in the *Annunciation*. The Mother of
God is standing opposite the angel of the Annunciation
before a golden curtain, her eyes lowered.

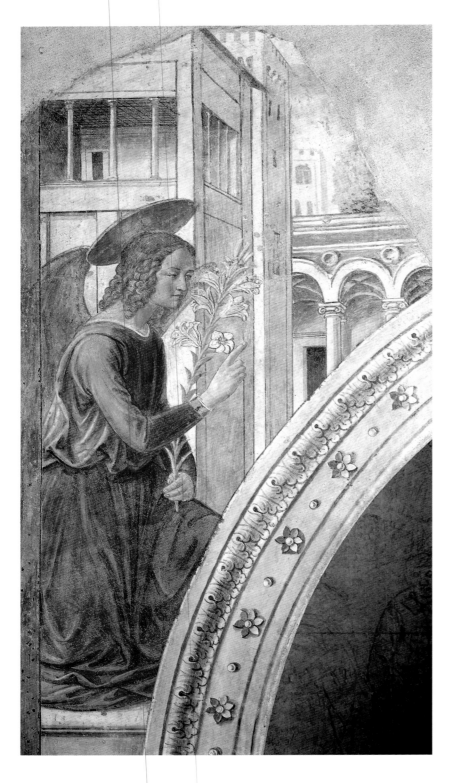

on display in the library in Castelfiorentino, used to be located near to the convent of Santa Maria belonging to the nuns of St. Clare on the Via Volterrana. It shows the meeting of Mary and her cousin Elizabeth, the mother of John the Baptist. From the 13th and 14th centuries onwards, when the feast day of the Visitation was introduced in 1263 by St. Bonaventure, the number of depictions of the subject increased.

In 1872 a chapel was built around the tabernacle, which was painted on both sides, in order to protect it from the elements that had already severely damaged it. The heavily damaged outer arch face shows the *Annunciation* (ills. 108, 109), and the intrados depicts *Christ with His Hand raised in Blessing*. The exterior walls are covered with scenes from the life of Joachim, Anne and Mary, some of which have been almost entirely destroyed. One that has survived is the *Expulsion of Joachim from the Temple* (ill. 110). In a rather statue-like picture, Benozzo draws our attention to Joachim,

who because he has no children is being expelled by the priest. As a result of his expulsion from the temple, Joachim withdrew to lead a life of seclusion with shepherds and pray. There he received the *Annunciation to Joachim* (ill. 111) by an angel of the birth of his daughter Mary who would later be the mother of Jesus of Nazareth. In the *Meeting at the Golden Gate* (ills. 112, 113) Anne, at the command of an angel, is waiting for Joachim at the Golden Gate. His story is only mentioned in the Apocrypha – the "Evangelium de nativitate Mariae" ("Gospel of the Nativity of Mary") and the Protoevangelium of James. The last surviving fresco depicts the *Birth of Mary* (ill. 114). A document dating from 1632 cites the lost inscription, according to which Benozzo of Florence and his sons Francesco and Alesso produced the frescoes in 1491. In the *Birth of Mary* and *Expulsion of Joachim from the Temple*, the collaboration of his sons is equally evident. Benozzo concluded his extensive work in the Elsa valley with this tabernacle.

110 Detail of *Tabernacle of the Visitation:* Expulsion of Joachim from the Temple, 1491
Transferred fresco
Biblioteca Comunale, Castelfiorentino

The exterior walls depict scenes from the lives of Joachim, Anne and Mary, but only sections have survived. Here the priest standing in the center of the picture behind the altar is pushing Joachim away from the tabernacle with both hands, for the latter's sacrifices have been rejected by the priests as he has remained childless. A striking feature is formed by the colorful slabs of marble on the altar which, like those in the *Assumption of the Virgin* (ill. 105), are reminiscent of the socle decorations in the Medici Chapel.

111 Detail of *Tabernacle of the Visitation:* Annunciation
to Joachim, 1491
Transferred fresco
Biblioteca Comunale, Castelfiorentino

In the badly damaged fresco Joachim is sitting in front of
a grotto and gazing at the angel making the annunciation.
The latter prophesies the birth of his daughter Mary to
him and instructs him to meet Anne at the Golden Gate
in Jerusalem.

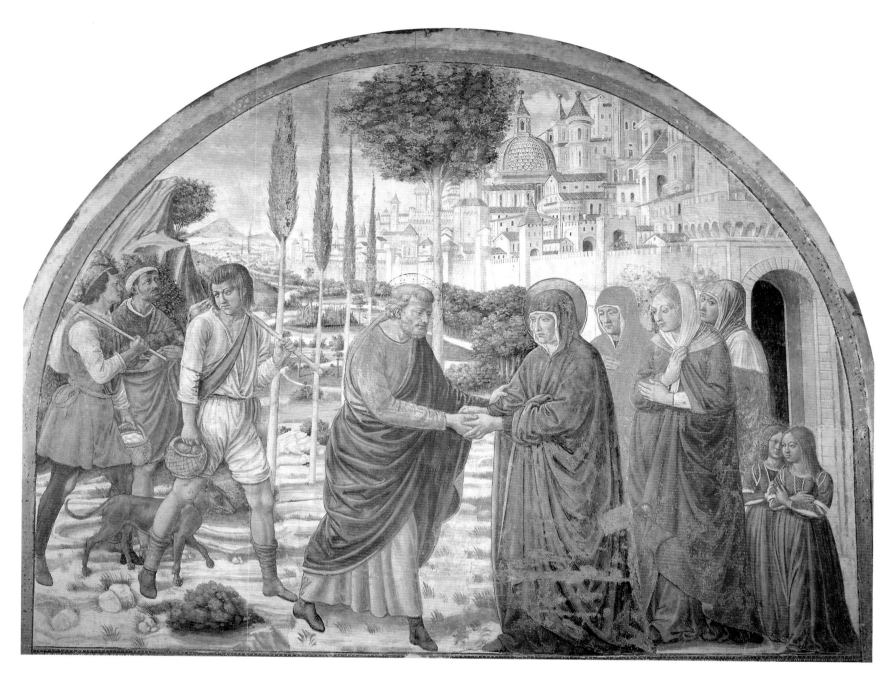

112 (above) Detail of *Tabernacle of the Visitation:*
Meeting at the Golden Gate, 1491
Transferred fresco
Biblioteca Comunale, Castelfiorentino

The meeting at the Golden Gate takes place before the
backdrop of a contemporary cityscape. Gozzoli has
highlighted the two main figures in the center of the
picture by means of the contrast between the group of
women quietly standing near to Anne and the group of
men in motion behind Joachim.

113 (right) Detail of *Tabernacle of the Visitation:*
Meeting at the Golden Gate, 1491
Transferred sinopia
Biblioteca Comunale, Castelfiorentino

The sinopia clearly shows the arrangement of the figures
in the space, which the fresco follows without any
changes. While the sinopias were produced by Gozzoli
alone, his sons and assistants helped him produce the
paintings.

109

BENOZZO'S LATE WORK

Gozollo spent the last years of his life in Pisa, where he was commissioned in 1469 to carry out a major cycle of frescoes for the Camposanto comprising 26 pictures from the Old Testament, and on which he was to work for 16 years. The order in which they were created can be reconstructed from entries in the account books: first of all he painted the *Vintage and Drunkenness of Noah,* then the *Building of the Tower of Babel* and the *Adoration of the Magi.* He was paid for these works in 1471. In 1472 and 1473 this was followed by payment for *Abraham and the Priests of Baal,* the *Departure of Abraham and Lot,* the *Victory of Abraham* and *Abraham and Hagar.* In the following year the *Burning of Sodom,* the *Sacrifice of Isaac,* the *Wedding of Isaac and Rebecca,* the *Birth of Esau and Jacob,* the *Wedding of Jacob* and the *Meeting of Jacob and Esau* were created. In 1478 Benozzo was paid for two further frescoes showing the *Story of Joseph.* One year later he started work on *Moses' Youth,* in 1480 on *Moses and the Tables of the Law* and the *Dance around the Golden Calf,* and in 1481 on the *Punishment of Korah*; in 1482 *Aaron's Rod* and *The Serpent of Bronze* were produced. In 1485 the final bill for the work was produced. At that point Benozzo had created a further three frescoes for which he was paid the amount for four: they were the *Battle by the Jordan,* the *Death of Aaron and Moses, the Fall of Jericho and David and Goliath,* and the *Meeting of Solomon and the Queen of Sheba.* The frescoes were almost entirely destroyed as the result of a bomb attack in 1944, which caused a great fire in the Camposanto. The undamaged sections were taken off the walls, and during the process parts of the sinopias became visible. During the same creative period Benozzo stayed in Legoli in the province of Pisa, where he had fled in 1478/79 because of the plague. There he created a tabernacle, of which fragments remain today. The main picture depicts the *Madonna and Child and four Saints,* while other scenes show the *Crucifixion, Annunciation, Doubting Thomas,* the *Archangel Michael, Christ Carrying the Cross* and the *Martyrdom of St. Sebastian.* The frescoes are carried out in a coarser painting technique and express religious pathos in an easily comprehensible narrative style.

The painting of the *Madonna and Child Enthroned among St. Benedict, St. Scholastica, St. Ursula and St. John Gualberto* (ill. 115) dates from the 1490s and is now on display in the Museo Nazionale di San Matteo in Pisa. According to Vasari, Benozzo painted it for the nuns of the convent of San Benedetto a Ripa d'Arno, who belonged to the Vallombrosan order of nuns. The Vallombrosans were founded in 1038/39 by St. John Gualberto, who lived according to the rule of St. Benedict in seclusion in Tuscany. The Vallombrosan order of nuns were founded by Bertha of Bari (died 1163), and were at their peak in the late 13th and early 14th centuries with St. Humilitas (died 1310). The last Vallombrosan convent was closed in 1869.

The enthroned Madonna is flanked on the left by St. Scholastica and St. Ursula and on the right by St. Benedict and St. John Gualberto, who are named by inscriptions in their haloes. St. Scholastica, born in about 480, lived in a monastery close to Montecassino and from there visited her brother, St. Benedict, once a year. St. Ursula, who died in about 304 in Cologne, is standing opposite her. Her attribute, the arrow, is a reference to her martyrdom.

The decorative scene at the beginning of an antiphonary belonging to the Franciscan convent of Giaccherino in Pistoia (Library, ms. VI, FF) was unfinished and exists as a preliminary drawing dated 1497. It shows the *Dream of Innocent III* and the composition of the picture is reminiscent of the picture with the same name in Montefalco. However, in this scene the church is already collapsing.

During this last creative period of his life, Benozzo also produced two oil paintings: the *Descent from the Cross* (ill. 116), now owned by the Museo Horne in Florence, and the *Raising of Lazarus,* now in the Widener Collection in the Washington National Gallery of Art. Gozzoli painted both pictures for Bishop Pandolfini for the bishop's residence in Pistoia. The technique of oil painting did not begin to spread throughout Italy, coming from Flanders via Naples, until the 1460s and 1470s. The most significant difference between oil and tempera painting lies in the richness and depth of the colors. To begin with, wooden panels continued to be used, but in the 15th century Hugo van der Goes (between 1430/40–1482) was

115 *Madonna and Child Enthroned among St. Benedict,*
St. Scholastica, St. Ursula and St. John Gualberto, 1490s
Tempera on panel, 153 x 133 cm
Museo Nazionale di San Matteo, Pisa

The panel painting that was originally produced for a Vallombrosan
monastery unites the order's saints: on the left of the Madonna St.
Benedict is depicted, the author of the rule according to which the
Vallombrosans lived, and on her right is St. John Gualberto, the
founder of the order. The picture is completed by two female saints:
St. Scholastica, the sister of St. Benedict, and St. Ursula, the virgin
martyr. The illustration shows the panel during restoration work.

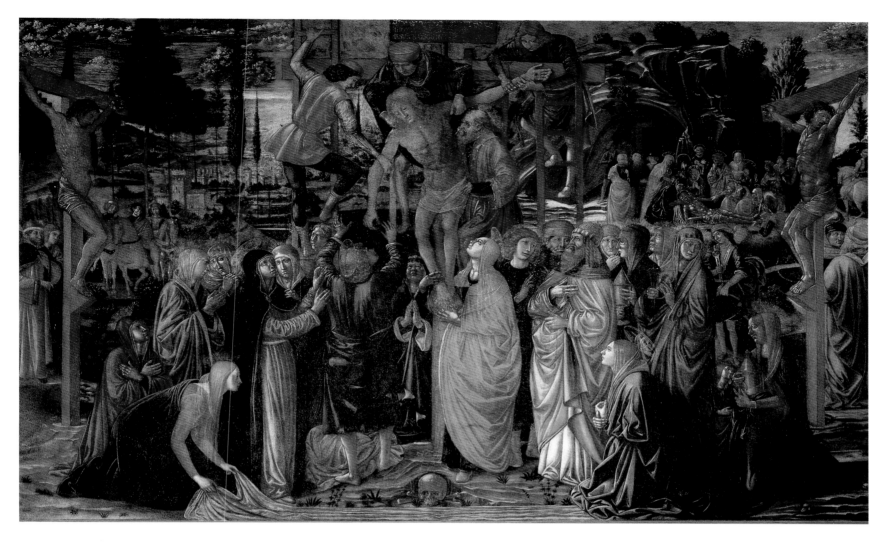

already using canvas and this had become the accepted medium by the 17th century.

In the foreground of the prestigious format, which measures approximately two by three meters, the *Descent from the Cross* is depicted in a balanced arrangement of figures. A conspicuous feature is Benozzo's omission of any form of decorative addition. As the composition of the foreground is determined by the clear geometrical form of a triangle, the asymmetry in the background is particularly noticeable. On the left one can see out onto an extensive landscape, while on the right the tomb in the rock is visible, in front of which a group of mourners is gathered about the dead Christ.

The *Descent from the Cross* already represents the religious clarity and omission of secular decorations demanded by Savonarola. What appears, in a strict interpretation of the biblical subject matter, is a religious drama without any display of magnificence. It is possible that Benozzo had heard the preaching of Savonarola in the church of Santa Caterina in Pisa. Many of Benozzo's contemporaries, including artists such as Botticelli, found a new intensity of religious feeling because of Savonarola.

Benozzo Gozzoli died in 1497. From a document we know that he died on 4 October of that year. He was buried in the monastery of San Domenico in Pistoia.

While Benozzo Gozzoli's early works were still marked by the style of his teacher Fra Angelico, he already showed his artistic independence in his very first commissioned work, the cycle of St. Francis in Montefalco.

In the Medicis' private chapel, Benozzo fell back on stylistic means which were already outdated but corresponded to the taste and requirements of his client.

Benozzo's epic style culminated in the extensive cycle of frescoes in San Gimignano. Here he embellished the saint's legend with genre motifs such as the punishment of a pupil in the *School of Tagaste*. In addition, Gozzoli also proved his abilities in the use of perspective in this cycle. Without doubt the innovative system of framing the frescoes, a direct anticipation of the loggia-like constructions in Domenico Ghirlandaio's works, must be emphasized as his achievement.

In contrast to the innovative style of Masaccio (1401–1428), Benozzo Gozzoli was certainly not one of those artists who made a major contribution to the theoretical development of perspective, the study of proportions, and the painting of light and air. While Masaccio's pictures distinguished themselves by a unified spatial perspective, a precise anatomical recording of figures and a psychological feeling for the representation of various frames of mind, Benozzo fascinates us by his naturalistic portraits, his genre-like naturalistic narrative style and the decorative wealth of his pictures.

116 *Descent from the Cross*, 1491
Oil on canvas, 180 x 300 cm
Museo Horne, Florence

This picture reflects the influence of the Dominican monk Savonarola, who demanded religious clarity without secular ornamentation. The strict interpretation of the biblical subject matter made it completely impossible to produce a display of magnificence such as in the Medicis' private chapel. In the scene, which contains many figures, the open view into the background and the gestures of Mary and St. John the Evangelist guide us compositonally towards the central theme of the *Descent from the Cross*. In the background on the right, the dead body of Christ is lying in front of the tomb in the rock, surrounded by a group of mourners.

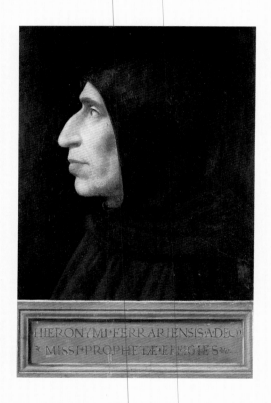

117 Fra Bartolomeo (1472–1517)
Portrait of Savonarola, end of the 15th century
Panel painting
San Marco, Florence

The Dominican monk Savonarola, who preached the godliness of poverty and condemned injustice and immorality, directed his criticisms primarily against the powerful Medici family. This portrait of Savonarola was painted during his lifetime by Fra Bartolomeo, who became a monk as a result of the impression Savonarola's sermons made on him. Today the picture hangs in cells 12–14, which are interconnected and were once used by the prior. They are now used as a place of remembrance for Savonarola.

Girolamo Savonarola (ill. 117) was born in 1452 in Ferrara and went to Bologna in 1472, where he entered the Dominican order. In 1482 he was sent to the monastery of San Marco in Florence. There he at first preached, without result, in the Medicis' family church of San Lorenzo. Savonarola interpreted his lack of success as a symptom of the decline in moral standards in Florence. After a period in Ferrara, where he was shown the art of preaching, he returned to the monastery of San Marco as a lector in 1490. The Florence of the era was shaped by the Medicis. Lorenzo de' Medici (1449–1492), also known as "the Magnificent", founded a carnival which was always celebrated on the first of May and which was a large fancy dress party with classical gods, nymphs and demons, for which the best artists of the period designed costumes. Savonarola later abolished this carnival. By 1491 he had already been promoted to being the monastery's prior. He first preached in the cathedral during Lent, 1491. His sermons fiercely condemned the general decline in moral standards and prophesied God's imminent judgment. He also, however, spoke out against the tyrannical rule of Lorenzo and announced his imminent end. One year later Lorenzo died and his son Piero, after a short hapless reign from 1492 to 1494, was driven from the city. By this time Savonarola was already so powerful that he took over important political tasks after the expulsion of Piero. He belonged to a group opposing those who wanted to restore the Medicis to power. The main points of argument in internal politics were the debate about tax reforms and the high cost of food caused by two crop failures. Together with the middle classes, whom the Medicis had deprived of their rights, Savonarola drew up a new constitution. Politics were to be subordinate to religion. To begin with, Pope Alexander VI did not interfere, but on 16 October 1495 he issued a brief forbidding Savonarola to preach, as he had prevented Florence from joining the Holy League.

From the High Middle Ages, the Established Church repeatedly burnt books that it felt to be heretical. This tradition was revived in the 15th century, principally by preachers of repentance. For example, Bernardine of Siena had bonfires lit during Lent 1424 on the Piazza Santa Croce in Florence and in July of the same year on the Capitol in Rome. These so-called autos-da-fé were primarily directed at luxury goods. Savonarola also had a political intention. On 7 February 1497 and 17 February 1498 he initiated the "Bonfire of the Vanities" on the Piazza della Signoria. These autos-da-fé were encouraged by two Signorias who ruled

the city for a short period and favored Savonarola. According to Savonarola's conception, children embodied godfearing purity, in contrast to the depraved world that enjoyed the pleasures of life. For this reason they were particularly well suited to the task of guardian of public morals. That is why Savonarola founded a "children's police force", which he sent out into the streets of the city to demand that the inhabitants should give up disreputable writings, pagan statues and sinful pictures. A wooden pyramid was built and the objects were arranged along the outside according to the degree of their shamefulness. At the bottom, wigs, carnival costumes and masks were moral references to the carnival that Lorenzo introduced. On the next level were classical, humanist and astrological books, including ones by Petrarch and Boccaccio. Jewelry and toiletries were next, representing the despised attention to physical appearance. Musical instruments as well as games and gaming tables embodied the transitoriness of human vanities. On the top level, finally, were paintings, nude statues and luxury items with erotic motifs.

On 13 May 1497, shortly after the first *bruciamenti*, Savonarola was excommunicated by the pope. Despite this, he started preaching again just over six months later, on 11 February 1498. The second "Bonfire of the Vanities" took place on 17 February 1498. On 8 April there were riots in the cathedral against Savonarola, and the incensed population stormed the nearby monastery of San Marco. He was taken prisoner with two followers, interrogated thoroughly and tortured. With his hands tied together he was pulled up on a rope, causing him to dislocate his shoulder. The pain caused Savonarola to confess that he was not a prophet and that the matters he had preached about had not come from God. On 19 May he was examined again, on this occasion by the papal commissioners, and he retracted his confession. But the verdict had already been decided and on 22 May he was condemned to death; the next day he was burned on the Piazza della Signoria (ill. 118). A plaque which was mounted ten meters in front of the fountain 400 years later commemorates the event: "This plaque commemorates the place where Savonarola, together with his fellow brothers Domenico Buonvicini and Salvestro Maruffi, was hanged and burned on 23 May 1498 after an unjust verdict."

Savonarola influenced the artists of his age. His conception of art was based on late classical Neoplatonism as shaped by St. Augustine and St. Thomas Aquinas: according to this, nature created by God occupied a higher

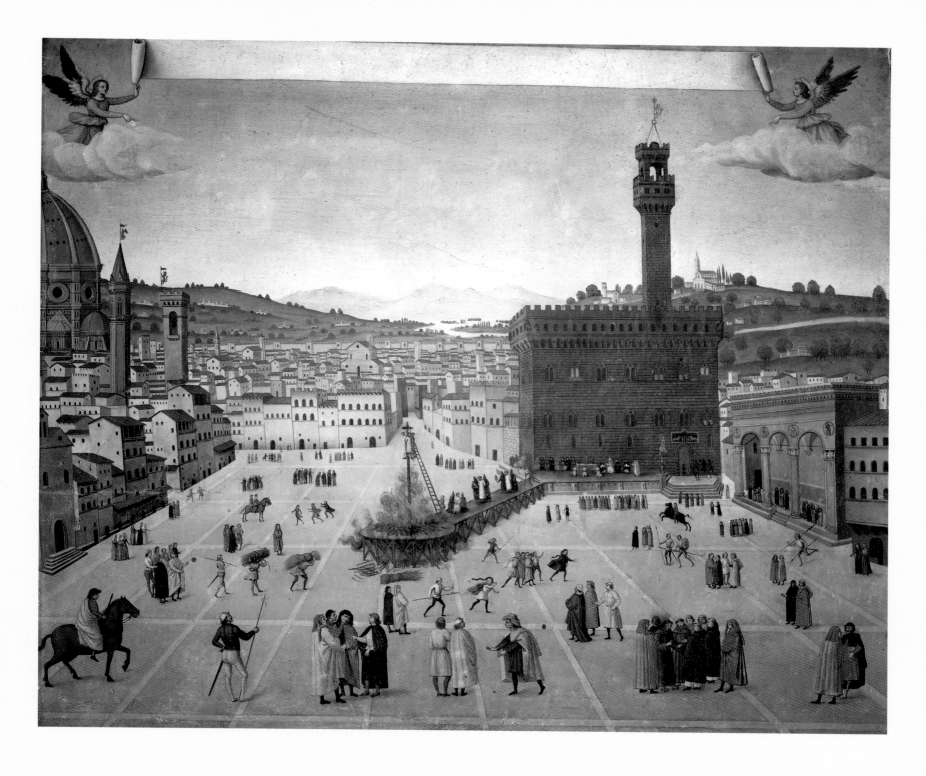

position than art, whose beauty came second to that of the absolute, divine beauty. However, Savonarola was not in principle an opponent of art. His view was that it should serve religion in all public and private areas of life. He condemned mythological and pagan themes, erotic motifs, and also naturalistic portraits of donors within religious pictures; in short, he condemned the secularization of art and its outward display of magnificence as the antithesis of religious contemplation and worship. Art had to be ascetic and serve the Christian hope for salvation exclusively: "I tell you that the Mother of God dresses like a poor woman, plain and modest; you, however, present the blessed Virgin as a whore." Savonarola saw art as a social and Christian medium for addressing the faithful of all classes. He considered its function to be acting as a component in

an ascetic and pious coexistence. For Savonarola, the promotion of a religious and ascetic art could have only one legitimate goal: to provide religious and educational instruction for the untutored and illiterate. His comment that "the pictures in churches are the books of children and women" made his basic position clear. Art should be intelligible to all, didactic and an exhortation.

118 Unknown artist
The Execution of Savonarola on the Piazza della Signoria, 1498
Tempera on panel
San Marco, Florence

When the population refused to comply with the ascetic lifestyle required by Savonarola and the city's former rulers had regained power, the fanatic was accused of heresy and sentenced to death. His execution is depicted in this painting. Three men dressed in the white robes of penitents are approaching from the municipal palace on the right side of the picture, and are being led by executioners, whose heads are shrouded in hoods, across a footbridge to the burning stake.

CHRONOLOGY

1420 In autumn or winter Benozzo di Lese di Sandro was born in Florence, the son of the tailor Lese di Sandro.

1439 First documented reference to the production of an *Ascension of Christ* for the Compagnia di Santa Agnese al Carmine in Florence.

1444 Contract with Lorenzo and Vittorio Ghiberti to work as an assistant on the so-called *Gate of Paradise* in the Baptistery in Florence.

1444/45 Works as an assistant in the workshop of Fra Angelico, painting the dormitory of the Dominican monastery of San Marco in Florence.

1447 Assists Fra Angelico to paint the Chapel of Pope Nicholas in Rome.

1448 Contract to assist Fra Angelico in painting the Chapel of San Brizio in Orvieto Cathedral.

1449 Silk picture of the *Madonna and Child giving Blessings*, Santa Maria sopra Minerva, Rome.

1450–1452 Period in Montefalco (Umbria). First independent works in the church of San Fortunato and San Francesco. Production of the panel painting of the *Madonna della Cintola* for the high altar in San Fortunato, now in the Pinacoteca Vaticana, Rome.

1453 Cycle of frescoes comprising nine scenes from the life of St. Rosa for the convent of St. Rosa in Viterbo, which were lost during the course of extension work in the church in 1632.

1456 Panel painting of the *Madonna and Child with Saints John the Baptist, Peter, Jerome and Paul* for the Chapel of St. Jerome in Perugia, now in the Galleria Nazionale dell' Umbria, Perugia.

1458 Panel painting for the cathedral in Sermoneta showing the *Madonna in Glory*.
Production of flags and standards for the coronation of Pope Pius II in Rome.
Return to Florence, where Benozzo Gozzoli creates frescoes in the private Medici Chapel showing the *Procession of the Magi*.

1461 Production of the altar painting of a *Sacra Conversazione* for the Compagnia delle Purificazione in Florence. The panel painting has since been taken apart and is kept in various museums: the main panel is in the National Gallery in London; the predella panel with the *St. Zenobius raising a Child from the Dead* is in the Staatliche Museen in Berlin; the predella panel showing the *Dance of Salome* is in the National Gallery of Art in Washington; the predella panel showing *St. Dominic raising a Child from the Dead* is in the Pinacoteca

Brera in Milan; the predella panel showing the *Presentation in the Temple* is in the Johnson Collection in Philadelphia; and the predella panel showing the *Fall of Simon Magus* is part of the Royal Collections at Hampton Court in London.

1464/65 Painting of the choir of Sant'Agostino, San Gimignano, as well as production of the fresco of *St. Sebastian Intercessor* for the church's nave. Fresco showing the *Martyrdom of St. Sebastian* for the collegiate church of San Gimignano.

1466 Restoration of the fresco of the *Maestà* by Lippo Memmi in the Palazzo Pubblico in San Gimignano. Creation of the panel painting of the *Madonna and Child between St. Andrew and St. Prosper*, now in the Museo Civico in San Gimignano.

1467 *Tabernacle of the Executed*, transferred frescoes that are now on display in the chapel of the Palazzo Pretorio in Certaldo.
Tabernacle of the Visitation, transferred frescoes that are now in display in the Biblioteca Comunale, Castelfiorentino.

1468 Cycle of frescoes from the Old Testament in the Camposanto, Pisa.

1471 Panel painting of the Triumph of St. Thomas Aquinas for the cathedral in Pisa, now in the Musée du Louvre in Paris.

1478/79 *Tabernacle of Legoli* (in the province of Pisa), enclosed by a chapel in the 19th century.

1484 *Tabernacle of the Madonna delle Tosse*, transferred frescoes which are now on display in the Biblioteca Comunale, Castelfiorentino.

1490s Panel painting of the *Madonna and Child Enthroned among St. Benedict, St. Scholastica, St. Ursula and St. John Gualberto* for the Vallombrosan order of nuns in Pisa, now in the Museo Nazionale di San Matteo, Pisa.
Fresco with the *Procession of the Magi*, in the oratory in Volterra Cathedral.

1497 Oil painting of the *Descent from the Cross* for the bishop's residence in Pistoia, now in the Museo Horne in Florence. Oil painting of the *Raising of Lazarus* for the bishop's residence in Pistoia, now in the Widener collection in the National Gallery of Art in Washington. Initial drawing for the *Dream of Innocent III*, manuscript VI, FF, c. 67, library of the convent of Giaccherino in Pistoia.

1497 Death of Benozzo Gozzoli on 4 October. He was buried in the monastery of San Domenico "a lato alla cappella di santo Sebastiano" (beside the Chapel of St. Sebastian). A commemorative stone was placed at one side of the church entrance, on the wall towards the large cloister, in memory of Benozzo Gozzoli.

GLOSSARY

altar panel, a painting that stands on or behind an altar. Early altar panels were made to stand alone; gradually they came to form the central work of elaborate altarpieces that combined several panels within a carved framework.

antependium (Lat. "hung before"), a decorative cover for the front of an altar, usually made of precious materials such as rich fabrics, metal work in gold or silver, enamels, painted wood panels etc. Also known as an altar frontal.

Apocrypha (Gk. "hidden things"), Jewish or Christian writings additional to the Old or New Testament. Though not accepted as part of the Bible, they continued to be read as holy texts.

apsidal chapel (Lat. *absis*, "arch, vault"), a chapel in an apse, which is usually a semicircular projection, roofed with a half-dome, at the east end of a church behind the altar. Smaller subsidiary apses may be found around the choir or transepts.

attribute (Lat. *attributum*, "added"), a symbolic object which is conventionally used to identify a particular person, usually a saint. In the case of martyrs, it is usually the nature of their martyrdom.

auto-da-fé (Port. "act of faith"), a public execution of heretics by burning at the stake.

balustrade, a rail supported by a row of small posts or open-work panels.

banderole (It. *banderuola*, "small flag"), a long flag or scroll (usually forked at the end) bearing an inscription. In Renaissance art they are usually held by angels.

baptistery (Gk. *baptisterion*, "wash basin"), from the 4th to the 15th centuries, a small building, usually separate from the main church, in which baptisms were performed. They were often circular or hexagonal, and dedicated to St John the Baptist. A well-known example is the Baptistry of the Duomo, the cathedral of Florence.

basilica (Gk. *basilike stoa*, "king's hall"), in Roman architecture a long colonnaded hall used as a court, a market or as a place for assemblies. The early Christians adopted this form of building for their churches, the first Christian basilicas being long halls with a nave flanked by colonnaded side aisles, and with an apse at the eastern end. With the addition of other features, in particular the transept, the basilica became the traditional Christian church.

biblical exegesis, the critical analysis and explanation of biblical texts.

boss, in architecture, a raised ornament, often seen, for example, at the intersection of the ribs in a vaulted roof.

Camposanto (It. "holy field"), a cemetery in Pisa. During the Early Renaissance the porticoed galleries that line the sides of the cemetery were decorated with frescoes, notably those by Gozzoli.

catacombs (Lat. *catacumba*, "underground chamber"), a series of underground passages with recesses for tombs.

catafalque (Lat. "scaffold"), a raised structure on which a coffin rests during a funeral service.

champlev (Fr. "raised ground"), form of enamelling in which the enamel fills small depressions and grooves cut into a metal surface.

chasuble (Lat. *casula*, "cloak, little house"), a long outer vestment worn by a Roman Catholic priest during Mass.

choir (Gk. *khoros*, "area for dancing; chorus"), in a Christian church, the areas set aside for singers and the clergy, generally the area between the crossing and the high altar.

cloisonné (Fr. "partitioned"), form of enamelling in which the enamel fills areas separated by thin strips of metal.

cloister (Lat. *claustrum*, "an enclosed place"), a covered walk, with an open colonnade along one side, usually running along all four walls of the quadrangle of a monastery or cathedral.

colonnade, a row of columns supporting a series of arches or an entablature.

cornice (Gk. *koronis*, "curved"), in architecture, a projecting molding that runs around the top of a building or the wall of room.

Council of Ferrara-Florence, a Church Council held in Ferrara (1438–1439), Florence (1439–1443), and Rome (1443–1445), its aim being the reconciliation of the Western (Roman Catholic) and Eastern (Greek Orthodox) Churches. An agreement was reached (the Greek side, fearing the growing strength of the Ottoman Turks, making the concessions) but reconciliation was short lived. The Council is significant both for having helped to define Church doctrine, and also for having introduced Greek scholarship to Renaissance Italy.

crosses: Latin cross (*crux immissa*): the best-known form, a cross with a long upright and a shorter crossbar. *Crux hastata* ("spear cross"): a Latin cross leaning against someone. St Andrew's cross (*crux decussata* or Saltire): an X-shaped cross, the arms being of equal length.

Dominicans (Lat. *Ordo Praedictatorum*, Order of Preachers), a Roman Catholic order of mendicant friars founded by St. Dominic in 1216 to spread the faith through preaching and teaching. The Dominicans were one of the most influential religious orders in the later Middle Ages, their intellectual authority being established by such figures as Albertus Magnus and St. Thomas Aquinas. The Dominicans played the leading role in the Inquisition.

embossed, made to stand out in relief (whether by stamping, chasing, molding etc).

familiari (It.), friends and associates, intimates.

fresco (It. "fresh"), wall painting technique in which pigments are applied to wet (fresh) plaster (*intonaco*). The pigments bind with the drying plaster to form a very durable image. Only a small area can be painted in a day, and these areas (known as *giornata*), drying to a slightly different tint, can in time be seen. Small amounts of retouching and detail work could be carried out on the dry plaster, a technique known as *a secco* fresco. See: Inset 1.

gable, in architecture, the triangular section at the end of a pitched roof.

glory, the supernatural radiance surrounding a holy person.

Gothic (Ital. gotico, "barbaric, not classical"), the style of European art and architecture during the Middle Ages, following Romanesque and preceding the Renaissance. Originating in northern France about 1150, the Gothic style gradually spread to England, Spain, Germany and Italy. In Italy Gothic art came to an end as early as 1400, whilst elsewhere it continued until the 16th century. The cathedral is the crowning achievement of Gothic architecture, its hallmarks being the pointed arch (as opposed to the Romanesque round arch), the ribbed vault, large windows, and exterior flying buttresses. The development of Gothic sculpture was made possible by Gothic architecture, most sculptures being an integral part of church architecture. Its slender, stylized figures express a deeply spiritual approach to the world, though its details are often closely observed features of this world. Gothic painting included illuminated manuscripts, panel pictures, and stained glass windows. See: **International Gothic**

grotto (It. *grotta*), a small cave or cavern.

historia (Lat. "story"), in Renaissance art theory, the story or incident to be painted or sculpted. It was thought the subjects depicted should be morally, intellectually, and spiritually uplifting, so the two main sources of subjects for artists were the Bible and Christian stories on the one hand, and classical literature and mythology on the other.

iconography (Gk. "description of images"), the systematic study and identification of the subject-matter and symbolism of art works, as opposed to their style; the set of symbolic forms on which a given work is based. Originally, the study and identification of classical portraits. Renaissance art drew heavily on two **iconographical** traditions: Christianity, and ancient Greek and Roman art, thought and literature.

illuminated manuscripts, manuscripts decorated with elaborately designed letters, painted in rich colors and sometimes with gold, and often illustrated with small, finely painted pictures (miniatures). Illumination flourished during the Middle Ages, dying out with the advent of printing.

International Gothic, an art style that flourished in many parts of Europe ca.1375–ca.1425. A style of the courts, and often depicting scenes of aristocratic life, it was characterized by an elegant stylization, and a richness of color and naturalistic detail. Among its leading figures (all flourishing in the early years of the 15th century) were the Flemish Limbourg brothers, and, in Italy, Simone Martini and Gentile da Fabriano.

intrados, the inner curve or underside of an arch.

Legenda Aurea (Lat. "golden legend"), a collection of saints' legends, published in Latin in the 13th century by the Dominican Jacobus da Voragine, Archbishop of Genoa. These were particularly important as a source for Christian art from the Middle Ages onwards.

liberal arts, in medieval education, the seven main subjects studied: grammar, rhetoric, logic, astronomy, geometry, music and arithmetic. These intellectual disciplines were thought the proper subjects for a "free man" (Latin *liber*) and were clearly distinguished from the mechanical or practical arts (such as painting and sculpture), which were thought to be of a lower status.

liturgy (Gk. *leitourgia*, "a service performed by a priest"), the public rituals and services of the Christian Churches; in particular, the sacrament of Holy Communion.

loggia (It.), a gallery or room open on one or more sides, its roof supported by columns. Loggias in Italian Renaissance buildings were generally on the upper levels. Renaissance loggias were also separate structure, often standing in markets and town squares, that could be used for public ceremonies.

lunette (Fr. "little moon"), in architecture, a semicircular space, such as that over a door or window or in a vaulted roof, that may contain a window, painting or sculptural decoration.

Maestà (It. "majesty"), a depiction of the Madonna and Child enthroned in Heaven and surrounded by saints and angels. They were particularly popular in Italy during the 13th and 14th centuries.

mandorla (It. "almond"), an almond-shaped radiance surrounding a holy person, often seen in images of the Resurrection of Christ or the Assumption of the Virgin.

minnesinger (Ger.) in the Middle Ages, a German poet-knight who sang songs about Minne, courtly love. Minnesingers flourished in particular in the 13th and 14th centuries, among the finest being Walther von der Vogelweide and Wolfram von Eschenbach.

nave (Lat, *navis*, "ship"), the central part of a church stretching from the main doorway to the chancel and usually flanked by aisles.

Neo-Gothic, a 19th-century style in architecture and design based on the revival of medieval Gothic architecture.

Neoplatonism, in the Renaissance, an intellectual movement that drew upon the teachings of the Greek philosopher Plato, though largely through early medieval interpretations of Plato that introduced various mystical concepts to his philosophy. Renaissance Neo-Platonism influenced philosophy, literature, and the visual arts. Leading Renaissance Neoplatonists include Marsilio Ficino (1433–1499) and Pico della Mirandola (1463–1494).

nimbus (Lat. "cloud, aureole"), the disco or halo, usually depicted as golden, placed behind the head of a holy person. It was used this way in Oriental and Classical, and Indian religious art, and was adopted by Christian artists in the 4th century. With a **cruciform nimbus** there is a cross in or around the nimbus.

obelisk (Gk. *obeliskos*, "slender, pointed implement"), an upright column with four sides tapering the top to a pyramid or cone.

oculus pl. **oculi** (Lat. "eye"), in architecture, a circular opening in a wall or at the top of a dome; a round window.

palazzo (It.), palace, large town house or mansion.

pedestal (It. *pie di stallo*, "foot of a stall"), a base or support for a column, statue or other object.

pediment, in classical architecture, the triangular end of a low-pitched roof, sometimes filled with relief sculptures; especially in Renaissance and Baroque architecture, a decorative architectural element over a door or window, usually triangular (broad and low), but sometimes segmental.

perspective (Lat. *perspicere*, "to see through, see clearly"), the method of representing three-dimensional objects on a flat surface. Perspective gives a picture a sense of depth. The most important form of perspective in the Renaissance was **linear perspective** (first formulated by the architect Brunelleschi in the early 15th century), in which the real or suggested lines of objects converge on a vanishing point on the horizon, often in the middle of the composition (**central perspective**). The first artist to make a systematic use of linear perspective was Masaccio, and its principles were set out by the architect Alberti in a book published in 1436. The use of linear perspective had a profound effect on the development of Western art and remained unchallenged until the 20th century.

Pestbild (Ger. "plague picture"), a devotional image meant to keep plague away. They usually depicted saints who were thought to offer protection against plague, such as St Roch and St Sebastian.

pilaster (Lat. *pilastrum*, "pillar"), a rectangular column set into a wall, usually as a decorative feature.

pinnacle (Lat. *pinna*, "wing"), a small turret-like architectural feature, often richly ornamented, that crowns parapets, pediments above windows or doors, spires, elaborate altarpieces and so on. Pinnacles were a familiar feature in Gothic architecture.

plasticity (Gk. *plastikos*, "able to be molded, malleable"), in painting, the apparent three-dimensionality of objects, a sculptural fullness of form.

pluviual (Lat. *pluviale*, "rain cloak") an ecclesiastical vestment consisting of a long cloak, usually often richly decorated. It is used by priests and bishops on ceremonial occasions other than the Mass, such as processions and consecrations.

podest (It.) during the Middle Ages and Renaissance, the official responsible for law and order in Italian cities, particularly republics; a chief magistrate.

polyptych (Gk. *poluptukhos*, "folded many times"), a painting (usually an altarpiece) made up of a number of panels fastened together. Some polyptychs were very elaborate, the panels being housed in richly carved and decorated wooden frameworks.

portal (Lat. *porta*, "gate"), a doorway, entrance.

Protoevangelium, an apocryphal gospel, supposedly written by the Apostle James. Probably written in the mid-2nd century, it deals mainly with events surrounding Christ's birth. Also know as the Book of James.

predella (It. "altar step"), a painting or carving placed beneath the main scenes or panels of an altarpiece, forming a kind of plinth. Long and narrow, painted predellas usually depicted several scenes from a narrative.

Quattrocento (It. "four hundred"), the 15th century in Italian art. The term is often used of the new style of art that was characteristic of the Early Renaissance, in particular works by Masaccio, Brunelleschi, Donatello, Botticelli, Fra Angelico and others. It was preceded by the **Trecento** and followed by the **Cinquecento**.

reliquary (Lat. *reliquiae*, "remains"), a container for the sacred remains of a saint, widely used during the Middle Ages. They were often made of precious materials and richly decorated.

repouss (Fr. "pushed back"), of metalwork, decorated with a pattern or design hammered into relief from the back.

roof truss, the framework supporting a roof.

Sacra Conversazione (It. "holy conversation"), a representation of the Virgin and Child attended by saints. There is seldom a literal conversation depicted, though as the theme developed the interaction between the participants – expressed through gesture, glance and movement – greatly increased. The saints depicted are usually the saint the church or altar is dedicated to, local saints, or those chosen by the patron who commissioned the work.

Salvator Mundi (Lat. "savior of the world") Christ as Savior of the World. The name is given to a devotional image that shows Christ holding a globe (representing the world) in one hand, His other hand raised in blessing.

sarcophagus, pl. **sarcophagi** (Gk. "flesh eating"), a coffin or tomb, made of stone, wood or terracotta, and sometimes (especially among the Greeks and Romans) carved with inscriptions and reliefs.

scorci (It.) foreshortening. Among the best-known examples of extreme *scorci* is Andrea Mantegna's painting *Lamentation Over the Dead Christ* (1464–1500).

seraph pl. **seraphs** or **seraphim** (Hebrew "angel"), an angel. In the Medieval hierarchy of celestial beings, they are the first in importance. They are usually depicted with three pairs of wings.

sgraffito (It. "scratched"), technique of decoration in which a design is scratched through one layer of paint or (in the case of stucco) plaster to reveal an underlying layer of contrasting color.

signoria (It. "lordship"), from the 13th to the 16th century, the governing body of some of the Italian city states. They were usually small groups of influential men presided over by the head of the city's most important family.

simultaneous narration/representation, the depiction of several episodes of a story in a single picture.

sinopia (Sinop, a town on the Black Sea that provided a fine red chalk), the preparatory drawing for a fresco drawn on the wall where the painting is to appear; the red chalk used to make such a drawing.

spandrel, (1) a triangular wall area between two arches and the cornice or molding above them, or between the curve of an arch and the rectangular frameworks around it (for example at the top of an arched doorway; (2) a curved triangular area between the ribs in a vault.

stigmata, sing. **stigma** (Gk. "mark, brand, tattoo"), the five Crucifixion wounds of Christ (pierced feet, hands and side) which appear miraculously on the body of a saint. One of the most familiar examples in Renaissance art is the **stigmatization** of St Francis of Assisi.

stucco lustro (It. "lustrous stucco"), a form of stucco (plaster decoration) in which wax and color are added to the plaster to create an imitation of marble or other stone.

surplice (Lat. "over the pelt", originally a garment worn in northern climes), a long, wide-sleeved gown worn by priests.

tempera (Lat. *temperare*, "to mix in due proportion"), a method of painting in which the pigments are mixed with an emulsion of water and egg yolks or whole eggs (sometimes glue or milk). Tempera was widely used in Italian art in the 14th and 15th centuries, both for panel painting and fresco, then being replaced by oil paint. Tempera colors are bright and translucent, though because the paint dried very quickly there is little time to blend them, graduated tones being created by adding lighter or darker dots or lines of color to an area of dried paint.

terracotta (It. "baked earth"), fired clay that is unglazed. It is used for architectural features and ornaments, vessels, and sculptures.

tonsure (Lat. *tonsus*, "shaven"), that part of a monk's head that has been shaved (as a sign of their monastic status).

tracery, in architecture, decorative work consisting of interlaced or branching lines, usually found in the upper parts of windows (in stone), but also (in wood) on screens, doors. Elaborate tracery was a characteristic feature of Gothic architecture.

Trecento (It. "three hundred"), the 14th century in Italian art. This period is often considered the "proto-Renaissance", when writers and artists laid the foundation for the development of the early Renaissance in the next century (the **Quattrocento**). Outstanding figures of the Trecento include Giotto, Duccio, Simone Martini, the Lorenzetti brothers, and the Pisano family of sculptors.

vault, a roof or ceiling whose structure is based on the arch. There are a wide range of forms, including: the **barrel** (or **tunnel**) vault, formed by a continuous semi-circular arch; the **groin** vault, formed when two barrel vaults intersect; and the **rib** vault, consisting of a framework of diagonal ribs supporting interlocking arches. The development of the various forms was of great structural and aesthetic importance in the development of church architecture during the Middle Ages.

vestibule (Lat. *vestibulum*, "entrance"), small entrance hall or antechamber.

votive picture, a picture or panel donated because of a sacred promise, usually when a prayer for good fortune, protection from harm, or recovery from illness has been made.

SELECTED BIBLIOGRAPHY

Acidini Luchinat, Cristina: Benozzo Gozzoli, Florence 1994

Acidini Luchinat, Cristina: Benozzo Gozzoli. La Cappella die Magi, Milan 1993, 1994

Cennini, Cennino: Il libro dell'arte, ed. Franco Brunella, Vicenza 1982

Cole Ahl, Diane: Benozzo Gozzoli's Frescoes of the Life of Saint Augustine in San Gimignano. Their Meanings in Context, in: Artibus et Historiae, no. 13, 1986, p. 35–53

Cole Ahl, Diane: Benozzo Gozzoli, New Haven and London 1996

Crum, Roger J. and Roberto Martelli: "The Council of Florence, and the Medici Chapel", in: Zeitschrift für Kunstgeschichte, vol. 3, 1996, pp. 403–417

Emmenegger, Oskar, Albert Knoepfli, Manfred Koller and André Meyer: Reclams Handbuch der künstlerischen Techniken. Wandmalerei und Mosaik, Stuttgart 1990

Exhibition catalogue: Pittura di luce, ed. Luciano Bellosi, Casa Buonarrotti, Florence 1990, Milan 1990

Giese, Elisabeth: Benozzo Gozzoli's Franziskuszyklus in Montefalco, Frankfurt/M. 1986

Gombrich, Ernst H.: Norm and Form, London 1966

Kiel, Hanna: "Das Sinopienmuseum im Camposanto am Dom zu Pisa", in: Pantheon, XXXIX, issue II, 1981, p. 127–128

Kirschbaum, Engelbert S. J. (ed.): Lexikon der christlichen Ikonographie, Rome, Freiburg, Basle, Vienna 1968–1972

Lunghi, Elvio: Benozzo Gozzoli in Montefalco, Assisi 1997

Padoa Rizzo, Anna: Benozzo Gozzoli. Pittore fiorentino, Florence 1972

Padoa Rizzo, Anna: Benozzo Gozzoli. Catalogo completo dei dipinti, Florence 1992

Roettgen, Steffi: Wandmalerei der Frührenaissance in Italien. Anfänge und Entfaltung, 1400–1470, vol. 1, Munich 1996

Ryan, W. G.: The Golden Legend, trans. from the Latin Legenda Aurea by J. de Voragine, Princeton University Press 1993

Thieme, Ulrich and Felix Becker (eds.): Allgemeines Lexikon der Bildenden Künstler. Stichwort: Benozzo Gozzoli, vol. 3, Leipzig 1909, p. 341–349

Vasari, Giorgio: Le vite de' più eccellenti pittori, scultori e architettori, ed. Milanesi, vol. II, Florence 1878

Wiemers, Michael: Zur Funktion und Bedeutung eines Antikenzitates auf Benozzo Gozzolis Fresko "Der Zug der Könige", in: Zeitschrift für Kunstgeschichte, vol. 4, 1987, p. 441–470

Zesi, Federico (ed.): La pittura in Italia. Il Quattrocento, Milan 1987

PHOTOGRAPHIC CREDITS

The publishers would like to thank the museums, collectors, archives and photographers for permission to reproduce the works in this book. Particular thanks go to the Scala photographic archives for their productive cooperation.

Oskar Emmenegger, Zisers, Graubünden (14 right); Fototeca Regionale dell'Umbria, Perugia (17); © Nicolò Orsi Battaglini, Firenze (63); Rheinisches Bildarchiv, Köln (60, 61); © RMN, Paris – Photo: H. Lewandowski (98); Scala, Istituto Fotografico Editoriale, Antella/ Firenze (6, 8, 9, 10, 11, 12, 13, 14 left, 15, 18/19, 20, 22/23, 24, 26/27, 28, 30, 31, 32, 34, 35, 36, 38, 39, 41, 43, 45, 46, 47, 48/49, 50, 51, 56, 57, 58, 64, 65, 67, 68, 69, 70/71, 72, 74, 75, 76, 77, 78, 80, 81, 82, 83, 84/85, 86, 87, 88, 89, 90, 92, 93, 97, 99, 100, 105, 106, 107, 108, 109, 110, 112, 113, 114, 115).